Art

Become Confident Fast

Aron Kuehnemann

Art: Become Confident Fast
Copyright © 2017 Aron Kuehnemann

Cover design by Islam Farid. www.islamfarid.net
Figure images by Stephen Reich.

ISBN-13: 978-1548738747
ISBN-10: 1548738743

Images

Venus of Willendorf, unknown artist, c. 24,000–22,000 BCE. Naturhistorisches Museum, Vienna, Austria.

La Nona Ora, Maurizio Cattelan, 1999. Musée des Beaux-Arts, Rennes, France.

Judith, Gustav Klimt, 1901. Österreichische Galerie Belvedere, Vienna, Austria.

The Ambassadors, Hans Holbein the Younger, 1533. National Gallery, London, England.

Cabinet of Curiosities, Andrea Domenico Remps, 1690s. Museo dell-opificio delle Pietre Dure, Florence, Italy.

Rainy Season in the Tropics, Frederic Edwin Church, 1866. Fine Arts Museums of San Francisco, California.

Vitruvian Man, Leonardo da Vinci, c. 1490. Gallerie dell'Accademia, Venice, Italy.

Christ at the Column, Caravaggio, c. 1607. Musée des Beaux Arts, Rouen, France.

Male Figure Standing, anonymous Egyptian artist, c. 746–335 BCE. Walters Art Museum, Baltimore, Maryland.

Metropolitan Kouros, anonymous artist, c. 590–580 BCE. Metropolitan Museum of Art, New York, New York.

David, Michelangelo, 1501–1504. Galleria dell'Accademia, Florence, Italy.

Nefertiti, Thutmose, 1345 BCE. Neues Museum, Berlin, Germany.

The Last Supper, Leonardo da Vinci, 1495–1498. Santa Maria delle Grazie, Milan, Italy.

Last Supper, Jacopo Tintoretto, 1592–1594. Church of San Giorgio Maggiore, Italy.

St. Michael Archangel, Guido Reni, 1636. Santa Maria della Concezione dei Cappuccini, Rome, Italy.

Balloon Dog (Yellow), Jeff Koons, 1994–2000. Metropolitan Museum of Art, New York, New York.

Depiction of aurochs (black bulls), horses, and deer, c. 17,300 years ago, Lascaux cave, France.

Apollo Belvedere, possibly Leochares, c. 130–140 CE. Vatican Museums, Vatican City, Italy.

Bust of Marcus Aurelius, anonymous, 161–169 CE. Musée du Louvre, Paris, France.

The School of Athens, Raphael, 1509–1511. Apostolic Palace, Vatican City, Italy.

Venus of Urbino, Titian, 1538. Uffizi Gallery, Florence, Italy.

Still Life with Bouquet and Skull, Adriaen van Utrecht, 1642. Private collection.

Self-Portrait, Rembrandt, 1655. Kunsthistorisches Museum, Vienna, Austria.

Liberty Leading the People, Eugène Delacroix, 1830. Louvre, Paris, France.

The Seine at Bercy, Paul Cézanne, 1878. Bridgeman Art Library, Kunsthalle Hamburg, Germany.

Le Flâneur, Paul Gavarni, 1842.

(Untitled) First Abstract Watercolor, Wassily Kandinsky, 1910. Musée National d'Art Moderne, Paris, France.

Les Demoiselles d'Avignon, Pablo Picasso, 1907. Museum of Modern Art, New York, New York.

Tableau I, Piet Mondrian, 1921. Museum Ludwig, Cologne, Germany.

Space-Force Construction, Lyubov Popova, 1921. State Tretiakov Gallery, Moscow, Russia.

Campbell's Soup Cans, Andy Warhol, 1962. Museum of Modern Art, New York, New York.

Laocoön and His Sons, c. 200 BCE. Vatican Museums, Vatican City, Italy.

Lamentation (The Mourning of Christ), (probably) Giotto, c. 1305. Cappella degli Scrovegni, Padua, Italy.

Massacre of the Innocents, Rubens, 1611–1612. Art Gallery of Ontario, Toronto, Canada.

Water Lilies and Japanese Bridge, Monet, 1899. Princeton University Art Museum, New Jersey. From the collection of William Church Osborn, Class of 1883, Trustee of the Princeton University (1914–1951), President of the Metropolitan Museum of Art (1941–1947); Gift of his family.

Guernica, Picasso, 1937. Museo Reina Sofia, Madrid, Spain. Courtesy of www.PabloPicasso.org.

Fountain, Marcel Duchamp, 1917. Destroyed.

Dedication

This book is dedicated to clients and friends of The Art Circuit. Together we discovered that most people feel less comfortable with visual arts than they could, and that a few pieces of critical information transform our artistic experiences.

It is also dedicated to my wife, Chisaka. Her encouragement kept us sharing art for years and supported this book coming to fruition.

Contents

Part III: Rapid History When/Who160

Introduction

This book exists because I didn't know enough about art to credibly run an art network. We simply bought art we liked, which ultimately is what matters, and then shared it, but couldn't contextualize that into a credible position about our curatorial vision—about why we selected certain artworks to share with the community. We began to sense a distinct difference, beyond the obvious, of viewing art at home versus the range of public and quasi-public locations of street murals, museums, and galleries, and we needed to diagnose what would create easy and positive art experience in client homes.

Then, more important, we realized that our clients weren't confident in their own art experiences. They were confident in the sense that successful, educated professionals are generally secure in their opinions and outlook, but less so about the details of visual art than music, literature, movies, or other cultural experiences. The conversations atrophied more quickly. They centered on interior design themes, practicalities of matching curtains or carpets.

Yet in private moments, at cocktail parties or hosting a few guests, there was recognition that the artistic process—even the viewing experience, remained a creative aspiration we culturally value, that many consider a vestige of human creativity, which software algorithms will have more difficulty replacing than customer service or manufacturing activities, and that using a simple painting or artwork at home could serve as a conduit for thinking more about creativity and talking more about beauty—or shock, the elements in art that grab our attention and convey meaning, and that seem simply human.

That themes of art and creativity matter doesn't mean people have time to pull away from commerce or family, email, text, or social media, to study and refocus our lives around them. We want shortcuts. What used to be CliffsNotes are now hacks. We expect that service providers distill fun or knowledge into organized packets, nutrient content to concentrated supplements.

Rather than lament our requirements for speed, I'll acknowledge to also worship at the temple of productivity, of daily routines and habits, and to expect that I can undertake rapid learning for a language, dramatic body transformation through diet and exercise and so, why not a whirlwind through art? After all, it's a timeless human endeavor and

most of us have studied it at one point or another. But it hasn't been packaged to provide a framework nor have books been directed at adults who simply want the why, what, how, when, where, and who. Incidentally, that almost became the subtitle of this book. The parts, sections, and contents are still arranged around these themes, although the subtitle became the outcome we want to achieve—confidence, fast.

But why, I asked myself, had a book like this not been written? Famous thinkers with knightly titles of "Sir" have written volumes about art history, as have Noble prize winners, journalists, and a proud lineage of world-famous artists. But they fail to take the perspective of the viewer—the customer perspective, if you will. The story of art is told as if art is the only hero of the journey, passing through eras of Renaissance and abstraction. Or, in other cases, it's the artist's journey, because certainly, without them, we'd have only vacant canvas and fully formed chunks of rock or clay. Fair enough.

Even so, at any given moment why are we, the viewers, viewing a particular artwork in the first place? It's our journey, the viewer or experiencer's journey, and it's never been simply about visual stimulation or absorbing exactly what artists or artworks we find in front of us. And what is *it* anyway, this word that's so hard to define, that provokes controversy equally among sane accountants and religious devotees? How should we look at these pictures or sculptures? Is there a method? I certainly felt like a meandering fool in most museums, puzzled both by millennia of Christian images and the color-field paintings that simply juxtaposed shades of red.

Can we apply a method and make it easier? In fact, we can. And once we know a few keystone approaches and seminal artistic ideas—the essential topics that artists have addressed, we can engage with art in any environment, embrace it for what it is, and also more critically evaluate it, disagree with it, decide if it applies to our lives.

In a world of scarce time, that's also filled with art books, you should read this one because it showcases the range of critical questions rather than following linear art history or specializing in a single area of philosophy, psychology, or neuroscience. We need a dose of each and a common palate to become confident, fast. It's my hope to provide the minimum effective amount as a foundation for your future exploration.

Art

A word that's too big and too small to be easy. We can't define it yet, but we will.

Become

To change from a current to a future state.

Confident

Self-assured, not the way you think and feel today about art.

Fast

Four to ten hours of reading.

Part I: Does Art Matter? Why/What

Why Is Art Important?

When Vincenzo Peruggia stole the *Mona Lisa*, on Monday morning, August 21, 1911, he would later claim patriotism as the motivation. He wanted *La Gioconda,* as it's often known in Italian, returned to its motherland of Italy, blaming French military leader Napoleon Bonaparte for its captivity in the Louvre Museum in Paris, France.[1] Letters to his father indicate that he also harbored mundane financial motivations, at least matching his claim about national pride: "I am making a vow for you to live long and enjoy the prize that your son is about to realize for you and for all our family."[2] Peruggia's vow was never legitimized. Two years after perpetrating the heist in Paris, he was arrested in Florence trying to offload the painting, which had suddenly risen from relative obscurity to global artistic fame, courtesy of two years in the headlines. The reading public has always appreciated a mysterious treasure hunt.

Napoleon didn't steal the *Mona Lisa*; it was gifted by its painter, Leonardo da Vinci, to France's King Francis I, when da Vinci moved to France in the sixteenth century. Napoleon did covet and plunder thousands of other precious artifacts though. He institutionalized cultural looting in the wake of conquest, at one time boasting that he would "have everything that is beautiful in Italy." Indeed, he formalized rules to make it so, including the Treaty of Tolentino, which forced the pope to hand over hundreds of precious items, and listed locations and types to be transferred. Napoleon viewed his possession of cultural treasures as adding to the grandeur of his rule.[3]

Nazi Germany followed a familiar script, although administered with distinct cruelty. Adolf Hitler, leader of the Nazi party, was a failed art student after all, twice falling short of admittance to the Academy of Fine Arts Vienna. The rejection didn't quell his appetite for the arts. He dreamed of a Führermuseum, a glittering

display of millions of artworks from conquered territories. Like other Nazi ambitions, although not fully realized, the atrocities unleashed a chain reaction of damage that the world is still grappling with today. Individuals and organizations continue to lobby museums across Europe to return looted artworks.

Victors and vandals don't only loot artwork, they often destroy it. In the chaotic Middle Eastern wars that have raged in Iraq and Syria, there are videos of a militant group, ISIS, destroying Ashurnasirpal II's palace in Nimrud, modern-day Iraq, a royal residence and administrative center populated since at least 1,000 years before the Common Era. The Byzantine Christian empire of the eighth century also destroyed artistic icons. They feared the power of godly images. "At the heart of the argument was the concern that images of Christ and the saints might displease God, due to their potential to be misused as idols. This was not a mere theoretical debate but one that acknowledged the power of icons and the idea that being on the wrong side meant the entire empire might lose God's favor."[4] The misuse of art could sway battlefield outcomes and collapse an empire.

Besides thieves, despots, and destroyers, many of us take artwork home from Paris, Rome, Egypt, or New York. We chronicle our travels and collect objects that showcase our ideas of beauty or personal significance. We hold pictures of deceased relatives or ex-lovers, and even the most scientifically minded among us feel an aura of their presence in our hands. Artistic images represent our gods, preserve our children, transport us to past vacations, and create our clearest memories of memorable nights with friends. They bestow glory on their protectors and generate collective identity within cultures. Most of us have more than a vague sense that art objects matter.

And yet, outside these personal keepsakes and a short list of global treasures, the vast middle seems to fall short—the museums and galleries, the buzzy shows, the collective identity known as "the art world."

The (Unwelcoming) Vast Middle

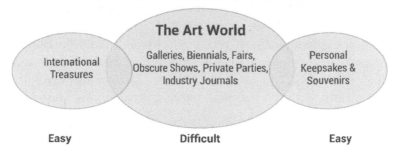

Understanding that religious zealots might loot sanctuaries or deface images of competing doctrines or that victorious emperors parade into conquered cities headed directly to museums, as do art thieves intent on fortune or national pride, isn't enough to make us understand or rationalize why the art world should be compelling. The breathless writings of history don't align with our distracted, periodic, museum visits, and don't provide us with the sense of awe that seems expected from objects that pillaging rulers would seek, thieves would target, or that would command eight-figure financial sums and grab global headlines. It doesn't add up.

We probably spend more time binge watching a TV show during one weekend than viewing art in a year, as we spend more money on a single gym outfit, even if we skip too many sessions, than we do on artistic activities or purchases. When we are confronted by Marcel Duchamp's *The Large Glass* in the Philadelphia Museum of Art, our coldness is predictable. We wonder what we are missing. An equivalent vacancy appears across whole wings of art museums, usually the medieval and more religious sections or the most contemporary, electronic installations. We look in art gallery windows but rarely enter. We sense that other people are having more fun around art, but they are "artsy," or maybe we'd accuse them of pretentiousness. So, we resign ourselves to visiting museums on vacation and doing our best to comprehend the images, but admit we'll never sit in front of a single artwork for seven or eight minutes or buy a painting instead of a car.

Art is inherent and biological, but the art world doesn't make it

easy. I'm not sure what to make of a red pulley with rocks hanging on one side and a baby's crib on the other, or a silent film in sepia-tone colors that shows the Icelandic landscape for thirteen minutes. Contemporary art prizes novelty and trades on cultural innuendo; it's completely liberated from standard artistic forms of paint and stone. In contrast, music moves us naturally, hypnotically, while fictional stories project us into the protagonist's life through empathetic immersion.

We are educated about music and fiction in grade school, as we are with art, but the artistic subjects are jettisoned away, like the first engines of a rocket, as we reach escape velocity into adulthood. Suddenly, we aren't getting practice sessions with visual art, and although we're somewhat comfortably educated and usually consider ourselves professionally successful, art is that nagging, creative topic that fills the debris of our academic memories but that most of us would like to know better. We don't have time to study it—but why would we, when we're behind on last season's hot TV episodes that are filling social media, and when we haven't been to a museum since our friends visited town?

We might be missing exposure to one of life's more natural and fulfilling pursuits. Running a small art network, I realized that my less-studied clients weren't quickly enjoying artwork, and many people weren't becoming customers in the first place, usually because they didn't think art was "for them." Nonsense. Humans painted walls and drew stories long before writing them. In a world where we often fall into superficial news scanning and easy watching, we have few other mediums or practices that are explicitly dedicated to provoking questions, wrapped in a beautiful package. Art can do that for us.

Most books about art treat the subject historically or thematically. You start at the beginning of an art period and end today. You deep dive into Impressionism or Minimalism, the Renaissance or the Romantic Period. A few books introduce the philosophy behind art history, while many more aspire to fill a corner of your coffee table with small images from a high-profile museum

exhibit. They don't ask you *why* you consider art in the first place or nudge you to *build your own working definition* of the word, "art." The histories are too long and the philosophy too opaque.

A better approach would be to quickly learn enough to ask yourself critical questions about art's meaning and purpose, thinking about the places and times you've seen art and how it impacted you—or didn't, and about understanding not just the visual compositions of artwork, but the intellectual movements that surrounded them. Then find your own answers. *Our goal is to efficiently become comfortable with the cornerstone questions of the art world, so that during a few hours, between more distracting activities, you can wipe the furrowed brow off your face and make art engaging.* Become confident fast.

Because visual art is composed of objects we must view to appreciate, it's helpful to know that between 80 and 90 percent of the information our brains process is consumed visually. Even if you know that a picture is worth a thousand words, this is profound and you need to dwell on it, rather than using the data as a throwaway factoid. We gather more information visually *than all the other senses combined.*[5] And we do so faster than reading text. Visuals change the quality of associated sound and taste. Food on a red plate is sweeter because of the accompanying hue.[6] Yes, vision is the dominant, alpha sense. Critical elements of social knowledge, such as personal interactions, facial expressions, and body language, are *only* possible to learn through sight. We can't study them orally or simply read, we have to look.

Although visual information is core to our sense of the world, and key to sharing and learning human knowledge, the purest visual art form is walled off and guarded by quiet galleries, formal auctions, private events, and supposedly special rules of taste. Most of us took art history in high school or maybe college. We have a few art books lying around the apartment, but it's been awhile since we looked at the contours of artistic practice, and we certainly haven't spent much time thinking about a place or community called the art world. But if we spend a few hours right

now getting smart about the foundations of visual culture, we'll be more comfortable and independent when we do encounter it.

Beyond superficial comfort in the art world, we examine art so that we don't settle for first impressions. Your reaction to art changes with time. For more than two years, I collected responses from participants in The Art Circuit, a network that rotates fine art through people's homes on a subscription basis. First impressions run the gamut of emotions, from boredom or confusion to an arresting joy, surprise, aversion, awe, or a combination. But reactions almost inevitably change when you spend more time with an artwork—*if* you spend more time.

Given the percentage of information we gather through visuals, it's worthwhile to pause and consciously consider our approach, and then to examine relevant elements of an artwork, to think about the colors, shadings, lines, formats, and styles, and why they attract or repel you. Explore attributes in artwork the way you analyze other creative topics: textures and combinations in food; folds, zippers, and fabrics in fashion; space and lighting in interior design; biases and sources in news articles; or casting choices and cinematography in a movie. Your initial opinion will evolve, and it might change completely.

Art speaks through beauty, shock, and innovative color tones, but don't let the visual magic mislead you, enduring art taps into essential emotions of the human condition. It's about a lot more than being pretty. Art has long helped build culture by visually transmitting stories about lofty topics: conquests, gods, heroes, love, tragedy, social causes, and cultural protests. Given art's grand ambitions, we'd all do well to refine our understanding of the big questions it asks and how it asks them, to build our own ideas about artistic objects, creation, and beauty. Most of us don't have those ideas today. Having your own answers is more important than hearing mine.

Questions about visual art are difficult, and our answers are often more superficial than for movies, books, or music. We have less exposure to art, and our art encounters are shaped by prior

knowledge, the subconscious, our cultural background, and the art's physical location. You can't meaningfully change most of these attributes *during* the viewing process. Much of your art experience is predetermined *before you ever see any artwork.*

Certain reactions to artwork are guaranteed, or at least they are heavily constrained. Imagine two people viewing similar objects: The first is a black, Zambian female, who is familiar with tribal crafts. My wife, Chisaka. She unexpectedly encounters a large collection of African masks at the de Young Museum in San Francisco, California. The second person is a white, American man from Iowa, shopping in a high-end South African antique shop after a week on safari. That's me. He is unfamiliar with tribal objects. How can we possibly begin to reconcile our immediate impressions about tribal African masks, based on our personal identities and backgrounds, intellectual knowledge, and the physical locations? Even miraculously transporting objects from the de Young Museum to the South African shop couldn't hope to align reactions, because too much is built-in beforehand.

After the immediate reaction, the first impression, you have a choice: spend a few seconds or minutes, in a museum, months or years, at home, viewing an artwork, discussing it with friends, considering it in silence while listening to the audio tour or drinking morning coffee in your wooden chair. Your final opinion, if such a thing is possible, could be far from the point of embarkation, if you earnestly reconsider the style, medium, and content of the object you're viewing. Through mighty concentration and a humble mind, the Zambian

- What are your favorite artistic styles or mediums?

- Which countries and time periods are these works from?

- When did you begin to like these styles?

- What is your "process" for viewing artwork? Do you have a process?

and the Iowan might even join, or begin to align, their perspectives.

But if you don't spend time *consciously* investigating an artwork, then your first impression will be your last. You'll have an immediate, biological, and subconscious response, followed by a random collage of disjointed analytical thoughts. Who's the artist and where's the artwork from? Do I like it? What does it mean, or what does the museum's descriptive wall text say? Mid-question, you might unintentionally walk to the next artwork while multitasking on your mobile device. We've all done it. The artwork will fade into the background and add nothing more to your worldview, except maybe a selfie. You might forget the artworks immediately when that crisp, wintry wind hits your face outside the museum, and the memories will surely have faded after tomorrow's breakfast.

Moderating First Impressions

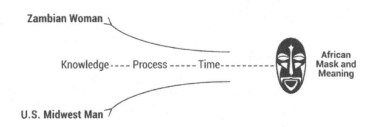

We learn about art to prevent the first impression from being our last and so that new experiences and memories have gravity to retain them. And perversely, we agree with the tyrants and the thieves that art objects shape our collective identities and build a shared past. We also recognize that much of the art we see today doesn't fit the classic mold of gods and conquering heroes. Contemporary art compels us to become *comfortable being uncomfortable*. It provokes us and tries to throw us off balance, to enhance controversial feelings. It attacks our general sensibilities and ways of living, because it questions our religion, consumption

patterns, history, gender, or other value systems. Art will present itself through unfamiliar forms of abstract sculpture, silent films, or mixed media, not only oil on canvas or nudes in marble. Without increasing our tolerance, many of us will simply scowl or giggle when confronted by puzzling artwork. We can do better.

Relevance

What if all art was removed from the walls and the courtyards, if a nation's public structures weren't adorned with heroic statues or immortalized bronze relics? How would we behave if we never saw the exploration of color and form on book covers or in stained glass windows, or if we didn't see humble scenes of countrysides and kitchen settings elevated to respected images of a quiet life's ideals? What if we had no visual memory or continuity of history and myth through commonly known stories or if images never provoked us to consider our beliefs in social status, race, and gender? In short, what if there were no visual art?

It's for a thoughtful novelist or scriptwriter to conjure such a world and examine the burden on the human psyche. Humans in the artless world would probably be a more callous and less thoughtful bunch. We'd be ever more focused on the hyperpresent and future, and we'd lack a cadre of role models and cautionary tales. Or, on the off chance that art is a Platoesque distraction of imitation (more on that later) or that we lazily ponder images all day, the artless world might not be dystopian at all, but rather charged with focus on business, politics, and family.

I'm not sure how it would play out today, but I do know that a world of scarce art *did* exist for most people across much of human history. We were not better for it. Rather, we needed to evolve *from* it. The broad distribution of art objects in common human dwellings is a relatively new phenomenon in the past few hundred years. Outliers have existed, such as Pompeii, where almost 2,000 years ago wealthy homes were filled with sculpture, tapestry, and painting. But before and after—during much of human history—art objects were primarily safeguarded in places of worship and hoarded in royal quarters. The average person was only occasionally exposed to art.

Instead of art objects, our ancestors found aesthetic beauty under the stars and in nature's fields, and with smaller devotional objects tucked away with family items. Few homes were adorned with

decorative objects, and fewer still were filled with cabinets or galleries with Rubens or van Dyck art, maps or globes, relics or jewels.

Without frequent exposure to art, humankind still pushed forward from the savannas and caves to cultivate agricultural fields and expand social structures beyond immediate tribes. The elaborate doodles and carvings didn't seem to help us propagate. For thousands of years, humans rumbled past the occasional cave painting or dirt drawing, pressing their hands into ochre and smudging them on a wall without the faintest preparatory sketch. Eventually Homo sapiens decorated garments with ink dyes and hung tapestries, but still, artistic displays weren't the norm. Physical and mental resources were allocated to locating calories and perpetuating humankind. Ancestral art viewing parties didn't put food in the fire.

And yet it seems that humans evolved in a dialectic with artistic objects. When no objects were available to collect, we tinkered with carvings in bone, wood, stone, fabric, and eventually, bronze. We had an insatiable drive to explore our surroundings by playing with them. We started with a repetitive construct. Archeologists have discovered small, stone horses and fertility figures, often called Venus figures, palm-sized limestone figurines dug up throughout Europe, mostly in the eastern and southern regions, with oversized breasts, buttocks, and thighs, thought of as dedicated to female powers of procreation, dating to about 30,000 years ago.[1]

This period is when Homo sapiens arose and began their ascent past Neanderthals. The earth shuddered with an explosion of creative symbolism. Recent discoveries have hinted at a Neanderthal inventive streak, but the evidence is scant and uninspiring compared to the flourish of dynamism that arose around human communities. In *Masters of the Planet*, author Ian Tattersall says that humans didn't think or act remotely like Neanderthals:

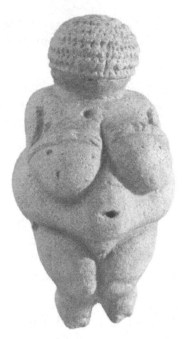

Venus of Willendorf, unknown artist, c. 24,000–22,000 BCE.
Naturhistorisches Museum, Vienna, Austria.[2] Public domain.

*"Some scholars have suggested that the dazzling Cro-
Magnon art represented such a break with the past that a
recent genetic modification must have been acquired in
the Cro-Magnons' lineage to make all this creativity
possible: a modification whose effects were confined to
their neural information processing, and were not
reflected in the fossil bones which are all the physical
evidence we have of them."[3]*

The art object and its less flashy predecessors are deep expressions
of our humanness. They were produced through craft, toil,
partnership, and, probably, joyful chatter around communal fires
in wooded glades. Through producing first, then viewing and
sharing artworks, we recognize our communion with other
humans, and we recognize our appreciation for creating things out
of nothing. Our unsettled relationship with forgeries and copies
seems to condemn those who tricked us, and those who take the

easy path to replicate what's already been done. The art world in particular has a sharp disdain for copies, and a biting critique of those who overly follow another artist's imagination. We respect the raw act of creation.

In that sense, art is at the core of what makes humans unique, and what makes us distinctly capable of breaking our prior constraints. Throughout the centuries, we slowly thrived and emerged victorious against Neanderthals in the competition for resources. If not producing calories, art contributed to the next best thing, solidifying culture. The theory of Dunbar's Number is the commonly accepted largest size (150 individuals) that a bonded social group can achieve. Beyond that, group connections start to fray and the inability to regularly interact might reduce familiarity and trust. Before social networking reduced our need to be in a friend's presence to share their life's stories, Dunbar's Number was the choke point that constrained the size of Homo sapiens groups, that is, until they started to believe in ideas larger than themselves. From the book, *Sapiens: A Brief History of Humankind*, historian Yuval Noah Harari says,

> *"How did Homo sapiens manage to cross this critical threshold* [Dunbar's Number of 150], *eventually founding cities comprising tens of thousands of inhabitants and empires ruling hundreds of millions? The secret was probably the appearance of fiction. Large numbers of strangers can cooperate successfully by believing in common myths."*[4]

While Harari notes fiction broadly as stories, it's not hard to imagine art's role in propagating narratives. A single image can perpetuate an entire myth. Art codified and accelerated shared understanding. To this day, a heroic statue in a city square or a solitary, waving flag, can each solidify the imagined idea of a nation, state, or event. A pastoral kaleidoscope of pastel lakes and gardens tells us about the idyllic, good life. It tells us how to live or about the aspirations we should have.

Art objects helped us eclipse Dunbar's Number. The artistic

process seems unignorably situated in our brains and our bodies, and helped us survive amidst violent competition. If we awoke in a science fiction nightmare devoid of art in courtyards or over our beds, people would still complete their morning routines, commute to work, and suffocate under a pile of largely unnecessary email. We might be less proud of our past, generous to our neighbors, devoted to our idols, and questioning of our social conditions, but we'd eat and laugh and probably function. But we'd suffer from the choke on our desire—our compulsion— to create and share creative objects, an urge that we probably couldn't ignore. To that end, most important, if allowed, we'd probably get right down to the inevitable—the business of building new visual icons and expressing our personal and shared stories.

Evidence that we can't or wouldn't persist for any length of time without tinkering and creating is preserved in the artistic caves of Sulawesi, Chauvet, and Altamira. They provide striking reminders from more than 30,000 years ago that artistic expression is tightly linked with our humanity and arose in lockstep with our emergence. Our ancestors documented stories about animal migrations, prey, the stars, and the environments that surrounded their caves. They did so for rituals and to foster communal understanding. And they likely did so for reasons that we'll never verify, lost to history's faded threads. Cave paintings were drawn and shared long before writing, which only appeared about 3000 BCE.[5]

Look no further than Mandarin Chinese characters and Egyptian hieroglyphics to see that early attempts at writing fused brief vignettes with alphabets. The same Mandarin character represents "home," and "family," telling us the connection between a happy version of each, although in modern society we might not agree on the contents of that happiness—the symbol is composed of a structure where people and animals, namely pigs, take shelter.

Early cave paintings concentrated more data in one place than pictorial writing, and their purpose was slightly different. If early

sapiens only cared about narrative communication, it's unlikely they would have gone to such great lengths to depict their art in rich color hues, movement, and texture, that they would have risked their lives to locate diverse pigments and binders, rather than sticking to effortless inputs. If they only needed *communication*, simplified shapes would have worked, such as what Mandarin and hieroglyphics became, but they went much further to present the visual complexities of life beautifully.

Cave artists were the first among a lineage that stretched thousands of years in pursuit of accurately and precisely presenting visual imagery. From Hellenistic Greece to Imperial Rome, Gothic and Baroque Europe, Renaissance and Reformation devotional artists, until the mid-nineteenth century, cave painters striving to replicate visual reality shared characteristics with their artistic progeny. That is, creating attractive and idyllic representations of their environments and imaginations. Early Homo sapiens needed to forge common beliefs, and they did so by creating immediate, visually compelling, arresting, and communal images to complement and sometimes replace spoken folklore. Art was intended to *present the real in light of the ideal* by being attractive.

If art formed an early pillar of human continuity, by the Hellenistic Greek era (300 BCE) it had already begun to generate controversy. Prominent thinkers, such as Plato, questioned art's utility. In fact, Plato proposed quite the opposite. He cautioned against viewers being misled by the aphrodisiac of beauty. Plato's intellectual heft across moral topics raised the visibility of his critique on visual art, which he saw as a mere imitation, a derivative, of a more pure, intellectual world. Seizing on Plato's thinking, subsequent philosophers and religious iconoclasts—image breakers—were able to erode visual art's reputation in the Western world.

Plato believed that abstract, non-materials forms, sometimes called ideas, were the true elements of reality. Any physical object or manifestation was anchored in a more universal concept of that thing. The universal forms of circle, boat, and table were the

source from which myriad physical circles, tables, and boats were manifested. A person with the name "Chisaka" was a derivative of the foundational idea of person. Worse, if Chisaka were to sit for a portrait, and an artist were to paint her, that painting would be a derivative of her, and a second derivative of the pure idea of person: (Portrait of Chisaka → Chisaka → Person).

An Idea–Twice Removed

Viewer →	Portrait of person named Chisaka	2nd Derivative of Idea
	Person named Chisaka	1st Derivative of Idea
Nonphysical	Idea of Person	

Visual artworks that depicted people, boats, or circles were not simply wastes of time, they were dangerous, because viewers could, and did, become enamored with the enchanting images at the expense of contemplating ideas. Plato said that only by comprehending the transcendent ideas could people achieve growth and satisfaction. A boat was possibly created with faulty craftsmanship, owned by an unsavory character, and was prone to decay, but the idea would endure.

Plato's theory rests on a blinding flaw. Ideas reside in individual minds, not a collective or unified mind. We can't guarantee, or even find favorable odds, that two people share a common idea, if such a thing exists. What's the average idea of a boat or a person, or much less a simple circle? A mathematically average person *does* exist in a given population, but no artist could draw or precisely describe his or her characteristics. Was it Eve or Adam? Is it your neighbor?

The concept is absurd. In fact, the exact opposite is often true. Ideas we hold in our minds were planted there by objects we see in reality. Life imitates art and prior memory. A citizen of Plato's Athens would not have the idea of a military aircraft carrier when asked about a boat, but a present-day Navy service person might consider it immediately. Aircraft carrier and schooner both fall under the classification of boat-ness, but we don't need to devalue either option by making them subservient to ideas.

Despite flaws, the theory endured. Given Plato's personal heft and the stature of Hellenistic Greece, it's probably no coincidence that the Abrahamic religions are also careful with visual art. Whether or not they ban it outright, they are conscious to control its images and distribution. In cautioning against visual art, Plato and later religious leaders were also validating the weight of artistic expression. Why would they advocate against art if not for fearing the influence it held? Images of meaningful, relevant, and inspiring icons could engender tenderness and devotion, as they could prompt criticism and revolution.

Those concerned about art's influence were on to something. When we make visual evaluations, we do pass judgments. We assess the pieces *within* an art object and the spirit *of* an object. Subtly, we mimic emotions we see.[6] We subconsciously mimic smiles or turn our noses in disgust. Given art's role in making evaluations, forming habits, or copying and following virtues and vices on display, its study was often linked with morality. What is good, or true, or beautiful? That's why, much to my surprise, studies of art and aesthetics were linked to and categorized under the philosophical study of morality, until the eighteenth century, when it finally became an independent study of sense perception and matters of taste.[7]

Maybe Plato, Socrates, imams, and clergy feared the mysterious reactions that art provoked. Art was a topic that philosophers couldn't tame through their dialectical methods, as religions couldn't mandate that you find an object ugly instead of beautiful. Art is subjective enough that universal arguments tend to fail, but

universal enough that standout works galvanize a critical mass of support. Furthermore, if insightful artists are able to create work that's universally applauded, shouldn't the artists be exalted for their connection to pure ideas or God, and wouldn't that confuse the supposedly direct and exclusive connection to God that priests and philosophers claimed?

Art's connections to morality persisted, and cautionary advice remained. As art's popularity and accessibility grew between the sixteenth and eighteenth centuries, intellectuals and philosophers began to advocate for a sense of viewing without longing. Art objects were imbued with such power that viewers might become overwhelmed with awe or struck by covetousness and possession. They would be corrupted by a desire *for* an object rather than appreciation *of* it. The fearsome awe was specifically in reference to a concept called the sublime, a Romantic era term coined by Edmund Burke to describe overwhelming beauty.

> *"By about 1700 an additional theme started to develop, which was that the sublime in writing, nature, art or human conduct was regarded as of such exalted status that it was beyond normal experience, perhaps even beyond the reach of human understanding. In its greatness or intensity, and whether physical, metaphysical, moral, aesthetic or spiritual, by the time of the Enlightenment, the sublime was generally regarded as beyond comprehension and beyond measurement.*
>
> *It was at this point in the history of the word sublime that visual artists became deeply intrigued by the challenge or representing it, asking how can an artist paint the sensation that we experience when words fail or when we find ourselves beyond the limits of reason."*[8]

While nature provided the subject matter for the sublime, fearsome waterfalls or imposing mountains, nature was not immediately accessible and didn't unveil itself on command. Art was increasingly recognized as the necessary conduit for access to the sublime, and genius artists provided the gateway.

To prevent attachment, viewers were encouraged to adopt a dispassionate gaze while viewing artwork, to see the art with their minds, not fully embrace it with their emotions. Dispassion provided a sort of separation that created space for art to be appreciated on its merits rather than coveted for ownership and possession. Dispassion was the Romantic era's method for hacking visual attachments. For any of us caught in a social media photo stream, maybe the advice was prescient. We seem to have difficulty pulling away from the spikes of interest that are generated by compelling images. Yet it's not entirely clear that dispassion is the way for us to fully enjoy art, or that it's entirely possible to be dispassionate. We'll explore the sublime and approaches to it further in Eras of Aesthetic Philosophy.

Again, a world without art would probably become a fragmented and lonely place, one where groups couldn't collectively visualize imaginary ideas, myths, or community. Without art, we'd struggle to forge common understandings of historical and moral concepts, and we'd lack tools to evaluate our lives. We would avoid, however, the dangers of worshipping false idols, falling for beautiful trickery, and needing to adopt dispassion to avoid coveting objects. Despite art's proximity to social evolution, it hasn't grown without cautions, but think how those are easily outweighed by the continuity of culture it has perpetuated.

Think about the recurring motifs throughout art history: angels speaking divinity to saints and rulers; displays of bravery, wisdom, compassion, and devotion; nature shining in glorious seas, skies, flora, and fauna; and graceful interior scenes that turn a common home into inspiration. The themes echo archetypal patterns, albeit with uniquely pitched melodies, tuned to their respective times and places. Some are outdated or oppressive, and now artists are regularly challenging that convention. Art's beauty enabled a visually convincing medium that could transfer dominant ideas, memes—from ancient Greek meaning "imitated thing,"—across populations.

Visual art is an enduring, meme-producing engine. For most of

history, art was controlled by governments, religions, wealthy nobles, and royalty as a visual Trojan horse and time capsule, secretly spreading ideas and passing them to future generations. Today, the producers of art are often antagonistic toward their former patrons, turning traditional themes on their head and questioning those saints and rulers, the meanings and devices of bravery, the attitudes we should emulate, what is beautiful in nature—and if beauty matters at all. Going deeper into what art is and how it works will enable us to understand how such a reversal can come about, and what it suggests for how we should get more from our art experiences.

What Is Art?

Let's acknowledge the elephant in the room. I've spent time discussing why art matters without defining it. I did so, because we didn't need to get bogged down in definitions to see how art's achievements and impact have credibly realigned the currents of society. If you're still reading, then you've probably answered the *why* question in the affirmative, that art has mattered and still does today.

But what *is it*? That I've personally spent hours, months, and years with the question almost doesn't matter. I'll propose definitions from objective sources, such as the dictionary; to the utmost of subjective sources, artists and philosophers themselves; to my own definitions, worked through via trial and error and logic games. Your definition is most important though. This book is about prompting you to find your own answer. That's what increases confidence. You can use our collective ramblings and stumblings to defend your own position and decide what art means to you.

Here is how a few famous artists and philosophers have defined art.

Art as Meaning

"We all know that Art is not truth. Art is a lie that makes us realize truth."

—Pablo Picasso (1881–1973), Spanish painter living in France

"Art is not what you see, but what you make others see."

—Edgar Degas (1834–1917), French artist

"If you could say it in words, there would be no reason to paint."

—Edward Hopper (1882–1967), American painter

Art as Utility

"An artist is somebody who produces things that people don't need to have."

—Andy Warhol (1928–1987), American artist

Art as Purpose

"Art needs to stand for something."

—Ai Weiwei (1957–), Chinese artist

Art as Criticism

Art is *"The criticism of life."*

—Matthew Arnold (1822–1888), English poet and cultural critic

Art as Experience

"In life that is truly life, everything overlaps and merges . . . Only when the past ceases to trouble and anticipations of the future are not perturbing is a being wholly united with his environment and therefore fully alive. Art celebrates with particular intensity the moments in which the past reinforces the present and in which the future is a quickening of what now is."

—John Dewey (1859–1952), American philosopher

"Art, really, is an engagement with the ways our practices, techniques, and technologies, organize us, and it is, finally, a way to understand that organization and, inevitably, to reorganize ourselves."

—Alva Noë (1964–), American philosopher

Art as Process

"Art is an endeavor after perfection in execution."

—John Stuart Mill (1806–1873), English philosopher

"The craftsman knows what he wants to make before he makes it . . . The making of a work of art . . . is a strange and risky business in which the maker never knows quite what he is making until he makes it."

—R.G. Collingwood (1889–1943), English philosopher

The quotes here present recurring themes in art history and criticism. You could find innumerable more. Art helps you understand basic human truths. It helps you to see deeply. We don't need it, but it stands for something. It is an object and an outcome, a process and an act. It's also a lens on the world, a tool to evaluate the world, and a comprehensive experience. This sounds like a riddle, or else a word that has grown too large for a single useful meaning.

Building a Definition

The mighty have fallen, searching for a definition of art. They've provided witty lines and half-attempts, and they've written entire volumes. But we lack more than a shred of consensus. In numerous, artistic publications and aesthetic philosophies, even introductory essays, writers unleash glorious prose for hundreds of pages about art's power—without defining it. They show us a procession of art objects and let us infer the rest.

Do art writers think it's so obvious that they'd offend us by offering a definition, or so painfully clear that editors remove the sections to save pages? Rather than sensitivity toward our feelings or aggressive editing, I think most have acquiesced to the impossibility of a definition. Rather than face the inevitable criticism of a failed attempt, they simply avoid the topic. Or they think the dictionary should have the last word.

Art, from the dictionary, is defined as:

> *"The quality, production, expression, or realm, according to aesthetic principles, of what is beautiful, appealing, or of more than ordinary significance. The class of objects subject to aesthetic criteria; works of art collectively, as paintings, sculptures, or drawings."*[1]

The expression of a thing that's beyond the ordinary. An aesthetic object. It's all dry and literal. Although specific, doesn't it seem that the dictionary is lacking a punch? Doesn't it fall short of the culture building and inspiration that we see driving and compelling us toward art?

The unavoidable belief that art is important (even if the "art world" leaves us cold) encourages us to look further. We struggle to define art, because it's so proximate to our essential humanness. We feel the dictionary is incomplete or its categorical list of possibilities is an unrefined tool.

The repeated avoidance and failures give me comfort about the inevitability that my definition too will be derided and ridiculed.

But we shouldn't meekly ignore that thing, that art-ness, which is core to human evolution, biology, and society just because it's hard to define. *To know if we care in the first place is to be clear on what we're discussing.*

I couldn't avoid starting at the point of received wisdom: the objects that I was always and everywhere told *were* art. Paintings and sculptures were art. Objects in museums and galleries and art history books were art. But we already know that's an unsatisfying, dictionary-style definition.

Built from Zero

Casting aside the predefined art objects, I sketched options.

Art is an imagined physical item.

An art object springs from imagination, but it's physical and real. It's not a verbal story or a thought. Art manifests a physical object, which wasn't there previously.

Art is an imagined physical item *or expression of that imagination.*

Put another way,

Art is *the physical creation of* an imagined item, or expression of that imagination.

More distilled,

Art is the physical creation *of an idea.*

Function

What does this art object do? It gives us something to think about. It gives us an idea and object of contemplation, whether that's two seconds in passing or years of focus. The object is interesting somehow.

Art is the physical creation of an *interesting* idea.

A lot of things are interesting; it's a bland word: My fern green chair is interesting, because the armrests and back lean with distinctive, diagonally reclining slopes and are covered in huge, white dots. A cute puppy flops around with curiosity and spontaneity that's interesting to follow. But the chair and puppy seem to *be* or *do* more than *only* being interesting—they go further.

Can art also be *more* than *the physical creation of an interesting idea? A physical manifestation of an interesting idea?*

The chair and the puppy are more than interesting; they are functional, or living—the chair for sitting and the puppy for being, playing, and frolicking. Thoughts of functionality are intertwined with mechanistic purpose. Functionality starts to become the design of a house or software program, the engineering of a car or a bridge.

A chair in a picture could be art, but a chair in reality is not. Beyond looks, it exists for sitting.

Shockingly, a dead puppy in a glass, museum box could be (morbid) art, but a live puppy in a yard could not. Gross, but the limits of usefulness are more striking.

By stripping the object of its original purpose and changing the context, a chair and a pet become art. But art objects stop before achieving mechanistic utility. They show you something and capture your interest. *That* is their functionality.

> Art is a physical creation *whose sole purpose is to convey* interesting ideas.

Critics often apply strict standards to the "no function" rule. Even a *sense* of functionality places certain objects outside the art label. For example, religious usage might situate an object outside the bounds of art. If the object or idol is used for prayer at all, it is functional beyond contemplative interest.

> *"However magnificent and beautiful the Sistine Chapel frescoes may be, they were not Art as we know it. They were instruments of religious and political authority."*[2]

Mary Anne Staniszewski, an art professor, said this in her book, *Believing Is Seeing: Creating the Culture of Art*. She's quite the purist. I find the definition overly strict, since few pilgrims functionally pray, necks upturned vertically for minutes, while uttering invocations gazing skyward in the Sistine Chapel. Even if most did, prayer is not much beyond dwelling on an *interesting idea*. In any case, certain art critics emphasize art's necessary lack of functional utility, and they seem to have a point.

Attention

How does the art object become interesting? Going back to beauty, pretty things are typically attractive. Like many people, I'm attracted to looking at pretty things. Most people can't help it. This explains the historic emphasis on beauty in the arts. The ideas of nobility, tragedy, conquest, and devotion can be articulated clearly through beauty. These art objects were compelling, because they called us through the prize of beauty.

But then again, ugly and horrific things are interesting too. Maybe not for as long a duration as the pretty things, but with a visceral magnetism when you first see them. Traffic inevitably slows as drivers rubberneck for a look at wreckage. A beautiful body or a grotesque face can both command attention. The "look" of interestingness spans the gamut of features that attract attention. A pious and preaching Jesus, and a tortured, crucified Jesus, both generate interest in the story of his life and teachings. Both attract attention.

Which lever is more enchanting and effective? Both work when treated by a capable artist. Beauty pleasantly tugs our attention, while shock is momentarily irresistible. In contrasting the two, an artwork can harness the delightfully addictive and confusing mixture of sweet and salty. Famous artworks, from the *Laocoön and His Sons* statue, to Picasso's *Les Demoiselles d'Avignon* oil painting, and today's superflat monster images from Takashi Murakami, generate market acclaim by combining the beautiful and grotesque, the attractive and repulsive.

Artists, critics, and viewers have their own preferences, which are often deeply held and emotionally difficult to sway. Michael Craig-Martin, an artist and prominent art teacher, said, in a BBC episode of *Why Beauty Matters:*

> *"The notion of beauty has been extended to include things that would not have been thought of* [before]. *That's part of the artist's function, to make beautiful . . . something no one thought was beautiful up until now."*

Craig-Martin promoted conceptual beauty. He contributed to and advocated for an expanded definition of attracting attention through whatever means are effective. Roger Scruton, another art historian, philosopher, and critic, disagrees with Craig-Martin, claiming that it's better to *"Show the real in light of the ideal."* Scruton, seen in the BBC show *Modern Beauty Season,* rejected Craig-Martin's expanded definition and remained steadfast that we should celebrate beauty and idyllic forms, rather than shying away from them.

For much of Western art history, this approach has predominated. Art's subject matter—royalty and wealth, god and devotion, heroism and power, lent themselves to visual idealization rather than conceptual treatment.

That began to change in the mid-nineteenth century and accelerated in the past fifty years. Today, many artists and academics favor attracting attention through shock or conceptual works, often invoking confusion or discomfort among audiences, or presenting work that's outside our easy understanding.

- Does beauty or ugliness attract your attention more strongly?

- Which attracts your attention longer?

- Which hits you harder?

Art is a physical creation that *attracts attention and* whose sole purpose is to convey interesting ideas.

Meaning

Going back to the dead puppy—it's a horrible thought, I know. It would be controversial to place a dead dog inside a glass cage at a museum. We'd all probably hate it, at least the average museum visitor would. It would generate outrage and might require age-based entrance restrictions, but artists have presented us other perturbed images of death and sexual acts. Moving locations and contexts, not to mention mortality states, do the trick of transforming the puppy into art. This is a common artistic approach applied to ready-mades and tribal objects:

- Plucking an item from its natural habitat not only strips away the original function (#1, removing utility);

- It shocks us to capture our gaze and thoughts (#2, attracting attention); and

- Placing the object in an artistic context transforms or comments on the original. In a displaced environment, a third artistic attribute arises (#3, conveying meaning).

An object's meaning changes when moving its location and or state—as a mask, puppy, or toilet. Art hints at the initial meaning but in new ways.

An artist might attempt faithful documentation of a factual scene—precise rendering of a fifteenth-century noble in his dining chamber or photojournalistic documentation of starving children in a civil war. Basic themes are obvious—the noble is wealthy, proud, accomplished, and secure in his stately manor, as the children are blameless and hungry.

But meaning gets tricky, especially when shock is involved. Take artist Maurizio Cattelan, for example. He's known for provocative taxidermy artworks, often presented with a heavy dose of satire. His artwork, *La Nona Ora* (*The Ninth Hour*)[3] from 1999, shows Pope John Paul II lying on the ground in devotion and anguish, while a meteor rests on his lower body.

The work is composed of wax, clothing, polyester resin with metallic powder, volcanic rock, carpet, and glass. Cattelan has my attention. I wonder about the science fiction-style meteor strike and whether religion is damaged by space or science, and if John Paul II is supposed to be suffering like Jesus or why else it might be important. What meaning does Cattelan want to convey, and is he aware that many audience members will miss the point?

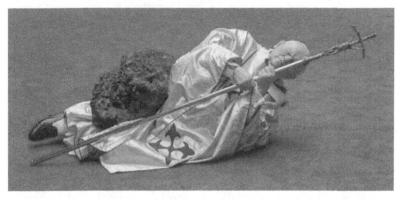

La Nona Ora, Maurizio Cattelan, 1999. Image 2014, Musée des Beaux-Arts, Rennes, France. Courtesy Perrotin.

Ok, Cattelan, you have my attention, what are you saying?

Even landscapes don't simply document the plump hedges, swaying grass, silent lakes, glowing sunrise, or lingering twilight. The ostensibly simple paints, textures, images, and colors produce a meaning beyond the observed scene; they usually comment on ideals of the good life, nostalgic perspectives on nature, or humankind's natural setting. Faithfully descriptive scenes that skirt audience subjectivity are difficult, for a painted scene and a dutiful camera. Also, viewers arrive on set with preconceived notions, as we showed in the Why section, with the graphic "Moderating First Impressions." We produce our own meaning, independent from an artist's intentions.

Artists have infinite options to convey meaning. They could expose an urgent thirst via a serene but parched landscape or through a pile of decomposing skulls. Pausing to remove our

contempt at misused puppies or toilets, popes or landscapes, the installations and paintings would prompt us to consider their *meaning*. We are interested because of the mystery an artist introduces and prompts us to uncover.

Art is a physical creation that attracts attention and whose sole purpose is to convey *meaning*.

Or, worded more succinctly, visual art is *"A physical creation whose sole purpose is to attract attention and convey meaning."*

Conclusion

Art doesn't *require* beauty or ugliness. Despite the method, it captures your attention, and once your attention is captured, it transmits meaning to you. Better yet, it prompts and nudges you to individually create meaning from what you see. Meaning might differ from the artist's intention.

An object like this, an art object, can have a profound influence on a person who's willing to engage it. If you allow your attention to focus on art objects, to be attracted by them, and be receptive to the meaning, you can have a moment of reflection and a cause for discussion. That's what art does.

It can achieve the call presented in the opening quotes:

- Realize truth.
- Make others see.
- Stand for something.
- Criticize life.
- Endeavor after perfection in execution.
- Reorganize ourselves.
- Be united with our environment.

The exercise of crafting my own definition helped me understand the art world and its goals. I see why art is hard, because it can attract our attention in myriad comfortable and uncomfortable ways. It can convey meaning that I don't understand or that I disagree with, not just meaning that easily reinforces my beliefs. We are naturally attracted to beauty, so beauty is more accessible for most of us than the alternatives, but I can also appreciate the rationale behind ugly, shocking, confusing, or disturbing objects being art: they attract our attention and uniquely convey meaning in ways that classical beauty cannot. Attention grabbing and idea transmission *are* the mechanistic functions of art. It doesn't overextend its welcome by doing more. It's proud to stop before becoming design or engineering.

- Do you agree that it's important to have your own definition of art, or are you comfortable with leaving it ambiguous? What is your definition?

Process vs. Object

We've focused a lot of mindshare on the art object. We acknowledged a process, but more as a means to an end than for its own benefit. We're missing the messy, cutting-room floor feel of art that supports a particular discipline, such as cooking, negotiation, war, happiness, sex, or communication. That's *the art of X,* with X being the subject of the art.

The art of X is an undefined or partially defined, non-algorithmic, intuitive, creation and recombination process. It's an activity of bringing something into the world that didn't previously exist, although not an art object per se. If you listen intently, art of X conversations arise daily in conversations and the media. Art of X mentions don't address the *objects* that represent war, happiness, cooking, or sex. They don't reference objects at all. Instead, they imply an artistic process as related to, but distinct from, outcome-based objects. We can't seem to ignore these references, because we recognize the intuitive aspects of work that feel more like novel creation than repetitive manufacturing. Questions about *why* we study art, and *what* it is, both beg another look into the artistic process.

We can't help ourselves but to create. Creation itself captivates and generates attention. Art's unignorable feature might not be the output (object) but the input (activity). As children, we scribble and color our way to understanding shapes and colors. Neither we, as children, or our parents are troubled by the incoherent outlines we display on kitchen walls. We're all proud of the process. Artists take the baton from childhood and carry it into studios where they draft and redraft, then destroy innumerable artworks before unveiling them. Artworks finally shown require months or years of iterations and adjustments using new tools, pigments, and dyes. The rest of us continue to tinker.

As adults, we might continue to paint, on canvas or walls, but we begin to iterate in other creative pursuits, as the child who

scribbled in crayon learns to design sweeping rooftops or study architectural supports, to build gardens and parks, to refine marketing collateral by meticulously adjusting copy, or to prepare food by furiously chopping meat chunks with a polished knife and tossing cubes into a high-lipped wok. Each failed version is a nibble at the bite of innovation, but they are all part of the process.

We discussed how the indefatigable urge to create suggests that artists existed before art. Art comes from zero to attract attention and convey meaning. The art that often captures our attention, and the meaning we create, is self-expression. The act of expressing is paramount. The object created and viewed by audiences is secondary. It's no secret that artists have used their faiths and beliefs, surroundings, political intentions, and life experiences as the wellspring for subject matter. Picasso is the model. His blue and rose periods channeled sadness and romance, respectively, as outpourings of his emotions into physical art. Picasso's life evolved from despair in desperate and lonely blue to the love of warm, rosy, champagne red. Political artists and those of minority cultures or identities use the artistic process and objects to express their positions in society. By experiencing the work, we might begin to feel their situations.

From this perspective, our attraction to art objects is assured. Humans are a perfect storm of new, creation-causing elements, and art is the inevitable outcome of uniquely human characteristics: imagination and tactical, highly precise, opposable thumbs. We can't help but be visually attracted to art objects, because we recognize and are inspired by, consciously and subconsciously, the creative process as distinctly human. And the unique artistic force is great artworks. Knowledge of the artistic process, the urge, and awareness about the art of X makes us appreciate the iterative drive required to achieve creative projects.

The Creative Cousins—Art, Design, and Engineering

If art is a process, questions arise about where it stops and other

creative endeavors begin, activities that make things which didn't exist before. The creative cousins of art are design and engineering. Practitioners of each might claim superiority, but they derive inspiration from a similar source.

Whether spectrum or overlapping Venn diagram, the creative cousins accomplish their productive goals through both *raw and visceral intuition and purely repetitive algorithms*. Within that construct, spectrum, or diagram, from intuition to algorithms, art, design, and engineering apply them in separate doses.

The Creative Cousins
Different Ratios of I and A

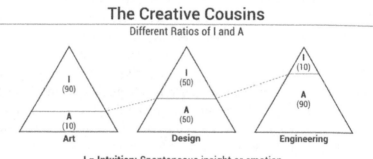

I = **Intuition:** Spontaneous insight or emotion
A = **Algorithm:** Defined rules, processes, and inputs

Intuition: A keen or quick insight, not dependent on a formal reasoning process.

Algorithm: A set of rules for solving a problem.

Art, design, and engineering are an imprecise combination of intuition and algorithm (I plus A). The ratios are unscientific, like the ratios of sugar and spice in the family fruitcake, but the mixture of structured and unstructured activities—both creative in nature—shows that the creative process builds off the same fundamental elements to produce a range of productive outcomes. Mystery and uncertainty reside in the application of engineering principles; design is a mixture of novel flair and consistent approach; and even the most intuitive artist relies on established fundamental knowledge.

Art

To be sure, an analytical mind is necessary to produce exceptional art. But that mind doesn't apply a formulaic process to each creative pursuit. Art is mostly intuition, with a dose of algorithms. The process is paradoxically careful, vibrant, spontaneous, planned, and a little mysterious. Many artists don't know what they will produce until they begin the process. When they do know the outcome, the path and steps are often unclear. And when they know the outcome and path, many times the result is *still* tweaked and refined beyond initial intentions. Once the project is underway, the path becomes clearer.

Art does have consistent methods, though. It's not *just* a messy or random process. Painting and drafting lines and shapes, displaying and contrasting colors, applying key styles and using basic materials—these are the inputs to an artist's intuitive production. To achieve the color of Ceil blue, Hex code 92A1CF, an artist must approach mixing consistently, or must buy the same product line to ensure accuracy. The color is an algorithm that can't be changed. Electronic media, paints, canvas, and sculpture materials all have known applications and reactions. From this foundation, artists leap into uncertainty.

Design

Design is the most complicated cousin. On any given day, it relies on intuition and algorithms. Designers create standardized products that must follow a stated code, such as steering wheels or baby cribs. They also determine how less-regulated, but still robust, items, such as mobile phones and software, should interface, look, and feel. Each item follows exacting standards, but differentiates itself through flair and uniqueness.

Today, design has grown to an outsized topic that rivals art for its ambiguity. Designers pursue amorphous and grandiose topics, like "organizational design," "lifestyle design," or other aggressive applications of the term. Nonetheless, they claim access to data and consistent best practices—algorithms, for

organizations and lifestyles, and they recommend individuality—intuition, to round out the perfect team or daily routine.

Designers often generate ideas or craft new paths without the benefit of prior examples. This is particularly true at the intersection of our digital lives, like software, and enhancing beauty through graphics and attractive layouts for media we consume and objects we use. Designers test, learn, guess, and innovate, trying to rely on how humans naturally behave, while bringing consistency and reliability to our actions. They are at the crossroads of intuition and algorithms.

Engineering

Engineering only functions because specific inputs lead to expected outputs. A collection of expected outputs creates a known quantity, such as a bridge, an assembly line, an office tower, or a software program. The laws of gravity, electricity, and software code follow the same algorithms day and night, throughout the year, and across geographic and national boundaries. If you test ten engineers with a *simple* software programming question, most of them will approach it similarly, if not following an exact, publicly established approach. Production gets more creative when engineering questions are steeped in complexity or novelty. Even the most algorithmically inclined will call on intuition while working toward an uncertain solution in new materials or unaddressed software challenges. Software and civil engineers will approach cutting-edge problems in unexpected ways, while saving standard approaches for known issues.

Even the most difficult biological sciences require intuition in the creative process. Hypotheses, the essence of the scientific method, are educated guesses. In any given month, a scientist could pursue myriad experiments to validate their expectations. They will reference data and prior research, but the next hypothesis they test, and how they test it, relies on more than a dose of intuition.

The Art, Design, and Engineering of X

Creative, productive activities, at the intersection of art, design, and engineering, underlie our reliance on the art of X. X is the combination of I plus A that drives creation in a given discipline. All the cousins are creative in the literal sense of bringing forth that which didn't previously exist. Art is the messiest and most mysterious, but it's also the most naturally accessible, because it relies heavily on individual intuitions without learning detailed background knowledge. Engineering and design require consistent application of additional rules. But the spirit of *bringing forth* unifies them, and that's what makes each fundamental to human nature.

> - How would you differentiate between art, design, and engineering? Where do they start and stop?
>
> - How do you see art improve design and engineering?

The Materials of Art

We are going to turn sharply from the theoretical concept of art and enter the studio. If materials bore you, best to skim this section. Art is more than the sum of its raw materials. But art is physical and tangible and is connected to the inputs used for the greater whole. Art is given life, attention, and meaning from a set of often mundane materials, which if used unformed would remain nothing but a dull pile of goods in the corner of a garage or cabinet. Beauty and shock are dressed up or disguised behind oil or acrylic paint; clay, stone, or bronze; color or black and white photography; or electronic videos or lights. The list goes on.

The medium is not the entire message, it cannot be, of the complete story behind how that artwork attracts our attention or about the meaning it conveys, but materials can push us in certain directions. A large, bronze statue of an ancient Olympian or a fresco of the same Olympian attract attention in different ways but convey largely equivalent meaning about the joys and honors of competing and winning in the games.

In contrast, when artist Ai Weiwei filled London's Tate Modern with millions of porcelain "sunflower" seeds, each uniquely sculpted by artisans in the Chinese city of Jingdezhen, it would be difficult to attract attention or convey meaning similarly, if visitors didn't walk over the sunflower seeds and have the tactical interaction with the exhibit. Meaning, attention, and message were distinctly possible via the materials.

Artists today can choose their mediums to match their messages, or to best communicate their intentions. As with the rest of our consumer society, choices are limitless and almost overwhelming. This means artists can use old wood, radios, photography, or spray paint to complete their crafts. It used to be much harder.

Artists were constrained by their access to pigments and dyes.

They couldn't choose to use whatever they wanted. Photography and electricity didn't exist, and colors like Tyrian purple, a plum color, required ink from cracking hundreds of Mediterranean mussel shells.

Artists were more limited to common pigments, dug directly from the earth, not manufactured, like red or yellow ochre, umber, or lime white. Their options weren't plentiful. Difficult to obtain pigments and dyes were reserved for regal or religious topics, rather than open to anyone with access to a paint shop. Medium has not always been such a conscious choice deeply tied to attention or meaning, but a linkage was present due to availability and effort to secure various inputs.

Today, mediums matter and artists have options. We should be aware and question the connection between material choices and attention and meaning. Although art objects come in an infinite variety of shapes, sizes, and types, certain materials fit our expectations more easily, are transported and displayed more readily, and so you will surely encounter them at a higher frequency than others. That's where we will focus. Rather than dwell on art's infinite possibilities, it's practical to target the most common materials.

Sculpture

We know classic sculpture when we see it, but the materials have evolved substantially and vary widely. Sculpture uses more mediums than painting, but most commonly, we see bronze, stone, wood, and clay. Increasingly, we'll also see electronic and digital media, which we'll cover later in this section.

Sculpture is more visible than its prevalence. Estimates put the amount of current sculpture being created at less than 5 percent of total art output.[1] It was dominant in the past and fills museums but is not being produced as frequently today.

Modeling and carving are the two most common methods. A

model allows the artist to add features as the sculpture progresses, while carving requires a reduction in the original material to unleash a unique form. Carving is the basis for Florentine sculptor Michelangelo's famous quote: *"Every block of stone has a statue inside it and it is the task of the sculptor to discover it."* Modeling does not require such a discovery but instead builds from nothing into complete form.

Sculpture is a task for hammers, chisels, and kilns. Innovation has been more dynamic in the methods for hardening and firing raw materials than for the chisels and hammers, which have been used for centuries in consistent formats.

You are also likely to encounter the French sculptor Rodin, the Swiss sculptor Giacometti, and even Picasso in the halls of many famous art institutions. We've seen traditions from Greece to China employ sculptures most prominently for public art of heroes and myths. Today, sculptures will almost inevitably reside on the lawns of famous art museums and throughout their hallways, but due to portability and display opportunities, they are far less common than pictures in galleries and homes.

Important for contemporary art, "ready-mades" are identified as sculptures. British artist Tracey Emin's *My Bed* or Marcel Duchamp's *Fountain* (a used urinal moved from its prior location and placed on display. See page 277.) are both ready-made sculptures, defined by the art world as such because they are three dimensional and because the artists claim the objects as art.

This is where contemporary art gets confusing and sometimes ridiculous for many outsiders. How can something that was already complete, before an artist conceived of it or touched it, be art? Because the artist envisioned the work in a new way. It relates to the definition and contextual attributes we discussed before: an object that once had function has been stripped of that function, moved locations, and now operates solely to attract attention and convey meaning.

A Tale of Two Toilets

Bathroom Toilet on Plinth
 "Art"

Today, classic sculptures, such as *David* by Michelangelo, are categorized alongside beds and urinals as seminal works of sculptural art. They do so for entirely different reasons in terms of vision, craft, and idea, but nonetheless represent artworks in the sculpture category that you can expect to see at art exhibits. Sculptures provide the unique opportunity for viewing on all sides, so take advantage. They tell a three-dimensional story, which often hides surprises from nonstandard vantages. Also, sculptors themselves are deliberate with their usage of materials and sizes. Don't take that for granted. Given the vast range of options to express their artistic ideas, they probably considered metal over clay for a reason, as they did with diminutive or oversized structures. Why did they do so? Finally, consider if the sculpture is site specific or if the meaning would function in another location.

Painting

The vast majority of art objects you'll see in museums, galleries, and homes are paint-based. Within the genre of painting, the two most common materials are oil and acrylic. Visual art on sale and on view today also includes a minority of photographs and mixed media (a combination of any/all types of media, such as crayons, pencils, etc., but most are oil and acrylic). In just a brief time, you'll begin to recognize the differences between these two, and even identify the two most common predecessors, tempera and fresco. Stirring and mixing paint was one of art history's critical functions until the modern era. Grinding, pounding, and mixing everything, from seeds to bugs, created the oils that now shine on

historic canvases. Until the late-nineteenth century, artists kept those prized paints in pig bladders, which were punctured with tacks when paint was needed.

All paint uses pigments and binders: oil (pigment) with flaxseed (binder), for example. The history of materials is a history of innovation around secret and unique pigments mixed with effective binders. Paint colors were critical to the art economy and culture. Their heritage and geographic origins were sources of pride. The word aquamarine, for example, derives from ultramarina—or "over the sea," in Afghanistan, from where the paint originated for Italian artists. Painters were long constrained by access to pigments and binders. He who had the best materials held an advantage.

Tempera[2]

Initially, much of Western art was created with tempera paint. This included altar pieces and regal commissions of all types. Tempera is egg-based paint. Artists ground materials, such as plants, seeds, and insects, with mortar and pestle and combined those with egg into a paint. The process was dirty and physical. You can imagine why aristocrats thought this work was beneath them, when you consider the purely mechanical aspects of the job. Artists could not walk directly out of their workshops with clean hands and crisp clothing. They were often stained from hands to chest with insect and egg residue.

Some colors, such as gold and aquamarine, were more expensive, due to their materials or source, and therefore usually reserved for painting regal subject matter. For example, the gold used in these artworks was often real! It was pounded into thin sheets and used atop other layers of paint. Gold with red clay would create a glowing and reflective surface, which was especially magical in the low, candlelit church spaces of the day.

Tempera paint was generally used on wood. Vertical and horizontal crossbeams were combined to ensure stability and avoid warping. Before tempera paint was used, gesso (pronounced

JESS-O) was applied as a foundational layer and sealant. Gesso is still in use today, as the base layer for canvas and many types of paintings.

Fresco[3]

Fresco was popular from the ancient times of Crete through much of the Renaissance. It was used largely for mural painting and wall art. The technique includes applying pigments in water to lime plaster that covers the wall, thus merging the paint onto the wall itself, rather than as a purely topical solution. This provides a durability, which endures in public spaces.

Because fresco dries quickly, it requires detailed preparatory and final drawings. Artists can't follow unknown whims of inspiration while working over a quick-drying fresco. That would be a recipe for half-finished work or awkward bodies merging into partial landscapes. That's why there are precise sketches in the leathery notebooks of Renaissance masters. Maybe they found joy in repetitive, preparatory drawings, but also, they had no alternative. Today, when you view fresco artworks, try to notice independent sections of the scene. The work was completed in patches and subtle hints of the trail still remain.

Nonetheless, much Renaissance and pre-Renaissance artwork was painted in the fresco style for public use and durability, plus the matte-like finish.

Oil

Since the late Renaissance, oil painting has been a staple, and at many times *the* staple, of painting. Today, almost half of paintings are created in oil, just more than acrylic in a given year.[4] Oil came to prominence in Venice during the Renaissance, because the watery climate and geography didn't lend itself so well to tempera or fresco.

In that environmental constraint, we are lucky. It caused artists to identify an innovative material, which enables visuals with multiple, thick layers that creates overlapping, mixed, or

translucent colors. The second innovation was around the artistic process: oil paint dries much more slowly than fresco or tempera.

This caused the dramatic shift toward artistic spontaneity that arose during the Renaissance and continued to accelerate. Oil paint includes pigments dyed in various oil types, from linseed to walnut. Artists layer successively thicker amounts of paint atop prior layers to prevent against cracking and to provide a vibrant, immediate luminosity.[5]

The transition to oil paint has been criticized as an era that uniquely prized paintings of possessions and ownership by Europe's ruling classes. Subject matter often included idyllic scenes of a noble's land holdings, portraits of the female nude, and hordes of jewelry and winnings from colonial outposts.

Oil was a medium that deemphasized topics about religious worship and public displays of government or military power. Instead, it ushered in modern concepts of color, commerce, ownership of goods, and industrial life. While unapologetically commercial, oil is also undoubtedly the medium of spontaneity that first allowed artists to rework a painting on the fly.

- Can you recognize the difference between fresco, tempera, oil, and acrylic?

- If you have any art in your home, what are the materials?

- Do you prefer one or two types of materials, including the canvas and paint types?

On any given day, you might see an oil painting in your house, an art gallery, museum, or office building, but its heyday ruling visual art was between roughly 1500 and 1900. It arose during the ascendancy of canvas, which we'll discuss momentarily. Collectively, innovations in oil and canvas enabled transportable art for trade and eventually ownership among an emerging middle class. New attitudes toward property,

exchange, and the "good life" were often the subject matter of oil paintings during this time.

Today, oil painting can be used for any topic or subject matter. You will still notice a translucent blending of colors and sections across the canvas, in contrast to a starker separation of images within an acrylic painting.

Acrylic

Acrylic is a relatively recent invention. It was developed and extended between the 1930s and 1940s to combine properties of oil and watercolor paints. It's a synthetic resin binder mixed with pigments, not a natural resin from a sap. Acrylic is created through chemistry, making it distinctly contemporary.

Acrylic is more durable than oil. It is said to be more elastic, in that the canvas it resides on can be rolled or moved without cracking, and an artist can paint directly onto the canvas without a priming layer.[6] It's an even simpler vehicle of exchange for modern commerce and the art trade.

Acrylic has a crisp edge, with bright and bold colors differentiating segments of the artwork. Artists can use methods that delay the drying of acrylic painting, but it generally dries fast and won't require multiple layers of paint. Once acrylic has dried, an artist can apply any number of other mediums atop it, including charcoal, pen, or pencil, or even thickening agents, such as sand. This makes acrylic a truly contemporary medium for artists combining styles under the genre of mixed media. If you see paint combined with other materials, the odds are high that the artist used acrylic paint. Acrylic has ushered in a new era of rich, design mediums with bright, fast-acting, and mobile artwork.

Canvas

Early human painting was completed on (lime)stone in caves, followed much later by wood. The limestone was, of course, entirely immobile, and the wood wasn't much better. As mentioned before, until the mid-Renaissance, art was hardly

transportable in large quantities for any but the most aristocratic of nobles—only they could afford the massive transport effort. Canvas liberated art exchange.

Canvas comes from cannabis, which was the Latin word for hemp. It became widely used in Renaissance Venice in tandem with oil paint, due to wood's troubles in the damp island state. Since the days of hemp, canvas is now more commonly made from cotton or linen and stretched over wood for framing.[7]

Cotton

Cotton is an affordable canvas material that stretches easily. It is durable, stretches firm, and effectively holds oil and acrylic. You might not see the largest paintings on cotton though, as some consider it too flexible for an oversized canvas. If you look carefully, you'll notice that cotton canvas is extremely smooth and flat. On the one hand, this allows the artist's work to take center stage, while on the other hand, criticism is that cotton can appear too cleanly manufactured, lacking authenticity or character.

Linen

Linen is strong and durable and remains the preferred surface for many artists due to the rugged look. Linen is expensive, though, so you won't see it as frequently in general artwork for your home. It's made from the fibers of the flax plant. The fibers are known to resist expansion or contraction despite temperature or weather changes. In addition, linen retains oils well, which allows the canvas to stay flexible over time and absorb many layers of paint. The main advantages of linen are the natural weave and strong fibers, which are robust enough to withstand heavy paint and tight stretching over an extra-large canvas.[8]

Photography

The invention of photography presented a point of no return for visual art. The mission of painting and sculpture to faithfully present realistic images was supplanted by photography in a single generation. January 7, 1839, was the date that photography was

introduced at the French Academy of Sciences. It was commercially available throughout the world shortly thereafter.

Photography didn't destroy painted or sculpted arts, but it did grab significant shares of their documentarian activities—portraits, city and landscapes, political scenes, and social gatherings. It was not until staged scenes arrived, when lighting, participants, and objects were intentionally constructed and aesthetically pleasing beyond exactly capturing events, that photography was accepted as art, not visual journalism.

Photography addresses topics that are infinite and varied, but the ones that document history or personal events aren't usually granted a large audience in the art world. Fine art photography often speaks to identity, whether it's gender, race, sexual, consumerism, modernity, decay, death, or pristine, untouched nature.

Cindy Sherman, for example, was an artist, director, and model, creating a vast canon of work showing herself filling various female gender stereotypes,[9] whereas Andreas Gursky introduced us to tightly packed frames of industrial production around shipyards and transport hubs.[10]

We know about the availability of photography today. It presents an ever-ready pocket camera available to capture anything, from a well-plated dinner to a personal selfie.

Electronic and Digital Media—New Media

"We live in the mechanical age. Painted canvas and upright plaster no longer have a reason to exist."

So said Italian painter and sculptor Lucio Fontana in 1947 in the *Primo Manifesto dello Spazialismo* (*White Manifesto*). He went on, pushing an aggressively modern agenda that would inspire artists who work with electronic and digital mediums:

"We conceive synthesis as a sum of physical elements: colour, sound, movement, time, space, which integrate a physic-psychic unity. Colour, the element of space, sound,

the element of time, movement which develops in time and space, *are the fundamental forms of the* new art, *which contains the* four dimensions *of existence. Time and space.* "[11]

Art's most contemporary medium is also the most confusing. Neon and fluorescent lights, lasers, digital interfaces, video, and sound, comprise electronic media materials. Digital media doesn't pull punches or restrain mediums. Often, they are combined. Contemporary technology is their artistic palette, and new media artists are unabashedly conscious about how their art merges and synthesizes elements of design and engineering practices and materials.

They see traditional visual art as stable, perhaps static. Instead, digital art enables a fixed duration, or a looped duration of sound and video. It moves in space and time, making visual art merge with forms such as movies, TV, and video. Artists began to experiment with mechanized and electronic materials about 1920. *Monument to the Third International,* 1919–1920 by Vladimir Tatlin, was a building with three parts that moved at different speeds.

On a smaller scale, *Rotary Glass Plates (Precision Optics),* 1920 by Marcel Duchamp, used plated glass of different sizing to create a visual, buzzing effect. Seems simple now, but no one had thought of it before. It's also worth emphasizing sound, because artworks were entirely mute before electronic art, and most remain so today, paused in a silent image. Leaders, such as American composer John Cage, brought classical composition into fusion with electronic music and contemporary art, creating a hybrid of visual-auditory formats.

Despite a linkage with technology and modernity, new media art is lower visibility than other art forms. Large industrial electronic installations are difficult to transport, display, and maintain. Truly digital software is easy to transport but is difficult to display on a personal computer at an impressive scale.

Additionally, many digital artists are openly opposed to or antagonistic toward visual beauty. They view digital art as uniquely placed to address philosophical and wide-ranging topics in social or political commentary, like fighting censorship, state surveillance, or corporate influence. The freedom gives it power, but also ensures that audiences need extra concentration when they encounter a new media installation.

> *"Electronic techniques for producing and reproducing sounds and images have affected the ways artists reflect on traditional aesthetic concerns and have expanded the creation and distribution of art, including its manifestations as code, as an image on a monitor and as an object."*[12]

Electronic mediums also facilitate audience participation. They rupture boundaries between artist and audience. For example, as early as the 1970s, American artist Douglas Davis was using art to make participants "content providers" by getting participants to submit information and contribute to his artwork over electronic networks, through exchanges of texts, phone calls, and participant-driven video movements. This is one example of digital art and electronic media portending changes in social media and business platforms that broke down boundaries between producers and consumers.

Other Mediums

The materials of art are limitless. Driftwood or tar, tacks and tarp, composite, glass, or software. We should be ready to encounter any physical medium available, and we should consider why the artist chose that mode in particular instead of the other infinite options.

Color

Color is mostly out of scope in this text, because the corresponding *meaning* is too adaptive. Meaning fluxes with eras and cultures, which can't be underscored enough. Color supports unique goals for artists operating across locations, times, and

contexts. So, what are we supposed to learn about it? Artists have experimented with color obsessively throughout history, tentatively and initially in caves and eventually as a habit and obsession during Impressionism. Artists have foraged among plants, vegetables, and grub insects for materials they can squish and drain to bind the dye for their canvases and walls.

The foundation of artistic practice is color theory. Basic tenets include the color hues and harmony. We use the color wheel to introduce both. The first circular color wheel was created by— here's a surprise from science—Sir Isaac Newton, in 1666. Multiple derivations have arisen since, all sharing the goal of mapping the spectrum of color hues and their relationships to one another. Hues include three tiers: primary, secondary, and tertiary colors. We know that the primary colors are red, yellow, and blue.[13] Our colorful reality is merely a potent mashup of these three forces.

Beyond hue, color harmony defines the combinations of colors, which create visually compelling groups and patterns. It rests largely on two ideas: analogous and complementary colors. Neighbors on the color wheel are analogous, while opposing colors are complementary. Harmonious patterns often emphasize color schemes, which follow one or the other. Random arrangements across the color wheel risk invoking a chaos of hues.

Neuroscience is tackling the color wheel in earnest. For example, researchers have validated what the color wheel intuits: colors pop best when they are *contrasted*. They don't operate in isolation. Famously, French Impressionist Claude Monet painted complementary colors in tandem to simulate the effect of shadows but without using a drop of black on the canvas. His technique provided the sensation of shadows while maintaining a brightness of lighter hues. To similar ends, French artist Henri Matisse left parts of his canvas white to enable crisp distinctions between colors. In each case, these artists experimented with sensations of color harmony.

Cognitive findings are also beginning to point toward patterns in

human color receptivity. It appears that specific brain regions detect unique hues. Red, a primary color, enjoys the largest neural processing area, followed by green, blue, and then yellow, another primary color, which strangely trails far behind. Red's consistent link to power and prestige is possibly related to the expansive neural network in the human brain that actively processes it.[14]

Remember, for most of history, colors—or should we say the bugs, oils, minerals, and plants which made them—were incredibly difficult to find. Artists needed unique dyes and pigments and special mixing techniques, many of which were closely guarded secrets. Artists could *not* paint whatever they wanted. Art supplies in general weren't easy to come by, as exemplified by Michelangelo spending almost *eight years* in quarries searching for sculpture supplies during his lifetime. For most of the Middle Ages—more than 1,000 years—plum purple, bright red, and most shades of blue were difficult or impossible to obtain for all but the wealthiest patrons. Blue must have caused an acute psychic pain, given that it's a primary color we naturally observe most days in the sky, water, or clouds, yet natural distance and harsh journeys ensured that procuring and painting with it was burdensome and rare.

- Do you enjoy certain colors or groups more than others?

- Which colors do you notice most frequently during your museum and gallery visits?

- Do you see certain colors more frequently when viewing artists from certain times and places?

Color is a study in hues, harmony, neuroscience, procurement, and, ultimately, culture. Today, the physical struggle of obtaining color is past, and artists are free to explore color's impact on our psychology and biology. As you view artwork, it's helpful to consider if artists are using color in expected or unexpected ways. Are they following the standards of realism by showing objects as we naturally see them, or are they recasting traditional visual

expectations? Do they follow rules of color theory to build patterns around analogous or complementary colors? If not, why not? After enjoying your instinctual reaction to an artwork, you have the opportunity to step back and examine an artist's color choices.

The Burden Is Eased

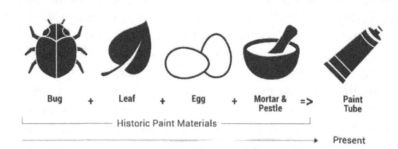

Bug + Leaf + Egg + Mortar & => Paint
Pestle Tube

Historic Paint Materials

Present

What is "Exceptional" Art?

Debating "Great" and "Exceptional" Art?

As a not-so-side note about what *is* art—as definition, color combination, and materials, a question quickly arises about how artists assemble these raw supplies into "great," or even "exceptional," art. I'd like to give us permission to explore and be so bold as to guess at and propose factors we'd expect to see in art that reaches the more rarefied tiers. It's more than an academic question. Having an answer for this question puts you in the unique company of people who can specify their ideas about supposedly subjective things, and who can defend those ideas.

Art is personal; it can attract your attention and provide meaning in the most private, individual, and tender way. That's fair enough, but I think that we expect to see broader consensus that an artwork provides something special before we certify it good or exceptional. More practically, when finding yourself in the throes of a debate about which artwork was best at a given show, or why you prefer one artwork over another, defaulting to individual preference is too easy. The personal preference card stops lively discussion and scapegoats from forming a defensible position. We won't do that. Being confident means being able to debate with our friends about why we like what we do and relying on more than simply, "That's what I think."

A paradox lies at the heart of this almost-trick-question about exceptional art. It's one identified by philosopher Immanuel Kant. He was able to name and clarify the frustrating thing that happens when we have personal opinions about art and think other people should agree with us, but they don't. For example, you might say, "I personally believe this painting is beautiful," which sounds harmlessly independent, but then you're surprised when friends don't agree. Kant called this phenomenon, now a

cornerstone of aesthetic philosophy, "subjective universality," and it's what makes matters of taste such a conundrum. Clichés about beauty being in the eye of the beholder strengthened later, in attempts to ignore dissent. Still, most of us are annoyed if we can't convince others to agree with us about artistic opinions.

Then, when arguing about who's right, we're often unable to identify root causes, which is to say, specific attributes that make an artwork beautiful. For example, that a sculpture of the male body is attractive because of a precise musculature, torso shape, material, colors, strength of the legs, or breadth of shoulders, is a level of precision we generally lack. Instead, our thoughts and feelings about beauty unusually emit from *something* beyond the sum of its parts. Even if and when a friend convinces you that the muscles are slightly elongated and the torso is unrealistic, you still feel the aura of beauty. It seems to exist outside and beyond the mundane attributes beneath.

Becoming confident in art means easily having these debates. It means learning why you feel a certain way and why others might not. Despite the hopelessness of it all, we still want to think about differentiating the basic from the good, great, and exceptional. Here are some attributes to consider about various artwork. These concepts will be discussed further in this section.

What Is "Exceptional" Art?

Exceptional ?

X-Factor, Je Ne Sais Quoi
Luck
Time

Great

Wrist Down ⊕ Up
Masses ⊕ Classes
Institutions
Financial Market

Art

Wrist Down ⊕R Up
Masses ⊕R Classes
Attention & Meaning

Art

We defined art. *You* defined art. It uses beauty, shock, or a combination to draw you in. It shares a story or an idea.

Going further, it's time we introduce another concept. Art can achieve its ends by emphasizing approaches called "Wrist Down," "Wrist Up," or both. From author Sarah Thornton's *Seven Days in the Art World,* this distinction revolutionized my framework for classifying and viewing art. It delineates the differences between conceptual and technical art, which partially aligns to our ideas of attention and meaning, but could be either, so it's best to consider them separately.

> *"It used to be said that some art colleges instructed their students only "up to the wrist" (in other words, they focused on craftsmanship) while* [famous schools such as] *CalArts educated its artists only "down to the wrist" (its concentration on the cerebral was such that it neglected the fine art of the hand)."*[1]

Wrist down is the mechanical use of hands to craft an object. *Wrist up* is the intellectual pursuit of a concept. Artwork might be a pencil-shaded drawing by the person next to you in an after-work sketch class. It's just a vase, but you can see the shadow, depth, and curvature. It looks real, only better. Art could also be the street performer protesting gun deaths in a public square, dressed in jeans, coming from his busboy job, not looking like much, but with chalk outlining his mock corpse on the cement. All that's to say, the textured vase and the man enacting a gunshot death both attract our attention and convey meaning.

They are both art but one, the vase, is a wrist down display of technical, sketching aptitude. The mock death is almost a pure idea, no wrist required. It's a wrist up display of a concept. In each case, either craft or concept are prominent, to the detriment or lack of the other, and so we label each work as either, respectively, wrist down or wrist up, to identify the approach they emphasize. When a lot of us started looking at art, we were more comfortable

with the wrist down variety, because we can understand technical aptitude more quickly than art theory. The art world likes both, but contemporary museums and emerging shows take a heavy hand with wrist up material.

For now, this matters because I think you'd agree that art could use either of those approaches. But great and exceptional art start to build a scaffolding from here.

Great Art

This isn't little "g" great art in my wallet or drawn in my diary. We're not discussing privately cradled art we hide under our bed. This is big "G" Great art in the public domain where debate rages, and where two or more people start to form a consensus. They form a community. People buy from one another or agree to display artwork for crowds, large or small.

Why do bridges form between buyers and sellers or circles between artists and dealers with crowds, galleries, museums, or graffiti walls? Because they see at least a spike in attention, meaning, wrist up or wrist down approaches. They see a sculpture that cuts a more perfect figure than the person who walks the office halls. They are struck by the struggle of a race, gender, or social class as shown by an object that builds empathy and teaches audiences about fears or pain they never grasped.

Great art overperforms—spikes—enough in at least one quality to begin building a community of groups, institutions, or financial players, who will back it for excellence. Spiking in one area often means novelty or innovation. It could occur *either* above or below the wrist, but often occurs in both ways. Innovation might push unique or underrepresented subjects, distinct stories, or use new mediums—electronic installations, laser lights, virtual reality, or organic earthen materials. It could present a new idea, struggle, challenge, or question. Novelty could be delivered through material, craft, or concept.

Picasso was wildly prolific across genres and through an immense lifetime of output. He reeled off a string of "firsts" or near firsts

in multiple genres. Conceptual leaders, such as Duchamp, intended to only undertake artistic projects if they hadn't attempted a similar work before. They showed us that great art is new art. It's untested, untried, and relentlessly aggressive in pushing boundaries.

This drive for novelty has propelled art, whether consciously or subconsciously, since the early-nineteenth century, when the half-life of artistic movements began shrinking precipitously, raging through Impressionism, Primitivism, Expressionism, Abstract Impressionism, Cubism, and Minimalist—the list continues in rapid succession.

The art world celebrates novelty, as do many viewers who frequently visit art shows. The trick is understanding that much of the bizarre art on offer is shown because it's novel for other people—dealers, critics, curators, artists, and sophisticated buyers, but we might not be in a particularly novel mood, instead preferring more accessible and pleasing artwork. Either way, it's useful to remember what the famous twentieth-century art critic, Clement Greenberg, said, "*All profoundly original art looks ugly at first.*"

And yet, the inertia against novelty is powerful, for viewers and artists. Artists repeat approaches, probably for the practical purpose of reaping commercial rewards from a signature style. We fall into fixed, not growth, mindsets. A single, unique breakthrough can solidify an artist's career. The temptation to ride that success is likely overwhelming.

The difficulty of achieving a breakthrough, and the traps that ensue, make sustained innovation across styles remarkable, whether in art, consumer technology products, or scientific milestones. The improbability of sustained novelty enhances our appreciation for artists and creatives who can provide it.

Philosopher and art historian Denis Dutton proposed the need for individuality in not only art, but in life. He cites the awkwardness we feel if two people arrive at a party with identical outfits. Dutton

uses the outdated analogy of ladies in matching dresses, but the awkwardness also applies to men in identical outfits, like suits, ties, or sweaters-over-button-down shirts in the office.

I don't like meeting men with my same name, Aron. A group with two Arons is a serving of annoyance, until I escape. We're all participants in an expressive performance. Our artistic adornments, whether a haircut, clothing, jewelry, or interior design, express our uniqueness. At the least, many critics argue that good art cannot be a copy. Authenticity is the humble version of innovation—it's not groundbreaking, but we trust its origin. Dutton says:

> *"Authenticity, which in the arts means at the most profound level communion with another human soul, is something we are destined by evolution to want from literature, music, painting, and the other arts. This sense of communion exhilarates and elevates the spirit."*[2]

Deciding

If art is subjectively universal, who decides that it's great or exceptional, or if we want it at all? Who decides if the art applies novel approaches and is innovative, if it should carry a hefty price tag, be shown in a museum, or allowed to persist on the side of a warehouse?

- Are you more likely to think that something new and/or innovative is good or great?

- How would you feel if you discovered an artwork was a forgery after spending hours, weeks, or months with it?

Art typically enters public consciousness via a gallery or a dealer selling to a collector, after which point, during an auction, or maybe after the collector's lifetime, the artwork might land in a museum and not in storage. Commerce is the common denominator throughout the chain. Outside museum lines and

social media *likes*, the financial community is an objective measure. We know that art is big business. Participants set a market price when they transact. The artists, their styles, artistic periods, and prior owners create an extended narrative around the work, which ultimately equates a new sense of value for transactions. Then museum visitors buy posters, postcards, magnets, and T-shirts.

It's a question of gatekeepers and consensus. Do we rely on opinions of the "masses" or the "classes"? A theory of the masses requires enough viewers to embrace the artwork before it's certified as "good," while a theory of the classes requires positive commentary from art critics and industry experts. This complex interplay is difficult to untangle and adjudicate, but, in practice, the process first rests on building consensus through a network of thought leaders and influencers. Most typical visitors don't issue an opinion until art world gatekeepers have provided initial blessings. Typically, that means the classes certify art as "good" before showing it to the masses, who then react with an assortment of awe, disbelief, apathy, and genuine excitement.

Philosopher David Hume tried to reconcile this paradox by employing *critics of taste*. Specifically, *because* matters of taste are so tricky to reconcile, we need experts. It took immense time and dedication, he said, but some individuals *could* develop a refined sense of judgment, which held greater merit than other opinions, that was more accurate and insightful. Consequently, Hume elevated the stature of critics for creative disciplines, from art, to literature, to music. While a certain logic flows from Hume's reasoning, and it's difficult to dismiss entirely, he contributed to disenfranchising the art-viewing masses by designating the "classes" as arbiters of taste. In practice, they would be anyway, because a small handful of a few thousand buyers largely fuel the financial markets that certify prices and enable art sales to hit international headlines.

Yet, art experts have been outrageously wrong-headed on many occasions, most infamously with their near-universal

condemnation of the Impressionists. The now-debunked quote from Impressionist critic Louis Leroy went as follows, *"Wallpaper in its embryonic state is more finished than that seascape."* Today it's unlikely you'll name a genre that typifies the accepted view of art more than Impressionism does, but their contemporary French critics hated Impressionism and passionately condemned it.

While regularly misfiring, experts *are* able to spot analogy, nuance, and freshness beyond what the untrained eye recognizes. They know art history, stylistic trends, and see when an artist is truly breaking with tradition. They're able to offer refined and reasoned "critiques" of the work on hand. They are able to initiate and deepen a cultural discussion, which is necessary to publicly vet artwork on display.

If you suffer more egalitarian aspirations, the masses also get it wrong. One insightful subversion of popular opinion was called "America's Most Wanted." Clearly a play on the 1990s TV crime show by the same name, in 1997, a pair of Russian artists, Aleksandr Melamid and Vitaly Komar, undertook a survey to learn what viewers wanted to see in paintings. They asked about medium, style, and subject matter—down to precise questions about which objects, animals, flora, and fauna should be included within the paintings.

Melamid and Komar were enamored with US political polling systems and thought to apply the same methodology to art. Politicians, advertisers, and producers interact with constituents through polls, so they would too. Their goal was to poll viewers on the attributes that viewers wanted to see in paintings, and then create those same paintings for the audience. Give the people what they want. Melamid and Komar also referenced the sculptors of classical Greece, and how they created images of the gods by replicating their favorite features of living citizens seen throughout the republic. Godlike sculptures were simply a recombination of the most attractive faces, lips, thighs, and navels. US and Greek inspiration drove their interest in polls and public

vetting that would capture populist opinions of the majority.

It all started with a big idea, that of the blue sky. Melamid said,

> *"It might seem like something funny, but, you know, I'm thinking that this blue landscape is more serious than we first believed . . . I think people want to talk about art, for better or for worse, and they talk for hours and hours. It's hard to stop them; nobody ever asks them about art. But almost everyone you talk to directly—and we've already talked to hundreds of people—they have this blue landscape in their head. It sits there, and it's not a joke. They can see it, down to the smallest detail. So I'm wondering, maybe the blue landscape is genetically imprinted in us, that it's the paradise within, that we can frame the blue landscape and we want it. Maybe paradise is not something which is awaiting us; it is already inside of us, and the point is how to figure it out, how to discover it, how to get it out.*
>
> *We've now completed polls in many countries—China, Kenya, Iceland, and so on—and the results are strikingly similar. Can you believe it? Kenya and Iceland—what can be more different in the whole fucking world? And they both want blue landscapes."*[3]

They followed the polls methodically, and yet, the resulting paintings in America's Most Wanted are a cruel joke. We know with almost complete certainty that these artworks would not be the most popular. The paintings were comically Frankenstein-ish combinations of disjointed subjects. No one wanted America's Most Wanted. You can define attributes, define art up front, and directly ask people what they want, but it won't look the way they imagined it. It won't *feel* that way.

The artistic community was shocked and outraged. The thought of artists talking about "what people want" was too much. It was blasphemy. Artists want to believe in their own vision, not play hostage to audience demands. But artists also aspire to mega

shows, blockbusters, and international acclaim, and they *do care* what people like, in terms of critical and audience reception. That's the central tension between creative vision and market appeal. Most artists seem to prefer following their internal compass rather than the crowd's specs. They'll take their chances with the outcome.

After Melamid and Komar published their poll in *The Nation* magazine, it received "more negative letters from readers than at any time in our 130-year history."[4] It also received more enthusiastic responses than ever. Readers were upset that artistic value would turn into a capitalist poll—ironically

- What do you think about subjective universality?

- To what extent do you think critics influence your artistic opinions? What about your peers?

- Have you ever purchased art? Did you think the more expensive artwork was better? If not, why was it more expensive?

conducted by Russians. Viewers wanted the artists and gallerists to choose for them, to curate. Komar said "Our poll results indicate that most people are dissatisfied with 90 percent of paintings currently hanging in museums, reproductions on posters, and sent on postcards."[5] These artworks were chosen by experts and they were failures. The pictures in America's Most Wanted were chosen by the masses and were also failures.

We might only know that an artwork will become good or great if it's controversial. In *The Painted Word*, author Thomas Wolfe said of modern art, "If a work of art or a new style disturbed you, it was probably good work. If you hated it—it was probably great."[6]

Exceptional Art

It's probably impossible to predict in the moment if a

contemporary artwork will become known as exceptional. Let's go back to Cattelan's *La Nona Ora*. Is it exceptional art or merely good art? I'm not sure we can say—yet. It achieved substantial praise and acclaim when shown in 1999 and years beyond, but critics and journalists do need to write about something. Will it be continually cited in art books and curatorial shows in twenty or thirty years or bypassed in favor of other pieces? Time has not yet worked its destructive magic. With luck, *La Nona Ora* will continue to be cited in future decades.

Conversely, Dutch painter Vincent van Gogh only sold one painting during his lifetime, from a portfolio of 900 works. But time has resurrected his name. Likewise, for El Greco, the late Renaissance painter from Crete who did achieve fame and luxury during his life, but was cast aside and scorned for more than 200 years before being rediscovered by historians and scholars, and then influencing movements such as Cubism. His work now hangs on prime real estate in Spain's Prado Museum and other international landmarks.[7]

A cynic could also call Mexican artist and painter of surreal self-portraits Frida Kahlo lucky, because she married immensely famous Mexican artist Diego Rivera, before gaining any notoriety, meeting him through social events hosted by the Mexican Communist Party. Over time though, her work has withstood scrutiny, supported by posthumous shows and historical visibility, championed for representing Mexican folk art, for being a trailblazing female artist and the first Mexican artist collected by the Louvre, and for her distinctive style. Her first painting sold in 1977 for $19,000, but now they regularly sell, if offered at all, for millions.[8]

Jackson Pollock was a wayfaring American artist muddling along to moderate notice when socialite art collector Peggy Guggenheim plucked him from an unexceptional career and installed him amidst the mid-century avant-garde in New York City. Luck found him, skill propelled him, and history has ratified his position.

Finally, we can't forget the *Mona Lisa*. It's history's foremost gift of time and luck. Before Vincenzo Peruggia stole it in 1911, historians say that authorities didn't notice the theft for about twenty-eight hours, until a still-life painter visited the gallery and mentioned its absence. Yes, *Mona Lisa* was painted by Leonardo da Vinci, a renowned name, but it wasn't his most famous work or even among the most prominent pieces in the Louvre. Peruggia's crime of opportunity christened a masterpiece.[9]

Beyond theft, a big-name gallerist could channel a young art student directly from his or her graduate project into a prominent group or solo show. That's the more likely route to fame. The young artist's work must catch the gallerist's eye, so it must have something, a je ne sais quoi to start, but what if the gallerist has an off day or misses their flight? What if the gallerist already allocated wall space in the gallery or capital for the season? You get the point.

Exceptional art might benefit from luck, either to reach its first showing, or later, after decades of neglect, through the diligence of studious art historians and critics who find artworks they can't ignore. Luck might give the artwork air cover and visibility, but only time under criticism, viewings, and discussions will certify it as something truly exceptional. Ultimately, critics, the public, and the financial markets must align to create mega successes. An artwork can't rely on a few desirous millionaires or art historians to propel its reputation forever.

So What?

We still find it difficult to escape subjective universals. Although, as we'll see later in the How section, neuroscience, biology, and psychology have placed a tighter frame around both subjectivity and universality. Science is driving clearer understanding about each reaction that might happen. That doesn't necessarily help us, as a community, to drive consensus toward great or exceptional art, but it does help reduce the claims that everything's subjective. It's not.

Ultimately, an object is *art* if you personally designate it as such. It's good art, maybe great, if communities begin to designate it as such through participation, trade, and visibility. *You need your own definition and criteria,* but I think *art exists to attract attention and convey meaning.* Nothing more and nothing less. Ideally, in the midst of this glittery, visual pattern, the art also expresses profound human thought. It's wrist down, excellent craftsmanship and wrist up, intellectual force. Communities, critics, the public, novelty, time, and a pinch of luck combine to certify artwork that resides in the pantheon of remembered works.

You'll probably reach agreement with friends and other viewers of artwork more often than not. It's more a matter of *degree* than a flat "Yes, I like it," or "No, I don't." Many artworks that strike you as novel, intriguing, or attractive will also hit a deep chord and resonate with the general audience. When discussing or debating, you can think about attention, meaning, materials, location, wrist down, wrist up, novelty, time, and luck, and use those factors to tell your friends why they're wrong and you're right. And if that doesn't work, it's okay, you can always claim that art is both universal and subjective.

The Future?

Before TVs beamed colorful moving images into our houses, unless you knew a royal family or aristocrat, you had to attend church or visit famous museums to see world-class visual images. Viewing art was a pilgrimage to places of power. Today, those same institutions, the Louvre, the British Museum, the Metropolitan Museum of Art, and the Museum of Modern Art (MoMA), still wield outsized influence, as do the ancestors of those royal families and nobles, but visual art has been liberated from these handful of locations. Our modern caves—homes— have access to digital channels, websites, and social networks that support art access and enable a single image to reach millions or billions of viewers. Art's geographic constraints have been wildly lifted. Even specially curated, site-specific exhibits travel more freely due to mobile materials and global logistics companies, and replica posters or show books are available afterwards.

As art has been liberated from location and medium, access might have become so easy that we've lost respect for it. Never before has an individual image seemed like such a commodity, one surrounded by 24/7 streaming and custom music collections and untold online videos. Digital files are flattened and reduced from their originals, and they seem static in contrast to increasingly immersive, virtual, reality games. New formats and devices enable access to traditional print media, but they also bypass traditional media and provide their own distractions through novel formats, such as podcasts. Art has never competed for attention like this before. As new generations spend lifetimes scrolling though digital art gallery feeds on social media, will tangible art keep its luster?

The fatigue of choice seems to affect our attention spans. A study released in 2015 cited the current human attention span as eight seconds, down from an already meager twelve seconds in the year 2000.[1] This is shorter than the attention span of a goldfish, at nine seconds, even if we tend to remember things a bit longer than

goldfish do. Can art captivate our attention in today's frenetic landscape? Does it inspire or provoke with a cultural net force that reaches beyond the digital media noise?

I see four broad scenarios that might occur with respect to art's cultural net force: sustained relevance, reduced mass appeal, visual complement, and vestige of humanness

Scenario 1: Sustained Relevance

Many signs indicate that the art world maintains reasonable cultural net force. Art is broadly accessible, and although it has more competitors for attention, it offers a unique activity, value proposition, and learning opportunity. The American Alliance of Museums says,

> *"There are approximately 850 million visits each year to American museums, more than the attendance for all major league sporting events and theme parks combined (483 million in 2011). By 2006, museums already received an additional 524 million online visits a year just from adults, a number that continues to grow annually."*[2]

While online visits will grow, museums don't attract TV viewership like major league sporting events command. Watching a museum on live TV would be, *exactly*, like the old cliché—"as exciting as watching paint dry." But 850 million visits is a powerful number, within striking distance of 1.3 billion movie tickets sold in North America across 2016.[3]

The art market is also a sizable industry at around $56 billion in annual revenue in 2016, albeit dwarfed compared to true economic stalwarts, such as retail, finance, energy, or transportation. That said, it fares well enough against "attention competitors." In 2016, global live box office revenue was $38.6 billion, video games netted $91 billion, books sold $120 billion globally, and TV and video revenue was about $286 billion in the United States.[4] Yes, you read that correctly: global art sales outpace Hollywood, a fact that few, if any, of us stop to consider. As of 2016, the art market is also still larger than the mobile app

industry, which is expected to earn about $50 billion but tends to attract all the headlines. Although the art market is smaller than some cultural industries, I was surprised to learn that it is relatively larger than my expectations. That it generates even 40 percent of the revenue that global book sales do, that it's larger than live box office revenue, is impressive.

Art's annual revenue and live museum attendance numbers are surprisingly robust in the cultural attention marketplace. Beyond that, social networks that emphasize images, such as Facebook, Instagram, and Pinterest, provide more visibility to artworks, given the medium, than to movies, books, or music. Relatively, art exposure benefits from image-focused digital channels. In addition, flat art and statues fit in homes and museums. They are visible with the naked eye rather than accompanied by augmented or virtual tools, and they don't require coding or technical degrees, which are in high demand at software firms and therefore draw talent due to economic rewards. Default art formats rely on relatively simplistic two- and three-dimensional works seen in physical, not digital, reality.

Scenario 2: Reduced Mass Appeal

Technological innovations might dull traditional art's sheen and cast it as increasingly plastic compared to emerging, virtual mediums. While art isn't confined to a particular space or format, and it will certainly evolve into new mediums, certain motifs are possible and more easily producible than others. That seems unlikely to change in the near future. It's possible that digital social networks increase art's dispersion while decreasing its impact, and flat art or statues, while accessible in the home today, become bland or outdated as technology, electronic and digital media, proliferates and consumer expectations demand immersive entertainment. The attributes that make art accessible today make it simplistic tomorrow.

Furthermore, although viewers *attend* museums in healthy numbers, their attention is often outside or in digital space. We know this because visitors spend an average of twelve seconds

viewing famous artworks, and they don't remember much after leaving. If art museums largely function as superficial cultural junkets, then viewers cannot value them for the power to change perspectives, attitudes, or behaviors. We might already categorize a day at the museum like binge watching a TV series or clicking social media video clips. It's nothing to disparage from an entertainment standpoint, just falling short of Leonardo da Vinci, Michelangelo, Pablo Picasso, and Ai Weiwei.

Perhaps most problematic is art's paradoxical home between populist intellectualism and the financial elite. Art has long been produced by a populist-minded creative class for de facto aristocrats. As seven- and eight-figure art sales steal headlines, people look around puzzled by why they rarely see this art, its artists, or the collectors. High-end art ownership isn't broadly relevant and that disconnect undermines the public relevance of such works, as many people scoff at what they don't understand, can't afford, or what is legitimately an overpriced trophy. What's the appeal of urinals, drab stone slabs, unmade beds, strands of yarn, and monochrome canvases? To the everyday rushed family and the urban services worker, avant-garde art addresses radical and mysterious themes, concepts that don't seem to trouble us at the dinner table or in private moments.

The voice of contemporary art is often revolutionary, culturally self-critical, anti-elite, and self-referential. It's often brilliant and provocative, but it's emotionally challenging in a way that mainstream movies, TV, music, and digital games are not. When people are at leisure, they usually reject mental challenges in favor of beauty or ease. Art could fall to a mainstream positioning challenge.

Scenario 3: Visual Complement

In a world with shorter attention spans and competing dynamic media, perhaps today's art will become more of a "feature" than an app. If art is drowned out by new media, or crowded out by "design," art could adapt into the world's best *complementary* good. Rather than vying for attention against long-form television,

tasting menus, virtual reality, and other immersive entertainment, art might become a complement that is subsumed into other services. We know that art can elevate the quality of an experience without taking center stage. Art magnifies its surroundings with a halo effect. It beautifies an office, study, dining hall, or bedroom and brings ideas, history, color, and style to an interior. Artistic objects, used strategically, could differentiate among competing options. Would customers prefer to linger in an art-filled café or restaurant, given the same quality of espresso? Probably yes.

Under this scenario, visual art would be window dressing. It's not a glorified future, not equal to art's trailblazing past. It might appear cynical to people closely tied to the art world, but if art cedes cultural force to immersive theatrical, musical and gaming experiences, or if it becomes narrowly relevant to a collecting elite, then it ceases to earn the distinction of shaping our shared values.

As consumer technology improves and attention competitors become more beautiful and provocative, perhaps only art's mega shows at top museums will continue to impress and surprise. Humble painting and sculpture would become complements to other services, because they do not help enough people pass meaningful time and don't perpetuate symbols and hold our stories. But making offices, homes, and restaurants attractive could become less expensive and easier to achieve, installing public art might increase a sense of community and reduce crime. Art in movie set design and TV shows enriches the visual periphery, while melding art into fashion would enable the self-expression many of us desire. As the price and ease of creating acceptable, if not frame-breaking, art, reduces, the dispersion reaches previously unrealized levels.

Visual art finds itself at a crossroads, seemingly strong and growing, but potentially on the edge of being disrupted. Software has eaten almost everything else, from food delivery and movie access, to taxi rides and driving itself. As digitally scalable and democratic media proliferate, art as shown today will need to

change mediums and/or increase its accessibility and dispersion through digital channels. Otherwise, it could lose the battle for relevance and attention.

Scenario 4: Vestige of Humanness

Ray Kurzweil, Google's director of engineering and prominent futurist, predicts computers will be smarter than humans by 2029. He was among the first to predict when computers would beat humans in chess and that the World Wide Web would evolve in importance. He's not alone. He says that 2029 is at the "median" of artificial intelligence predictions.[5] Other computer scientists and futurists believe the date will arrive sooner. If computers can joke and flirt, they might create visual art, or something near to it, although perhaps without the culturally embedded political or sports innuendo. Maybe. But if they can process nearly unlimited information and perform most of life's algorithmic tasks, then they will certainly be able to adopt more of the office drudgery that makes us numb.

This is not to be dystopian in an art book, although that's one angle. Rather, I prefer to think of computer intelligence as adopting more of the algorithmic work, enabling humans to devote more time to creative projects, all the creative activities— pure visual art, music, film, and games—an expanded purview for design, the more risky and uncertain engineering tasks. Our human access to intuition, and the ability to uniquely combine it with algorithms in the creative process, will be a central source of human productive focus and pastime.

* Which scenario do you think is most likely?

* What will cause art's position in culture to change?

Part II: The Art Moment
How/Where

Getting Good at Viewing Art

We read about art for simple reasons, to enjoy it and get more from it. Most people enjoy activities when they have at least basic proficiency. It's more difficult to find joy amidst the struggle of basic learning. Paddling hopelessly after waves and shanking golf balls can be fun at first, but it won't be fun for long. And if you only try to catch a wave or hit a ball once a year, you'll never break through. While viewing is biologically natural, examining visual art is not, for the traps we've introduced so far—definitions, meaning, materials, beauty and shock, and historical references. Learning and unlearning needs to happen. Viewing art in common artistic venues, such as museums and galleries, isn't effortless. We don't flow.

For the first thirty years of my life, each visit to a museum followed a predictable path. Excitable expectation, delight at buying an entry ticket, awe and intrigue at the first few sections of famous artworks, then a physically palatable and precipitous decrease in energy with each passing ten-minute segment. Being a person who doesn't take many pictures, I couldn't use that distraction either. The boredom usually required a museum café espresso and cookie.

During a gap year after high school, the masters captured my attention, the Klimts and Monets, so did the architectural wonders, the pyramids and the Great Wall of China. But I didn't understand or couldn't tolerate artworks outside the most recognizable tier. Little changed after college, living in Washington, DC, where I enjoyed free entrance, rarely used, to the nation's cultural treasures. The difference was that I accepted the importance of art, at least theoretically. The National Portrait Gallery drew me to its ingenious curation of artwork at the intersection of famous American personalities, noteworthy artists, and national history, despite being wrapped in the seemingly dull topic of portraiture. But dutifully walking the soaring archways was still burdensome

compared to watching a movie.

It wasn't until after five years of marriage, despite getting married in a museum surrounded by statues, when my wife and I finally bought our first artwork, a kaleidoscope-like photograph of a rainy Paris skyline, that I started reading art history. As I read, museum visits and art appreciation became easier. As our art collection grew, we started lending art to friends. We needed to discuss and justify our collecting choices, which drove me further to clarify my preferences.

Art is all around you, hanging in the background during your dinner, by your stairway, above the bar, your sink—subconsciously filling your vision like so many stimuli that tax our attention. By the time we started lending art, I had forgotten my high school art classes, and it seemed like this thing called the art world, the exhibits I saw at museums, had moved on to new topics, while I could only remember the Renaissance and the Impressionists.

To enjoy an activity, we learn it to a point that the experience flows naturally. We might be novices or experts, but we find a rhythm that allows our actions to match the challenge. We ski well enough on the green-leveled sloping hills to move toward the inclined blues and rutted, tenuous black diamonds. There's a formal theory to describe this phenomenon, the one of matching our expertise to a given challenge to find immersive performance, and unsurprisingly, it's named flow. What is surprising though, even to people who know about flow, is that its roots are not in physical competitions, but in artistic practice.

Flow was coined to describe *the psychology behind optimal human performance*. The formal theory is twenty years old, although historical seeds about presence in action extend to Taoist and Vedic philosophy. Flow has contributed to disciplines from psychology to athletics, business, and education, by showing practitioners how to reach optimal performance, how to achieve the ideal mental and physical states to accomplish goals and win

competitions. Supporters of flow are often productivity hackers and adventure sport enthusiasts, such as rock climbers, skiers, and surfers.

The originators of the flow concept, Mihály Csíkszentmihályi and Jeanne Nakamura, identify the following six factors as encompassing the flow experience.[1]

1. Intense and focused concentration on the present moment

2. Merging of action and awareness

3. A loss of reflective self-consciousness

4. A sense of personal control or agency over the situation or activity

5. A distortion of temporal experience, one's subjective experience of time is altered

6. Experience of the activity as intrinsically rewarding, also referred to as autotelic experience [being an end in and of itself]

When these attributes appear in concert, *you can attain a submersive experience where your mind and body function in optimal unity as distractions fall away.*

Competitors who achieve flow arguably find the podium in athletic championships, and realize breakthrough scientific and artistic achievements. If you've ever been blessed with a few minutes of athletic success, you might remember feeling the "touch," or "hot hand." Researchers found that business executives are about *five times* more productive in a flow state than during normal spouts of working. Imagine the high volume of emails you could write while pounding on the keyboard in a flow state instead of fighting through colleagues stopping by your desk, the temptation of Web news just a click away, the magnetic pull of your cell phone, and the distraction of your to-do list. Consulting firm McKinsey found that if we could increase the occurrence of flow in the workplace by 10 percent, we could double global GDP.[2]

During investigation after investigation, it appears people learn and perform better when they experience flow.[3] It sounds a little grandiose and questionable, and you might wonder if art applies here. I think so, and that goes beyond assuming that most activities would benefit from a phenomenon as effective as the one just described. When we combine focus, presence, and intrinsic motivation, our lives improve. Whether you call it flow and denote it as the formal theory presented, or if you remove the academic classification and say it's simply comfort and ability, rather than uncertainty and struggle, we see why the actions of evaluating artwork apply. We've already established that most people aren't comfortable in the art world because they don't understand a combination of the messages and the mediums. We've looked at why art matters and how to define it. We probably already feel more comfortable in art world environments, and that's because we are creating a framework to easily enjoy the experiences.

To do so, we must first overcome *foundational* obstacles to reach a level of proficiency that matches the challenge. Looking at pictures or souvenirs from vacation is easy. We know the location and why they're important. Leonardo's *Mona Lisa* would be easy too. Walking through a museum isn't like skiing or surfing, but we do struggle. We do miss visual jokes and innuendoes from past eras and societies we only superficially comprehend.

It's relevant to know flow's back-story. Csíkszentmihályi first conceived of flow after becoming fascinated with artists, especially painters, who appeared completely immersed in their work, to the point of skipping meals and forgetting personal obligations.[4] It doesn't seem like a coincidence that flow enables creative endeavors of all types. Although the theory has since gained notoriety primarily outside the arts, the genesis story is rooted in artistic practice.

Csíkszentmihályi went on to write a lesser-known work about viewing art, *The Art of Seeing: An Interpretation of the Aesthetic Encounter.* It was a study commissioned by the J. Paul Getty

Museum to investigate the link between flow and the aesthetic experience, and to understand how to increase the likelihood that art viewers would experience flow in a museum. In *The Art of Seeing,* Csíkszentmihályi directly equates the aesthetic experience with flow states based on the similarity of attributes required to experience each. He references research into aesthetics by philosopher of art Monroe Beardsley, who cites five components of the aesthetic experience:

1. Investing attention on an object

2. Feeling a sense of freedom while focusing

3. Detached affect as in not overly immersed

4. Active discovery

5. Wholeness or integration of experience

Comparing the aesthetic experience to flow, Csíkszentmihályi found that both share *at least* intense but free focus, loss of self-consciousness, and an active discovery of the current activity. Even if the criteria don't overlap perfectly, the aesthetic experience and flow are both immersive experiences of dynamically interacting goals and challenges. Csíkszentmihályi first observed flow in painting and then carried it through to viewership, closing the circle and acknowledging that we can find and use flow at any step along the creation to consumption journey, if the right pieces are in place.

The Art of Seeing survey population was composed entirely of museum *professionals* rather than everyday museum *visitors.* This certainly skews the results' applicability to mainstream audiences in many ways.[5] That said, *Art of Seeing* study participants—again, trained museums professionals—cited foundational artistic "knowledge" as *the* most important factor that drove their enjoyment of art. Yes, hundreds of museum professionals said that even they needed more knowledge to fully enjoy art, proving that even lifelong professionals can't fake it or default to simplistic appreciation of pretty forms. Given that the most well-educated

among us still believe they need more information, hopefully they don't pity the rest of us, gazing at us sympathetically as we try to decipher the artwork on their walls. Viewers need information like surfers need boards, golfers need clubs, and climbers need ropes, so we read, and then we look. There's no substitute for action, finding flow through repeated learning.

Flow Is the Capstone

Viewing, reading about, and discussing art are natural human activities. But we don't feel automatically fluent discussing art objects, because they address controversial topics and we don't get enough at bats to establish confidence. We're stumbling through sentence formation in a foreign language.

But art is at the core of our ability to form coherent societies. The Homo sapiens rupture with past evolutionary constraints heavily features language, thumbs, and visual imagination. Art sits at the intersection of those skills—using imagination to show, not tell, stories. Visual art's proximity to our biology makes it easy to acquire foundational comfort with minimal effort. It doesn't require specific genetics or predawn practice sessions in a gym or conservatory. We can easily become engrossed in a flow of art appreciation rather than stuck in the oddities. We can learn to become capable more often, and comfortable in the discomfort of experiencing novel artworks.

The Unique Art Experience: You're on Your Own

We might feel better about our admission that art is strangely difficult by acknowledging its uniqueness from a consumption standpoint. The visual art experience is unlike other participative, cultural pursuits. The duration of our experiences and the levels of focus we dedicate, are entirely unlike music, books, magazines, TV, movies, or video games. No one tells us when the show starts and ends or passes us to the next level after we achieve scoring milestones. To understand art's unique position, I think about art in terms of the **duration/attention/guidance framework.**

Duration

You can consider art briefly, repeatedly, continually, or periodically—no rules apply. And yet, art looks physically equal whether you view it quickly or slowly. In contrast, you can't watch a feature film in two minutes; you must follow the full timeline. You can read a book faster than usual, but not ten times faster or slower. And likewise, if you change a song's speed, well, it becomes a different song. No other artistic format has such a flexible relationship with our temporal dimension.

Attention

When art captures your attention, you might focus *actively* or *passively*. Other creative genres force your behavior in a particular direction. It's difficult to passively watch a movie, and it's impossible to passively read a book, although no one seems ashamed of bursting into a room and interrupting your reading time. Music can linger in the background, you can choose to dance or sit, but the song always starts and stops on the same note.

Guidance

No five-star rating systems exist to provide similar guidance that we receive for movies, books, or restaurants, although perhaps they should. Before spending time and resources, we often seek guideposts, from lowbrow rags to highbrow criticism, to make a

choice or temper our outlook, and we might contribute to those rating services ourselves. If you're a fan who ravishes in sci-fi or fantasy novels, you have the conviction and multiple platforms to contribute ratings. Few of us have the gumption to attack art with equal confidence.

Viewing

Most cultural art forms, and art's attention competitors, are linear, while art is not. You can start on the thick mustache in the center of an eighteenth-century portrait or the regal bust and armor. You can engage the foreground then background and figures on a picnic blanket, or follow the reverse order. We fall into consistent natural patterns, but no rules apply. Our freedom makes art harder, but through understanding the challenge we begin to take control.

Art Is All Over the Map

Duration (of Experience)

- **Music:** Music has a short duration. Most songs only last a few minutes and repeat an exact tempo each time. We can focus actively, which often coincides with the full-body immersion of dancing, but we can also choose to let music linger passively. No one tells us *how* to listen, but scoring systems proliferate, and we can't seem to avoid the prevailing pop songs.

- **Movies and TV:** Video stories are short-to-medium experiences that follow a linear path and require our active focus to follow the plot and storyline. Ratings systems abound to provide guidance before and after viewing movies and TV, and precise commentary exists on specific scenes and plot themes.

- **Books and Magazines:** Books require long duration and active participation. Magazines, novels, and nonfiction books are longer form *and* more active media than music and cinema. You can bite it off in chunks, but rare is the book you can read in the time it takes to watch a movie. You construct the visual world mentally through active participation. Guidance is robust. Few people read books today without first considering peer and critical reviews.

- **Video Games:** Video games get an honorable mention as attention competitors to visual art and as cultural events. If you wonder about their inclusion here, more money is spent on video games annually than movie tickets, and children spend more time immersed in their levels and storylines. Video games are medium-to-long duration activities with active focus. Guidance exists about the quality of games, as do tips and ideas for exactly how to play them.

- **Art:** No rules apply. We choose what to see, how to view it, how we focus, and the amount of time we dedicate. You can passively view an image by allowing your prior knowledge and subconscious to immediately form judgments. OR, visual art can provide a longer, iterative, active experience. You can view the same artwork repeatedly by quickly walking past it, or pausing to analyze texture, context, meaning, and history, or by letting it hang quietly in the background. There is no linear path. It's shorter *and* longer than other art forms.

The visual art experience is short and passive *and* long and active, and any combination thereof. It has no clean beginning or end in time or visual location. A song starts on the same note, while a movie opens with the same scene. Twenty people standing in front of an artwork will begin at individual starting lines. Where should we start and what should be our path through an artwork? How should we evaluate it?

Art is a quick observance and/or a thorough examination. We lack standards and we don't read left to right. We have no opening action or closing credits. As a side note, researchers have seen that many art viewers follow a process of making smaller circles around an artwork—examining key features in tighter and more rapid succession, until resting on dominant features and finally leaving the canvas. But no path is guaranteed.

The duration/attention/guidance framework isn't meant to diminish the power of music or written and cinematic stories. It doesn't attempt to undermine the adrenaline or tension of video games. These art forms represent a pinnacle of human creation and experience. The framework *is* meant to classify the time-bound and linear nature of those media, and to emphasize that visual art is unique from a consumption perspective in that it unveils itself on command, any time—day, night, with friends, or alone—perpetually, if you engage it, but that it offers little guidance before or during the event.

- Where do you start when viewing an artwork?

- What's your "path" through a visual?

- What have been some of your positive and negative experiences viewing art?

Art's uniqueness doesn't place it hierarchically above other creative formats. If anything, it places art at a disadvantage while clarifying why it might seem dull or why we're not sure what we'll get when we step into a museum. The framework compels us to

reflect on how we consume artworks.

Art allows freedom of exploration. You can allow your attention to wander or focus. The visual format creates unity in a variety of access points, but you choose. We read about and study art so we can forge our own paths. We know that finding flow or competence in art requires us to be comfortable with the ambiguity that art presents.

Lacking guidance brings distinct positives. We're uniquely unbiased when viewing artwork. Art critics are notoriously inaccurate about predicting hits in visual art. They still provide useful guidance but mostly in obscure journals or the Sunday newspaper, and we won't likely read those before attending an art event. Even if we do, individual art objects are rarely critiqued before or at the place you view them, so you are left to make independent evaluations. That said, it's important to note that critical commentary is *implied* by what's selected for display in noteworthy institutions.

When art is placed, quite literally, on a pedestal at the Tate Modern in London, it achieves an invisible "fresh status." The network of renowned institutions, curators, and critics provide approval and cover for artwork housed within their walls. Once you arrive, the "informational" placards, known as wall labels, suffer from serving up monotonous factoids over biting questions, but they are helpful. Outside museum walls, in your home, at a friend's house, in a gallery, or at a restaurant, you create individual opinions. No one cares what you think, but you don't need to care about anyone else either. It's blissfully selfish.

So, there you are: you find yourself standing in front of a swirl of paints and shapes. You're happy to be here but not sure who or what told you to come. You're with friends and expected to conjure witty or insightful descriptions, to say something smart or almost pretentious, like finding hints of cinnamon or cat pee flavors during a Napa Valley wine tasting or spinning wild inside theories about how a TV series will unfold.

But whether in wine or art, a blithe improvisational description, while funny, is unfulfilling—to the speaker probably more than the audience. You know you aren't certain about the wine description or art interpretation. With wine, it might not matter, you're likely bound for intoxication anyway, but if you don't have better frameworks and a foundation for art, you'll take what you see and numbly move on. The first step is to recognize the uniqueness of what you're viewing, to liberate yourself from any kind of expectations, to understand that art will baffle you and everyone else in ways that other media won't, and to steadily follow a consistent method.

Investigate How We Perceive Art

We talk about being with art as both *viewing* and *experience*. Viewing implies a singular direction—from artwork to person. While it's true we can't have an *experience* without art, *viewing* seems to belittle our personal contribution. For that reason, we'll emphasize experience.

Art experience is disorderly and still imperfectly understood. It can be visceral or nonchalant, depending on factors far outside our conscious control. Much is predestined before stepping in front of an artwork. We are nudged toward known tracks by biological and neurological wiring, personal and cultural history.

The smallest share of art experience is within our conscious control—questions, discussion, physical location, and process. We almost need to fight ourselves to actively question why we think and feel certain ways, to overcome boredom, confusion and distraction, to raise the odds of enjoying artwork.

How we experience art is a nascent and growing field, especially the neuroscience—or neuroaesthetics, a discipline dedicated to scientifically decoding our visual experiences. During the coming years, we'll likely look back to realize how far we've come. The crude tools we use today are like the nineteenth-century medical operating theater. But still the patient needs treatment.

The Art Experience Equation

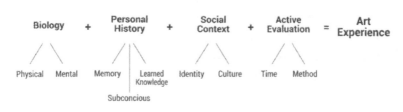

1. **Biology** (Physical + Mental Response)
2. **Personal History** (Memory + Learned Knowledge + Subconscious Knowledge)
3. **Social Context** (Culture)
4. **Active Evaluation** (Time + Analysis Method)

The **art experience equation** describes factors at play during an artistic experience. "At play" is the key phrase. Certain forces act linearly, while others iterate on our understanding as we linger with an artwork. It's not orderly.

Biology

Your physical body reacts to artwork through an attraction or repulsion mechanism. Attraction or repulsion is a more accurate term than the familiar fight or flight, which both imply negative reactions to external stimuli. You might not want to fight or run but instead to *approach*, out of curiosity or sexual appetite, or *retreat* due to disgust, confusion, sadness, or fatigue. To a large extent, this mechanism is out of your control—certain visual features in an artwork carry appeal despite your cultural context. Our brains are wired to diagnose prominent visuals in a consistent manner, which researchers have validated repeatedly via brain wave scanning. The postmodernists were wrong, dashes of truth do exist. While this is an emerging field, scientists are rapidly gaining deeper understanding of the mechanisms behind our physical and mental reactions to images.

Personal History

Experiences of joy or pain from childhood, stories from your parents or favorite teachers, memories from travels abroad, love and relationships, are all personal histories unique to your past. Sometimes we remember these moments—the schoolyard fight, our grandmother's funeral—sometimes we do not, and the memories remain lodged in our subconscious unless activated. You carry this unique imprint of memory to each artwork. While you create new memories constantly, they are unchangeable at the

moment you encounter an artwork, meaning, to change this vector you'd need to override your historical grab bag of memories.

Social Context

Beliefs are built within the pressure cooker of culture. We might have lived in multiple societies and studied many more that we don't experience directly, but we have deeper and easier access to the rituals and symbols of our familiar cultures. The color red and a Euro banknote will trigger wildly different reactions, depending on the environment where they appear. Red might prompt thoughts of Christmas, the Chinese flag, bullfighting, romance, or blood, while a Euro note could be your cash for commuting on the train, a tourist experience, or a currency you wish your country would abandon. Depending on where and when you are, bullfighting and money for the train will be more likely. We can hardly change our social context, even if we can learn alternate viewpoints.

Active Evaluation

At last, a feature we directly control! You are free to define your viewing method. You can follow any path you'd like across an art object, starting with the historic, political, stylistic, or technical ideas. You could ask yourself identical questions, in the same order, in front of each major work. Alternatively, you could simply walk around, like most people, read the descriptive plaque, and hope for the best. While biology, personal history, and social context don't change during an art experience, you can compensate for a rigid history with active evaluation.

In the next section, we'll go deeper into each of the four forces that shape the art experience. While the forces don't follow a clean, straight line, biological responses do begin before active evaluation, and subconscious or personal history subtly tug on our sense of meaning. Eventually though, active evaluation can rebuild, complement, or contradict our biological responses. Let's examine each part of the equation.

1. Biology

Art acts on forces at the deepest roots of our biology, and, in turn, biology cannot help but play a role in our artistic experiences. We are aesthetic creatures. Faces, bodies, hands, and landscapes are basic human images, repeated throughout our evolution, history, in our daily life, and in art. Our biology nudges us toward certain reactions to bodily shapes and proportions, to the human glance, touch, or a sublime natural scene. We deeply comprehend basic human emotions in facial expressions, across cultures, races, and societal boundaries: *anger, fear, surprise, sadness, joy, contempt, and disgust*—these are universal emotions. They're accessible through black-and-white sketches and plastic sculpture with nearly the immediacy of a live companion. That this occurs shouldn't be surprising, although the extent of the similarity to real life might be.

When art acts on biological systems, our brains and bodies diagnose and process it similarly to experiencing the flesh-and-blood version. We see a beautiful figure in artwork and respond to the mimetic object as our biology suggests we should, perhaps with lust or empathy. When we are repulsed by grotesque bodies or advised to take shelter from foreboding storms on the high seas, our heart rate might increase and begin to pump cortisol. Stress ensues. Because art tends to express basic and universal human concepts, basic and universal biological reactions come into play.

Today, we are beginning to effectively measure biological attraction or repulsion to visual stimuli. The emerging field of neuroaesthetics applies neuroscience to the appreciation of art and art objects. Using functional magnetic resonance imaging (fMRI), researchers can clearly detect which parts of the brain are active when we process shapes and colors, and when we judge if an imagine is beautiful (the left dorsolateral prefrontal cortex). The beauty decision happens almost instantly, but it isn't final—viewers *can* reappraise their assessment over time.

Researchers have also investigated visual complexity to determine if more or less complex images are enjoyed. Broad, sloping

strokes are labeled lower spectrum complexity and faster, tighter, and more jagged images are labeled high spectrum complexity. Not surprisingly, images across the spectrum might be attractive under different circumstances, but also, a Goldilocks zone exists around balanced complexity.

The majority of paintings from the Western art canon employ similar visual spectra as natural landscapes at middle distance. In fact, when artists paint portraits and draw faces, the images they create do not follow the visual complexity of a photograph—of real life. Instead, they look like landscapes. According to researchers, *"Artists do not merely imitate the statistics of the real world, but could have a preference for the usage of specific image statistics in their work."*[1] Artists can't seem to help themselves but frequently employ patterns that conjure natural scenes.

What's more, fundamental human images highlight discrete pathways in the brain. Landscapes, faces, hands, and bodies, which we mention repeatedly throughout the book for a reason, each employ unique pathways for interpreting visual phenomena. These objects are so core to human visual experience that we have evolved to uniquely manage them. Not surprisingly, "art" as a whole does *not* follow a single consistent pathway. Rather, it's a holistic experience that accesses numerous areas of the brain, depending on the artistic medium and content.

While this would seem obvious, some researchers have used it as an argument that no "art instinct" exists, at least neuro-aesthetically, because if one did, we'd be able to see it in an fMRI. We can't even agree on what art *is*. Art is far too diverse to expect a single mental response in one particular part of the brain. We do not process art linearly but through a network of multiple, parallel processes and neurotransmitters (for example, dopamine, endorphins, oxytocin). Researchers who use fMRIs as justification for our minds *not* having artistic pathways must have a precise definition of art they aren't sharing with us.

Researchers have also learned that thoughts and emotions are *not* at odds, processing visuals or otherwise. We see them both

working together in the mind. For centuries, scientists and philosophers proposed duality between thought and feeling, but we can rarely make decisions or take action without both. This is especially true of complex moral decisions when multiple options are justifiable. Should we take a loved one off mechanized health support, or should we advise a friend to leave an unhappy marriage?

Why is this important for art? If thoughts and emotions work collectively when processing visuals, then we cannot regularly make correct assessments if we actively try to halt emotional responses. It undermines the idea of a "dispassionate gaze," as initially proposed by Scottish philosopher David Hume, then German philosopher Immanuel Kant, and unquestioned by most aesthetic philosophers and art critics. Their favor for strict mental assessment at the expense of emotional involvement will drive a stake through the heart of your art experience.

Collectively, systems responsible for social interaction, storytelling, and group interactions are overlapping, if not the same. Our minds recreate emotional situations we observe in artwork, as we would when we experience similar events firsthand. Internal and external states work concurrently and at cross-purposes. For example, you might view the same wing of an art museum on two occasions while in different emotional states. This is not even so extreme as walking in with a hangover or after doing wind sprints, it's subtler, and relates to your disposition or grogginess. You might feel impatient during one visit and want to linger during another. This would be especially true when viewing complex artwork that displays multiple emotions. Complex artwork acts on numerous emotions simultaneously! We bring ourselves to the artwork, but it also brings itself to us.

While complex artwork generates multiple, independent, biological reactions, researchers are uncovering additional consistencies. It turns out that people across ethnicities and cultures find similar traits beautiful. This is true for landscape features and scenes, bodily shapes and composition, facial

structures and visible emotions. Using faces as the first example, *"The consistency of ratings of facial attractiveness across ethnicities and cultures suggests that there are common elements in faces to which adults are responding that are not just a cultural creation."*[2] We inherently understand the human condition and empathize with our companions. Indeed, when people do *not* empathize and are unable to detect or respond socially to emotional outputs, we label "these people" with a broad range of disorders, from Asperger's to narcissism.

Researchers have measured facial profiles, angles and distances between ears, eyes, chins, and more. Generalizable perceptions exist for "averageness" and symmetry, which are both viewed positively, if subconsciously. Francis Galton, English naturalist Charles Darwin's cousin, made the accidental discovery that average faces were considered most attractive to the general population. Not "plain" faces, but *common* ones. In a scientific twist of serendipity, Galton was trying to determine facial features that appeared frequently among a population of criminals by overlaying them upon each other, so as to use the predictive power of facial features to identify likely bad actors. His abomination of a hypothesis hinted at eugenic studies that proposed racial purity and advantages.

In following his prejudicial trail, Galton uncovered that "average" faces were considered more attractive than unique ones. Superimposing face upon face upon face creates an outline of a common and generally accepted facial structure that is more attractive to a particular source culture. Furthermore, when researchers averaged the attractive faces, these generated an overall *even more* attractive face! For men, attractive faces include broad chins, while for woman small chins with higher foreheads are naturally attractive in many cultures.

As for bodies, societies from the ancient Egyptians to Greeks and Renaissance Italians espoused ideal proportions for bodies, while medieval artists pretended we barely had them. Ideal figures were expressed through painting and sculpture, although their

"proportion" wasn't mathematically proven as a theorem. We don't have as much data about bodies as faces but a few details are salient: symmetry is still critical. Across a wide swath of living creatures, symmetrical bodies are prized. This is true for humans and in animals from reindeer to birds. It's easy to guess that maladies wreak havoc on symmetry, both at the cellular level and as fully formed bodies.

We understand more about generalizable beauty in female bodies than male. Females have been portrayed more frequently, as they have been objectified more institutionally. As we will see in the When section, art objects, especially sculptures, up to and through the Renaissance, emphasized the male figure more prominently than the female. About 1,500 CE is a useful dividing line: the majority of art objects before 1,500 showcase uncovered male bodies, while afterwards they portray women, and they do so with a distinctly lustful gaze.

We should not ignore that many elements of physical beauty are cultural, such as skin tones, chest/breast size, hair, lips, musculature, and more. Features are coveted with unique zeal by region and era. That said, bodily ratios have appeared, and proven attractive, across eras and geographies. First, there is the golden ratio, which is roughly 1.618 / 1. Imagine a statue: The total height is 1.6 meters, from feet to head. The length of the feet to the navel should be 1 meter and the length from head to navel should be 0.6 meters. *Apollo of the Belvedere* (120–140 CE), a marble statue, follows this golden ratio. So does the Acropolis citadel of Athens (480 BCE) for the facade's width and height. So too do the De Stijl abstract artworks by Piet Mondrian of the 1920s.

The golden ratio appears time and again to conjure the elusive "proportion" that has been so idolized. Rarely have artists vocally admitted it, but pleasing architecture and artwork silently leans on this graceful proportion. It might also allow humans to more effectively process visual information.[3] The distance between primary features are just naturally aligned and dispersed enough to facilitate easy visual consumption.

Another mysterious and recurring measurement is the waist-to-hip ratio. It can indicate attractiveness of male and female bodies and is accurate for thinner and fuller figures, making it highly utilitarian. Based on multiple population studies, female bodies are considered highly attractive when the waist-to-hip ratio ranges from 0.67 to 0.80.[4] Women who scored as *most* attractive across studies measured about 0.7. Women with this ratio include actress Marilyn Monroe, multiple Miss America pageant winners, actress Jessica Alba, and singer Beyoncé. As you can tell, the ratio doesn't make value judgments about body size or weight, only how women carry that weight proportionally.

Attractiveness scores were strikingly similar across male respondents: young and old male populations across geographic locations from North America to the Pacific Islands find a similar ratio appealing. On the other hand, when women evaluate male attractiveness, a ratio of 0.9 waist to hips is considered attractive. Tellingly, the studies don't cite specific men with this ratio, but actor Brad Pitt and athlete Cristiano Ronaldo probably fit the bill.

These studies seem to clarify what we already intuit: many males like females with curves, while most females don't like their men the same way. Love might prevail, but it won't be love at first sight in the storybook sense. We'll always find detractors with studies such as these—you might even be doubtful while reading right now. While criticisms do exist, both ethically and methodologically, most critiques question the studies' approaches or noise in the data. Alternate studies are not producing contrary results or theories. The best that alternate studies do is say we should ignore this data as "the trees" and see "the forest," which they claim is a world where these few rules fail at attempting to bring any order to bodily beauty.

A biological pull acts on our experience of geographical surroundings. For about two million years, humans and our predecessors grew and evolved on the savannas and grasslands of Africa. We still show a deep-seated preference for savanna landscapes. We appreciate open spaces, where humans can expect

to locate food and can also identify predators from afar. We're content with a few trees, to climb them for safety and relax beneath in the shade. We don't necessarily need a thick forest.

Our biological attraction to areas of ancestral comfort is called the savanna hypothesis. The preference has been validated in somewhat astonishing ways. For example, visual tests of young children under ten—those from vastly different global locations and backgrounds and who *have never even been* to the savanna—indicate they prefer savanna to other geographic settings! As participants age, they become accustomed to their own environments. Eventually respondents tend to score their home geography more favorably than other terrains. But when we are young, with less conditioning and personal history, the savanna wins. Its pull on our biology is unsurpassed.

Attractiveness accrues a host of advantages that seem unfair or borderline hypnotic: strangers return lost wallets more frequently when the wallet's owner appears attractive in a photo ID. We believe attractive people are more intelligent. We think they make better leaders. We want to linger in idyllic savanna settings or around plush interiors. We are often unconscious about our biases, but we also consciously shuffle toward the cute guy or girl at the bar, and we book vacations after viewing a portfolio of property photos. We know what we're doing as often as we're surprised. Art accesses these biological responses to our genetic and evolutionary programming. Artists portray objects with the golden ratio or ideal waist-to-hip ratios in a drive to enchant us with their work.

Faces, bodies, and landscapes are topics where researchers have the most robust data and historical perspectives. The pattern is best described as approach versus avoidance. I used the phrase previously and prefer it as a more accurate alternative to fight or flight. Reactions extend along a scale from approach, due to attraction, intrigue, safety, comfort, and more, or avoidance, likewise due to a mix of possibilities that include disgust, fear, confusion, and uncertainty.

When you see a beautiful object, an attractive face, landscape, or body—or even an attractive, abstract composition of circles in cobalt blue—you probably approach. When you see a vicious face, grotesque figure, or foreboding landscape, you probably avoid it. You might remain stoic momentarily to assess why the artwork provokes a response you can't seem to shake, and attempt to diagnose the artist's intention, but you will still likely be relieved to eventually avoid the artwork. In both cases, the same location in the brain, the amygdala, regulates fear and happiness, two sides of the same grey brain region.

Going beyond our initial reaction to an artwork, we are drawn into the frame and begin to empathize with the objects directly, rather than following unseen attraction or avoidance. In the flash of a moment, we build a narrative about the images in an artwork: the lady in the theater or the man scribbling with an angel on his shoulder. We generate their internal monologue and project a story. When we cannot directly discern another person's mental or emotional state, we guess.

This is called the theory of mind, which describes our biologically programmed desire to uncover the mental and emotional motivations behind a scene we observe. It's an active empathy that diagnoses faces, bodies, postures, and social contexts to infer the next person's intentions. Different areas of the brain respond to movements in the eyes, mouth, and body in unique ways and then inform us how to react. And still we go further. We enact unconscious mimicry: upon seeing smiles, fear, anger, piety, rejection, or loneliness, we subtly recreate them, down to the posture of a figure, through microexpressions and actions. A person, movie, or artwork can literally inject us with a microdose of the emotion they convey.

Although researchers are still refining our understanding of this process, on an intuitive level, we've always known it. The church understood our inclination to mime images, and its monopoly on artistic production ensured generations of devotional mimicry. Most artists don't scour scientific journals during down time in

their studios, but for centuries they have instinctively created images that prompt empathetic biological reactions. Artists, like viewers, don't need to understand the biological mechanisms to instinctively follow them.

Art has always generated the three-part response of (1) approach versus avoidance, (2) theory of mind, and (3) mimicry.

But the modern era propelled art into a new phase of self-reflection and experimentation. Artists began to consistently engage audiences in unexpected ways. Far beyond godly devotion or civic pride, artists reached into a seemingly endless bucket of rarely discussed emotions. In reaction, viewers were confronted with Dada movement artists who sarcastically undermined social structures, with Impressionists showing playful leisure or wispy melancholy, Expressionists unearthing their deeper anxieties, and pop artists throwing commerce back in our faces. Art became a device for surprise, discovery, introspection, and discussion. It became a tuning fork for personal and social commentary, because it learned to stimulate our biological tendencies.

What and Where

Before deciding to approach or avoid, visual detection must do its work. Humans have two separate visual pathways that operate independently: a **what** pathway and a **where** pathway. *What* tells us the thing we are seeing. *Where* tells us how it's moving. To go further, the what pathway describes people, objects, locations, and colors. This detection occurs in the center of the retina. In contrast, the where pathway acts from the periphery of our retina. It is *colorblind* but notices contrast and movement. It provides a faster response than the what pathway. It seems to shut down unnecessary systems, like color sense, to emphasize speed. A lion or hostile tribe probably jumped at us from the side rather than approaching directly like the British Army during the American Revolutionary War. This pathway combats unannounced arrivals.

In both the what and where pathways, our retina does not respond to *absolute* light levels as much as it does to *relative* light levels.

Our attention follows the contrast between lighter and darker objects and changing patterns or arrangements. French painter Paul Cézanne was right when he said, "The mammalian eye is not a camera" in that it doesn't document an image or color like a photo does. Instead, the eye completes shapes and fills in lines when they aren't present. We see holistic groups, and we complete pictures where they are incomplete. Gestalt psychology identified and predicted this phenomenon before it was scientifically validated. The Gestalts proposed that humans see and perceive groups cohesively rather than individual items. In this discovery, Impressionism and Cubism are supported.

It all makes sense: the periphery of the eye catches rapid movements at the edges of our visual field. As those images reach the front and center of our focus, the central eye thoroughly diagnoses what's ahead. Our eyes and brain coordinate to complete our visual field before we have, or despite lacking, all the relevant information. Likewise, the what and where pathways merge when we focus attention. We cannot view an entire art object at once, so when viewing the object, we are testing visual hypotheses, moving quickly across an image to refine our understanding. We are constantly testing and discovering, guessing what we'll see. We validate or invalidate those expectations. Humans are visual investigation systems.

Perhaps this is why surprise and shock art compel our focus, and why we appreciate novel and unknown experiences. Our visual and mental systems are necessarily more engaged when diagnosing novelty. It is the stuff of dopamine, the most famous chemical produced in our brain. Dopamine is related to love, motivation, attention, and addiction. It's the chemical that causes us to seek rewards, and its main target is novelty. Dr. Emrah Düzel, a dopamine researcher, put it this way:

"When we see something new, we see it has a potential for rewarding us in some way. This potential that lies in new things motivates us to explore our environment for rewards. The brain learns that the stimulus, once familiar, has no

*reward associated with it and so it loses its potential. For this reason, **only completely new objects activate the midbrain area and increase our levels of dopamine.***" [Bold emphasis not in original quote.][5]

This is why we are attracted to shock art, even if we look away quickly. The same might be said of horror movies or tragic dramas. The biological rush of dopamine, and its decline in the face of familiarity, might also explain why art fans become more adventurous throughout the years. As Dr. Düzel said in the previous quote, known objects lose their potential to release dopamine, and therefore feelings of pleasure or motivation. "Normal" images become mundane.

This phenomenon of building immunity to novelty seems to repeat across domains. Your favorite meal becomes unexciting, a song that caused you to pump your arms vigorously but secretly at home tempers its notes, the mountains and trees from your window lose their gleam to views farther afield, and an addict becomes annoyed at a small hit of cocaine. Users seek more. It's probably not too different with art. We tire of genres and topics. We tire of methods—eventually. A tension arises because critics and curators seem to showcase artwork that is novel for them, but that's outside the average viewer's comfort zone.

An artwork's visual layout also influences our biological reactions. Viewers approach an artwork first with global scanning through longer, wider visual sweeps before transitioning into making tighter circles and spaces. We move from global to local scanning. Researchers have validated this pattern through eye-tracking experiments that monitor visual patterns.[6] As you'd suspect, viewers are more likely to follow distinct visuals paths depending on an artwork's layout: *more visually complex* artworks cause viewers to spend *less* time focusing on a *greater* number of visual features while l*ess complex visual styles* cause viewers to spend *more time on fewer features*. A dense artwork causes faster movements than a visually loose artwork, which guides viewers to linger on fewer items. Taut and constricted lines

might feel chaotic, like Jackson Pollock does, while wide, spacious blocks will feel relaxing, like Mark Rothko.

Finally, it's worth mentioning that biological reactions are broadly governed by two sets of interactions: top down systems and bottom up systems. Top down systems analysis includes most of what's included with the art evaluation equation: human images or faces, bodies, hands; personal experience; social understanding; and active evaluation. The new aspect, bottom up systems, on the other hand, modulate (emphasize or deemphasize) our experience through neurotransmitters in the brain. Bottom up responses contribute emphasis to top down systems.

Adding bottom up systems brings us closer to the way neuroscientists describe mental-emotional responses to art:

- **The Top Down Emotional Response** occurs from sensory input that is *mediated* (translated) through our eyes, brain, and body. We respond to known images and use personal knowledge to empathize with the subject we're viewing. We also reappraise what we are seeing iteratively and consciously change our mind through will or memory. For example, we might change a first response of sadness to one of acceptance. Top down responses are where we have spent the bulk of our time in this section.

- **The Bottom Up Emotional Response** occurs through *modulating* systems, which emphasize or mollify our initial reactions. Neurotransmitters, such as dopamine, endorphins, and oxytocin, play the major role here. These neurotransmitters control the brain's reward and pleasure centers, relieve pain, or increase trust. Remember surprise and novelty? We respond to a new or shocking image of nudity and blood through top down analysis and reappraisal, but the brain also generates dopamine that magnifies our reactions. You can imagine why it might be harder to reappraise a novel artwork when fighting against modulating systems that are reacting to an unknown object.

Top down perception is more individual while bottom up is more universal. For this reason, despite our emphasis on top down systems before, the bottom up neurotransmitter systems are relatively more well-studied and validated than top down systems, possibly because they're easier to measure. To understand the bottom up systems more comprehensively, here's a description by neuroscientist Eric Kandel:

> *"The key bottom-up modulating systems are the familiar dopaminergic system, which is involved in the anticipation or prediction of learning-related reward or in the registration of surprising, salient events; the endorphin system, which gives rise to pleasure and blocks pain; the oxytocin-vasopressin system, which is involved in bonding, social interaction, and trust; the noradrenergic system, which is recruited for attention and novelty seeking, as well as certain types of fear; the serotonergic system, which is involved in a variety of emotional states, including safety, happiness and sadness; and the cholinergic system, which is involved in attention and memory storage."* [7]

Anticipation, learning, pleasure and pain, bonding, fear, and attention—these bottom up systems act on the most important human emotions. The systems involved produce reactions, which are conspicuously close to the seven universal emotions that humans can recognize across cultures: anger, fear, surprise, sadness, joy, contempt, and disgust. To the extent that artists can call on our bottom up systems, they can pull levers that magnify our biological reactions.

Even so, despite vast new research identifying what, where, and how visual reactions occur, through fMRI brain wave tracking studies and details about neurotransmitters, as of this is writing in 2017, current research shows *where* in our brain visual stimulus is processed, but cannot tell us *why* it happens the way it does. Researchers quickly fall back to "it must be evolution," or "to drive procreation," but we lack nuance and certainty. Neuroaesthetics cannot connect us with the ideas, motivations, history, and stories—visual stories—that underlie our connection

with most art objects.

The field is challenged by the difficulty of measuring an experiment objectively, while its participants are tested subjectively. I can't ask for your thoughts or feelings about a Greek statue or Japanese graffiti installation without you knowing I'm asking.

It's also difficult to decompose the aesthetic experience to isolate drivers: what part of the visual is most critical to the story—the face of a hero or the flag he carries, how does your posture or the museum's track lighting influence your feelings or memory, does knowing more about the art itself, or the artist, change your opinion?

The questions are an endless quagmire. I wouldn't bet against the march of scientific progress, yet if researchers can solve the puzzles of why we have visual experiences and what they mean to us as sentient beings, then we are truly approaching **art**ificial intelligence.

2. Personal History

> "[Images in art], *like all images, represent not so much reality as the viewer's perceptions, imaginations, expectations, and knowledge of other images—images recalled from memory.*"[8]

—Eric Kandel

Our personal backgrounds deeply influence our visual art experiences. It's almost so obvious that it's painful writing and reading the words. But the extent to which this matters is worth extra thought. The accumulation of our personal experiences through dinner with friends, holding hands with our first love, cramming for exams, family road trips, struggles and victories at work—all inform our artistic interpretation.

Images that artists present are ripe with personal associations and history that accumulated long before we venture into a museum or gallery. The concoction of memories is entirely disconnected from

anything the artist intended and might operate in concert or opposed to their goals.

Here we again call on Mihály Csíkszentmihályi and *The Art of Seeing.* Why did participants rate knowledge as the most important factor that would improve their viewing experiences? If art were simply about appreciating visual beauty, a la neuroscience, then viewers shouldn't need much personal knowledge at all, but if art is intellectual also, and if your ability to decode meaning is required for enjoyment, then viewing art without knowledge is just reacting to splashes of color.

Foundational knowledge is necessary, we're not sure how much, but it raises the odds of achieving a flow state to enjoy your surroundings without friction. *The Art of Seeing* references a moderately sophisticated level of knowledge approaching professional aptitude. While that might be ideal for curating or educating art audiences, most of us won't have the luxury of accumulating such reservoirs of artistic background. I simply want to escape boredom and secret feelings of stupidity when confronted by provocative artworks.

Art presents decoding challenges that often leave us feeling like we missed a joke. "Getting the joke," as in interpreting the objects, requires historic and cultural references that are easier if we have studied them beforehand. Once you walk into an art museum or gallery the time for building personal experience is past.

That's why we rely on written placards, exhibit catalogs, multimedia, and maybe the occasional tour guide. Museum staff who understand that knowledge is required for a positive experience would do well to provide guidance for free, but if they don't, I still recommend taking the time and expense to supplement your visit with official facts and stories. Good research indicates you'll have a better visit if you do.

Between the artwork, artist, viewer, and environment, in terms of meaning, it's the *viewer* who matters most. You. Interpretation is an untidy affair, and our personal background and knowledge

form the opinions we adopt. Recent waves of contemporary art theorists will go so far as to claim that artist intentions don't matter. At all. Artists deliver viewers an image, while viewers bring their personal history to the art. A story emerges during the dialectic between artist and viewer, but you can only bring what you already have.

Most personal reactions, including those to art, aren't conscious, and rarely surface during our conscious evaluation. As early as 1930, art historians Ernst Gombrich and Ernst Kris linked psychology and the subconscious to art and perception. Neurologist Sigmund Freud and psychoanalyst Carl Jung weren't far behind. Unconscious thought is the *rule,* not the exception— an association of vague ideas and memories linger in the murky subconscious and drive our thoughts, seeking pleasure and avoiding pain. We react through habit, almost predetermined, following ingrained motor-sensory patterns and a trail of partial memories.

Austrian painter Gustav Klimt was the most famous of Freud's artistic contemporaries—Germany and Austria at the turn of the twentieth Century. Klimt linked sexuality and death through works such as *Judith,* dripping with gold, showing her exposed breast, and holding an off-centered, severed head. Judith is seductive and strong, a righteous murderer, decapitating her enemy, Holofernes, after seducing her way into accessing his bedchamber.

The Expressionists drew on emerging psychological frameworks to imbue their works with emotional richness. They were the artists who pioneered emphases on hands and faces, emphasizing deformed shapes, odd color hues, shaky lines, and partial shading to express disturbed mental states—anguish, desire, rage, and complex, often painful emotions.

Incidentally, it was also around this time, the late-nineteenth century, when French author Édouard Dujardin was the first author to extensively use interior monologue in his 1887 book *Les Lauriers Sont Coupés (We'll Go to the Woods No More).* From

that, Irish novelist James Joyce could build *Ulysses*, gifting the world stream of consciousness writing and bringing us inside the mind of art.

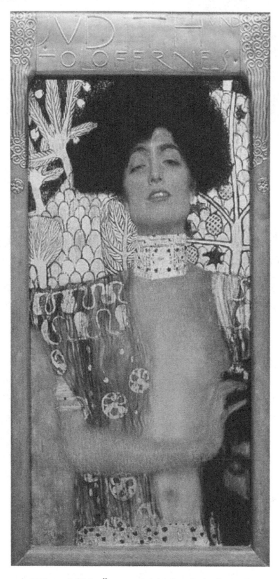

Judith, Gustav Klimt, 1901. Österreichische Galerie Belvedere, Vienna, Austria. Public domain.

Subconscious Desires and Fears Come Alive

The Gestalt also cite nineteenth-century Germany as their heritage culture. Their name means *configuration, or form*. Gestalt thinkers showed that our experience of something—an image in particular—depends on how the parts relate together, *and* how those parts relate to our prior experience. The visual and artistic whole is more important than parts, because the inborn human trait is to grasp concepts holistically.

We do so automatically and subconsciously, almost like following neuromotor patterns that sustain us. We perceive seagulls in a flock rather than as individual birds. We see negative space and fill it in. Gestalt psychologists noted that viewers see *what* an image is separately from *where* it occurs, and thereby unified an aspect of psychology and neuroscience by proposing the what and where pathways that we discussed previously, but which researchers had not yet verified when the Gestalt proposed them.

Surrealist painters also summoned the subconscious—Spanish artist Salvador Dalí chiefly among them. They sought to force confrontation with the dreams and subconscious states that drive our lives. Surrealists meant to challenge notions of conscious art interpretation and the dispassionate gaze by painting scenes that couldn't be logically diagnosed. By creating disorder, they fostered an environment that required viewers to embrace emotional interpretation over intellectual evaluation. Jung said,

> *"We* [must] *let a work of art act upon us as it acted upon the artist. To grasp its meaning, we must allow it to shape us as it shaped him. Then we also understand the nature of the primordial experience. He has plunged into the healing and redeeming depths of the collective psyche, where man is not lost in the isolation of consciousness and its errors and sufferings, but where all men are caught in a common rhythm which allows the individual to communicate his feelings and strivings to mankind as a whole."*[9]

Acts of creation and interpretation are both controlled by personal knowledge, but most of the knowledge related to those acts is subconscious. The motor-sensory capability to handle a paintbrush or to sketch cheeks and lips, the training required to decipher thirteenth- or fourteenth-century Christian murals, these are learned skills. Critical to not overwhelming our conscious thoughts, once learned, they are capabilities that settle far below the surface of conscious awareness. Artists investigate, interpret, critique, embrace, and rage against their personal histories. Many try to consciously uncover their subconscious. They aren't always successful. Fields of artistic analysis have risen around the psychological interpretation of an artist's intentions. At least many try. Audiences tend to ignore our subconscious. We require the catalyst of provocation, and when we are eventually confronted by artwork, whether the artists were aware of their intentions or not, our subconscious fills the canvas with meaning.

The Rorschach inkblot tests, not without some controversy, often accurately reveal internal mental-emotional states of participants. Psychological conditions are reliably tested through viewing these established images within the test. Not only is psychosis notable based on personal reactions to certain images, but other emotions also consistently appear. Because the Rorschach test is standardized, it serves to prove that while the realm of possible reactions to art objects is unlimited, images do prompt consistent, subconscious reactions. To better enjoy art, we should stop to ask ourselves why we feel the way we do.

3. Social Context

Philosopher John Dewey cautions us against being socially persuaded during our art experiences: *"Every professional person is subject to the influence of custom and inertia, and has to protect himself from its influences by deliberate openness to life itself."*[10] We must be careful when viewing art. We often see what society creates for us. Without pausing to question accepted wisdom, we make incorrect assumptions about an artwork's meaning, and yet,

without embracing cultural nuances, artistic meaning could be lost on us entirely.

At one extreme, artworks present as culturally unknown artifacts that we're forced to interpret as naïve outsiders, while at the other extreme, artists tip their hands to cultural inside jokes and memes. Missing the former leaves us feeling empty, while the latter makes us feel uncool. Artwork on marriage or fertility, piety or obedience, rock stars or movies might ring hollow with unknown messages if we lack the appropriate closeness and references.

We are left with no choice but to stay current in our society, while simultaneously questioning it, learning and using contemporary slang, while remembering corners of religious history. Otherwise we habitually interpret the world through first impressions and cultural lenses. Among the two, questioning received wisdom, in this case, known artistic styles and patterns, is the more difficult task. Even art critics regularly fail to spot or embrace trends that move against the status quo. We have deep expectations of meaning and of good and bad, well before we think about viewing art, so overcoming social biases is a tall order, one that settles on *being comfortable with discomfort.*

Again, our thoughts, languages, and norms are built within and by the social structure we inhabit. Art's great project is to comment on society. As Jung said, *"All art intuitively apprehends coming changes in the collective unconscious."* While it might be overly charitable to ascribe that kind of prescience to artists, they *are* astute ethnographers of the momentary zeitgeist and impending social trends.

The most difficult part about understanding society's influence on our aesthetic experience is that we usually don't know it's happening. Artists struggle mightily to reflect society in a mirror, to play back the grace, beauty, struggle, and ugliness that we propagate. But artists themselves work through a complex library of accepted social images and forms. Artworks speak to local fashion, celebrities, political figures and movements, social

pressures, and deep personal fears. Artworks also react to each other, critiquing past movements and drawing inspiration from them.

Ripping art from its social context strips the meaning. It often leaves an object with a beautiful veneer but a vacant soul or lack of purpose. How does Picasso's *Guernica* (1937) oppose war if we live in a world of tranquility? What is a revolutionary mural from Diego Rivera in a world of universally healthy democracies? The African mask in a cold modern gallery, Japanese landscape scroll in a polished business lobby, or the Renaissance portrait in a high rise amidst urban sprawl—viewers see the object, they can learn the intended meaning, but the artworks sit askance from their original functions. And yet, we don't need to lament the loss or change of meaning for its own sake. Viewers, being as, or more, important than the artwork they experience, change meaning. It's worth underscoring how far meaning travels, from artistic intention to viewer interpretation, when it crosses the chasm of culture.

When you wander the halls of the world's famous museums, wishing you had a plush seat or could touch the artwork, make sure to take the audio tour, make sure you read the wall labels, because you'll realize the breadth of social issues that artists were addressing for their contemporary audiences. A little information might tell you that the picture of nobles squabbling in a beer hall was actually politicians on the floor of British Parliament in the 1800s. It was a time when artists were finally free to depict politically negative images without constant fear of retribution.

We more easily gravitate to aesthetic beauty, because it's naturally aligned to biology. We can be lazy and still enjoy the look of gently sloping pastures. But beyond retinal pleasure, art is uniquely adapted to a temporal and geographic matrix. Unless you're standing in a contemporary art facility, the artwork in your view wasn't made with you in mind. It was made for viewers in a past time and probably a distant location. Likewise, few artists today are forecasting "World 2120" and placing their works in a

time capsule for viewers 100 years hence. *Great* art will spark engagement today and ring to an unknown future date, but our descendants will need to interpret today's artwork through the lens of their future environment. Some meaning will be lost then, as now.

Society also influences art through the mediating structure we use to describe it: language. Word choices frame what art *is* and how it matters. Words signify how art is adopted or rejected by society, from travel and leisure to politics and business. Is the city you're visiting picturesque? Is the food plated like an abstract artwork with marbled fats and pine green sprigs? Does it have a balanced composition? Are you succeeding in the subtle art of the deal or political messaging? We cannot separate art experiences from language, because we learn how and what to feel through our language. Is the artwork racial, post-racial, colonialist, neoliberal, feminist, or a litany of tags at the intersection of causes?

When we say the word **art**, our conversation partners have a vague feeling of art-ness, of "paintings," "museums," "galleries," or streetcar graffiti, or maybe a specific artwork or place—the Art Institute of Chicago and Monet's 1890–1891 *Stacks of Wheat (End of Summer)*. Your associations with art stem from your personal encounters, yes, but also from stories *told to you* by social narratives and media about what art is and should be. Our understanding of beauty, color, texture, and emotion—all aesthetic experiences—spring from social thought patterns and language. The mysterious confluence of personal experience and cultural stories program our minds about the term art, as they do no less in other areas of our lives.

Social narratives nudge us toward meaning. Tracing words related to "art," which we'll examine historically in the When section, preceding usages defined both *virtues* and *techniques*. Virtues were positive, as were most techniques, although techniques could be used for negative purposes, like war. Art-like meanings often flirt with negativity. The Middle French word, "artifice," is close to the negative word, "cunning," and is still very much in use, to

deceive. You might also apply art toward scheming ends with "artificial," "artful," and "artifact." Being *artificial* by copying a natural object or flavor, or faking a genuine human interaction, is decried. Being *artful* is employing a false device or trick, while an *artifact* is an object that, even being human-produced, isn't naturally occurring.

These words contrast art with nature. They train us that art-*like* objects or actions might be inferior to their organic alternative. At yet, the art of X, art of love, art of writing, art of cooking, art of teaching—each imbibe their subject with art's glamour by signaling the association. Words about art glorify its creativity while questioning its intentions. It's no wonder we hold art in high regard and yet criticize it as remote or overrated: society suggests art's intentions before we encounter the parking lot or sculpture garden.

Psychologists, philosophers, linguists, and anthropologists began to investigate society's impact on our thought processes more earnestly in the nineteenth century. Freud and Jung delved into the subconscious in unprecedented ways and reframed our understanding of internal phenomena, while their contemporary, German-born anthropologist Franz Boas, pioneered research into global cultural practices through anthropology. The loss for monarchs and organized religion was the gain for experiments in capitalism, socialism, communism, and an increasingly broad range of sexual orientations and family structures. It's easy to imagine that conventional wisdom was upturned in the midst of this tsunami. The gears of civilization stopped spinning the way they had for millennia, which necessitated a fresh evaluation of the human capacity to generate meaning and belief, methods for organizing communities, and the definition of a happy, free life.

The late-nineteenth to late-twentieth centuries were not lacking in academic movements, which arose to diagnose the times: structuralism, poststructuralism, semiotics, fragmentation, postmodernism, and more. Researchers and academics were freshly chasing clues about why we acted and felt the way we did.

Across movements, language usage was a clue. The idea arose, and reached unusual consensus among disagreeable academics, that language—speech and writing—mediated our life experience. It translated between ideas and physical reality.

Common archetypes and structures might exist across cultures— and indeed certain stories of gods, heroes, villains, and vices certainly do, but those structures are expressed by people using their distinct cultural methods, tuned to local practice. Artists and audiences are storytellers who must use visual, written, acted, or spoken media, with which they are familiar, to share their stories. This necessarily traps storytellers—artists and viewers—within the communication mediums they understand.

Those who speak multiple languages know that expressions and mindsets differ between tongues and enable nuanced worldviews. From well-known words like the German *schadenfreude* (happiness at another person's misery) to the less-known Inuit *iktsuarpok* (going outside to see if someone is coming), words in some languages require whole phrases to translate. Just like you can't take a photograph with acrylic paint—you can only tell a story with the tools you are given. If this is the case, and indeed we've laid the case for why it's so, then it's important to identify *who creates the accepted mediums, such as language and visuals.* While the structure of language is a dialectic between participants in a society, those who dominate the social structure also dominate the formation of meaning.

What, or *who,* does that mean? Although street slang and musical references find their way into the dictionary, typically this means rulers, lords, nobles, and the military. It also means religious and spiritual leaders, the wealthy and powerful, economically and politically. It's called history for a reason, although *her*story is catching on. Royalty and religious powers wrote history and commissioned art about themselves and for their own ends. For 5,000 years little changed, although since the late Renaissance and Christian Reformation, the narrative arc has expanded. Today, 140-character tweets contribute to both presidential microphones

and revolution. Most developed cultures critique power fearlessly and at will—if they are aware or passionate enough about their causes. And yet, social structure is still largely defined by those with political, financial, and military, power.

Given the profound influence that social structures and language have on our thoughts and experience, and given our awareness that these mechanisms are at play, I bet you can guess how artists treat the topic of social power. They will remind you of it at most shows. Yes, much of the art world sits at the vanguard of cultural criticism. Artists thrive by critiquing the visual-linguistic power structure. Art objects relentlessly pursue the blight of social injustice, to the point that many viewers are uncomfortable or confused by the graphic rage splattered through blood, death, feces, and sex around the art world. We need not be so confused when we understand the system they rage against. It's just artists dutifully fulfilling what they have recently confirmed was their mission statement after thousands of years of obeying these patrons.

Not only do artists vigorously question their social environments, but we as art viewers and readers question and evaluate the creative production of those artists. Audiences imagine their own narratives about artwork, but when art was about and for nobility, with images encouraged or approved by noble eyes, the circuitry was tighter. In a contemporary environment, audiences contribute layers of meaning derived from opinions that might be a world away from the original artistic vision. That's why audiences have become the defining force in artistic experience. Philosopher Roland Barthes is most famously known for his 1967 essay, "The Death of the Author," in which he outlined that due to linguistic ambiguity, embedded sociocultural biases, and the unknowable state of the author's mind, *it is the reader who makes meaning.* Writers say what they will, but readers issue the final verdict.

Meaning is not a monolith. Postmodern social theory argues that no single or unified explanation of "culture" is possible. Culture is a seething mass of flux and change. Digital technology has

enabled the expansion and connection of infinite subcultures devoted to esoteric topics, such as spider collecting or unicycles. With such a long tail of overlapping interest groups, it's increasingly difficult to know which *cultures* people belong to. Maybe there is no culture, only culture*s*, forming a quilt with infinite intersections. Reading the day's political news on opposing websites requires mental gymnastics, contorting oneself to understand how the same event could be presented in such opposing lights.

We don't even agree with ourselves from day to day on common topics, such as if we should exercise in the morning or have coffee past noon. We belong to too many divergent cultures, tell ourselves conflicting stories, and feel resonance with fragmented perspectives. At a minimum, we are of a gender, race, personal and geographic history, spiritual orientation, family background, educational and vocational history, and hobby or interest profile, such that no single perspective is universal. Perspectives are individual, conflicting within themselves, and even closely held beliefs can change rapidly as our identities shift.

While the nineteenth century began centered on Western cultural, economic, ideological, and military dominance, how quickly things have changed. By the twenty-first century, the balance of cultural theorists would probably cite the impossibility that modern citizens face in finding place amidst a buzzing landscape of digital media hashtags and weekly memes infiltrating our subconscious. How can we possibly interpret art consistently?

Which brings us to the **simulacrum**, a popular philosophical and art world term. Initially the term meant *a copy of an original,* but one of questionable or unacceptably low quality. Eventually, the term was coopted by postmodern social thinkers and used to describe the "hyperreal"—*a copy **without** an original.* An example close to our childhood imagination is Disneyland. It's an invented reality, existing in tangible locations, such as Anaheim, California, and Shanghai, China, that celebrates cinematic stories that were never real. Disneyland, despite our childhood nostalgia,

is a derivative of false reality. It's a hyperreality or virtual space. It *is* a real place but the value and meaning are nourished by our collective consciousness when we *agree* to believe in the characters.

Some philosophers would go so far as to say the simulacrum threatens the foundation of Western philosophy. If you remember, Plato's concept of forms said that every physical object—a cotton-stuffed bed or a gleaming national flag—was a second-order derivative of the *idea* behind that item. The concepts of national flag and nation, bed and cotton, are crystalline, pure, and unrelated to specific instances of the Ghanaian or Indian national flags, or your bed at home. But with the simulacrum, invented personas and stories commingle with natural phenomena at the wellspring of cultural belief.

The Simulacrum

When we are viewing art, we stand inside a society and think in a language. We can't create or consume art from outside our social knowledge, but social knowledge is increasingly fragmented and rapidly changing. This leaves us with a contradictory set of loose moorings.

Now we know the extent to which critics and researchers question our ability to freely interpret art objects. Art has and does imitate life, but increasingly, life is imitating art, and we are living

according to an N = 1 single interpretation of social factors—our own unique combination, one that no one else shares exactly.

4. Active Evaluation

Instead of understanding our experience as a reaction to visual artistic triggers, philosopher John Dewey offered an alternative,

> *"Perception is an activity of doing and undergoing, a transaction with the world around us. Or, as the psychologist James J. Gibson claims, seeing doesn't happen in the eye-brain system, it happens in the eye-brain-head-body-ground-environment system. It is something we do, not something that happens inside us."*[11]

Finally, we find solace in a topic where the art experience is *completely* in our control—**active evaluation**. The odds are against us. Biological, historical, and social factors automatically influence us. We must perform a heavy lift to overcome the external influences that whisper meaning. Success requires *time*, which we often don't have or misuse, and *focus*, which we are building habits against, in today's multitasking life. We must use both effectively while standing in the celebrated museum or gallery, and while thumbing through miniature art icons on social media.

Above all, active evaluation requires curiosity—a dash of wonder, a willingness to investigate visual expression and human stories. If we remain curious, if we elbow pretense aside and ignore the concern of "accuracy," if we forget about impressing friends with smart comments, or methodically checking off each wing of the museum, we can use active evaluation to overcome art's inherent roadblocks. It's that difficult but also that easy.

Understanding active evaluation requires unlearning and learning. Unlearning is ignoring expectations and building confidence in your own interpretation. Release yourself from the grading scale that accompanies high school and college exams where a professor has ordained accuracy. When we demand or expect to

decode German and Swiss artist Hans Holbein the Younger's Counter-Reformation artwork we are likely to fall short.

Try as we might, we always miss stray shots of meaning, which are embedded in the culture of a time, from the musical instruments to the scientific instruments. Unlearning is acceptance that we'll do our best but that mysteries will remain.

The Ambassadors, Hans Holbein the Younger, 1533.
National Gallery, London, England. Public domain.

For 25 points, what does this artwork show?

Learning in active evaluation requires defining a method. Know the repeated themes and apply a consistent framework. Read the wall labels and take the audio tours, yes, but not at the expense of asking yourself questions about the work. Our minds are more active in response to questions than to absorbing descriptions.

Personally, I've found two things helpful: (1) asking myself a consistent set of questions and (2) reviewing common artwork themes. We can develop heuristics for artist intentions, and we can build a habitual response to evaluating images. We still might encounter a flat dullness at the hands of supposed masterpieces, but consistent evaluation is more likely to illuminate why.

The **active evaluation framework** is explained in the next section. Using our definition of "art," we only need to ask ourselves a few questions. If art is an object that (1) attracts attention or (2) conveys meaning, then we should examine how an artwork accomplishes those goals, in the context of materials and location.

It's useful to review common artwork themes. This is easier than it might seem. The overwhelming narrative of modern and contemporary art is to rage against and protest the system, any system, and to critique capitalism, religion, racial or sexual preconceptions, existing power structures, politics, and dominant culture. There's a good chance that if you're viewing contemporary art, the objects in view are projecting active dislike for installed sociopolitical structures. As we know, before the nineteenth century, art was commissioned by and supported political and religious hierarchies. In both cases, we locate the power source or worldview and determine how the artwork is commenting on it.

While we risk mischaracterizing art with a broad brush, *we risk more* if we fail to develop habits and clues that allow us to quickly find comfort amidst an artistic environment, especially given the background forces that nudge us into preconceived interpretations.

Active Evaluation Framework

1. Attracting Attraction

Mechanism: What mechanism does the artwork use to attract your attention? Is it a color scheme, visual pattern, novel topic, or distinct medium?

Attraction or Repulsion: Are you attracted to or repelled from the artwork, or a combination of both, based on the raw physical appearance? Are you surprised, puzzled, or confused? Why did the artists choose attraction, repulsion, confusion, or their selected methods?

2. Conveying Meaning

Finite Themes: Most art addresses one of a finite set of topics: political power, sexual appetite, economic systems, racial and identity systems, religious devotion, fear and death, or interpretations of beauty and goodness. The topics are so grand that you should naturally understand them, even if you miss subtle clues from different cultures.

For or Against: Along with meaning, the most utilitarian secondary question is, **"Does the artist support or critique the subject matter?"** Think about if the artist is FOR or AGAINST the predominant cultural stance regarding the topic: for or against religion's place in society. Why or why not? For or against predominant images of beauty in the culture. Why or why not. For or against conventional gender or family norms?

3. Medium and Style

Does the artist usually work in this medium? Why do you think he or she chose it? Did the artist use this particular medium because of the attraction method or intended meaning, or were the choices independent? Is this combination of medium and style effective?

4. Location

Artists and institutions like to create site-specific work for a certain location. In other cases, the artwork is similarly effective despite the location.

Archetypal Themes in Artistic Meaning

Steps one, three, and four in the active evaluation framework are straightforward in that they require little background. Simply apply the framework. Step two, *meaning*, requires more information. In the next section is a list of common topics that artists tend to address repeatedly. After all, only so many significant human themes exist. It's useful to remember common themes and ask yourself about the artist's stance.

Religion

Does religion represent goodness, truth, or reverence, or oppression and conformity? How do subjects within the artwork portray their stance for or against religious meaning? Are there morals to the story? Who is the artist trying to convince for or against religion's importance?

Hint: Since 1850, most art has been against religion. From the beginning of the Reformation, in the early-sixteenth century, until 1850, the outlook on religion was mixed, with the balance still for religion or avoiding it (Dutch interiors, landscapes). Before the sixteenth century, art was decidedly for religion.

The question is how that position is uniquely conveyed.

State Power

Is state power in this artwork a force for good or evil? A force for war or peace? Is the artwork even aware that it's projecting state power, or are the images subconsciously supporting the state? Who wanted this artwork made, and who were they trying to convince? Which images within the artwork project power and why were they specifically chosen?

Hint: Before the French Revolution in 1789, most art was for state power or simply ignored it while painting other topics. Leaders were glorified through victory and war. After 1950, the emphasis decidedly turned. Few contemporary artists create nationalistic artwork. They are far more likely to critique state power; the question is how.

The West and Colonialism

Does the artist display human subjects from "other" cultures than their own? How are others presented, conquered, subjugated, or exploited? It's likely they are not shown as equals to the artist's native region or gender—usually European men.

Does the artist universally belittle other cultures, or does he or she glorify certain elements? Is the artwork aware it's making this comparison, or is it embedded in their cultural subconscious?

Commerce and Capitalism vs. Marxism or Communism

Which economic system does the artist respect? What do they think of fairness and equality in the economic system(s) shown? To what degree do they think money creates wealth and/or undermines social morality? Are they for or against capitalism, globalization, and trade?

Hint: A segment of spectacularly successful artists glorify wealth, but the majority offer a critique of capitalism and free markets. This is a hot space with nuanced perspective. Be vigilant about art's critique of capitalism, especially given that artists are dependent on wealthy collectors. The two are uniquely intertwined through mutual support and walk a thin line between disagreement and mutual affection.

Death

What does the artist have to say about death? Should we fear it? Is it peaceful, painful, tragic, or commonplace—or a mixture?

Hint: Death is often connected to other issues, like religion or capitalism, and, of course, war, so note its role across topics.

Physical Pleasure and Sex

Art has long been at the avant-garde of exploring human sexuality. As a simple matter of the visual medium, art holds a unique place exploring sexual expectations, orientations, roles, fears, subconscious patterns, and innumerable fantasies.

Hint: You probably won't need a hint to know if an artist is addressing sexuality, but it's important to consider if they are for or

against predominant views of sexual behavior. Is sex mutually loving, supportive, dangerous, prohibited, or otherwise judged for value?

Nature

Nature, in all its diverging attitudes—silent, rugged, imposing, remote, virgin, spiritual—has been a central theme in global artwork for more than a millennium. You won't need many hints to infer an artistic theme about nature, but it is worth assessing how nature is conveyed by the artist. The natural is often used to contrast with urban or mundane life as a nostalgic or pristine ideal that we must reclaim or use to purify. It shows an idyllic life of leisure or a supernatural power, perhaps close to a god, but at least not sullied by the forces of modernization. In Western art, between the sixteenth and nineteenth centuries, nature increasingly moved from the background to the foreground of artistic works, eventually becoming the central figure and independent subject.

Female Power

This is a huge topic that crosses almost all the others. Women are underrepresented as artists and art subjects, other than as sexualized subjects. How is the artist representing the female role in society, sexuality, religion, and commerce? Do they take any stand at all on women or are women in the artwork shown subconsciously according to gender biases?

Hint: Much of art history is incredibly sexist, and often unknowingly so, amidst chronically sexist cultures. You could view almost the entire canon of art history as a critique of women's roles in society, although only in the past 100 years have artists frequently and consciously elevated the topic.

Minority Cultures

Minority cultures is another massive topic, which also relates to state power and globalization. Much of art, whether African, Chinese, Western, or elsewhere, displays a bias for the home culture and against the "other." This is strongest in the European tradition, as already described through colonialism. The archive of racist

artwork is longer and more brutal than most of us are willing to face. Does the artist actively represent the humanity of minority cultures in his or her artwork?

Hint: Beginning with Matisse and Picasso, when they incorporated African art into European Modernism, African art arguably "saved" or rejuvenated European art, although initially with racist undertones. The blending of diverse cultural art ultimately showed a new path that liberated art for more than 100 years of innovation. Although not always actively stated, combining cultures in art is one of the most powerful sources of creative inspiration.

Fear and Pain

What are we afraid of? Does the artist think we should be afraid of the subject matter? Is the artist representing an existential fear, like loneliness, poverty, loss, or death? Does the painting make you tense or uneasy?

The Subconscious

What do the subjects of the artwork believe? Are we aware of the subconscious truths embedded in the artwork's meaning? Is the artwork subconsciously conveying ideas of power, commerce, death, sexuality, or other topics mentioned?

Hint: This topic is closely related to fear and pain, as many artists and psychologists believe we repress our fears. Therefore, they might visualize fears as being experienced subconsciously.

Semiotics of Symbols

What are the sociocultural images presented? Are they relevant to our contemporary culture as memes, celebrity personalities, or fashions? Are they uniquely situated to capture sentiment from a particular time period, and will the artwork function as effectively outside that?

Hint: There are likely many embedded symbols in artworks from all time periods and cultures: a certain robe, map, candle, or skull had a meaning in that culture and time. Likely we'll miss these symbols, and there's not much we can do about it except read supporting exhibit documentation.

Seeing Art, Fast and Slow

An analogy here is apt. Nobel laureate psychologist Daniel Kahneman, no relation despite the conspicuously similar last name, outlined a useful analogy in his book *Thinking, Fast and Slow,* one he did not intend nor apply to art viewing, but which I think he could have, and that we will. Kahneman proved that the mind is composed of two thinking systems, one that operates *"automatically and quickly, with little or no effort and no sense of voluntary control,"* and a second that *"allocates attention to the effortful mental activities that demand it, including complex computations . . . often associated with agency, choice, and concentration."*[1]

Examples of Tasks Performed by Each System

System 1, Fast: Detect one object as more distant than another; recognize emotion in a face and/or mimic it; detect hostility; use motor skills when no distractions are present; understand simple sentences.

System 2, Slow: Focus on a voice or a person in a noisy room; monitor your behavior; count recurring letters in a paragraph; check a logical argument.

I find a connection between Kahneman's two systems and their designations as either fast or slow, as parallel to our understanding of how the first, fast system, biology, personal history, and social context, create immediate artistic impressions, and then next, a second, slow system, similar to active evaluation, which requires patient and conscious, dispassionate analysis. An art encounter hits both systems. Art causes such varied reactions because we react to it emotionally, but then pause to actively assess the story and history within an artwork.

Interaction between Systems

We don't simply use one system or the other when evaluating art (or other environmental stimuli). More comprehensively, the two systems interact. Faster impressions drive initial reactions that prompt evaluation by our slower but more powerful, cognitive abilities.

"System 1 continuously generates suggestions for System 2: impressions, intuitions, intentions, and feelings. If endorsed by System 2, impressions and intuitions turn into beliefs, and impulses turn into voluntary actions. When all goes smoothly, which is most of the time, System 2 adopts the suggestions of System 1, with little or no modification. You generally believe your impressions and act on your desires, and that is fine—usually. When System 1 runs into difficulty, it calls on System 2 to support more detailed and specific processing that may solve the problem of the moment. System 2 is mobilized when a question arises for which System 1 does not offer an answer."[2]

Important though, art causes us to switch between systems. Switching methods for accomplishing a task causes friction and, therefore, increased effort. Holding multiple ideas or viewpoints in mind also takes effort. System 2 can be confused by and then agree with system 1, or the uncertainty might force System 2 to contradict, and then override, habitual responses. We realize a shadow isn't a predator but the outline of our dog on the side of a shop at twilight. Likewise, our System 2 evaluation of an artwork deepens and improves our reaction to an artwork, as it could when giving a person a chance, despite disliking him or her with the first impression. We don't like their tone or posture, but then we learn stories about their childhood or successes and failures at work, and we welcome them into conversation. The clash, interactions, and agreements between the two systems coalesce to a more complete, better outcome.

Easing Cognitive Burden

Kahneman's theory also aligns ideas about flow with the art experience framework. He shows that more deliberate and intentional activity, System 2 thinking, can become more automatic, System 1 performance, over time. As we learn skills to the level of habitual movement and instinctual behavior, we can reduce our cognitive and physical load. Trained actions can become

undistracted motors skills. If we learn enough about art, we can push much of it to System 1 thinking where the biological and subconscious impressions are fun, easy, accurate, and more insightful. We'll always need to, or want to, switch to System 2, checking logical arguments, so we can process the subtler history and meaning of an artwork, but we won't be overwhelmed by the new images so easily.

We build habits to reduce our cognitive load and make art viewing, rock climbing, or surfing, easier, and to give presentations at work or evaluate chess moves without stalling amidst the performance. We want to push activities from System 2 down to system 1. But with art, we shouldn't overly sympathize with either: After all, we wouldn't want only a first impression, one where we mostly consider an artwork's colors, shapes, and biological beauty, or think we grasp the entirety of its message on impact, nor should we only use dispassionate mental analysis to decode the story of an artwork without allowing ourselves to naturally enjoy it.

If we are only dispassionate, if we only allow System 2 to drive emotionless and cold analysis, as many philosophers have advocated, then we prevent or stunt our emotional and physical reactions to artwork. We prevent the physicality of art objects from doing their work to naturally attract attention and convey meaning. Art is hard because we task switch between the two systems, but it's better for the effort.

Conclusion

Although we've ventured into some detail about numerous, automatic, biological, and subconscious reactions that occur when encountering art, the art experience isn't something that happens **to** us. It's an effect we **create** through visual-mental processes and interpretation, through asking questions and interacting with the world. Biology and the subconscious tug at us. Social conditioning frames our outlook. Location sways our impressions. But, with focused attention, how we experience art, is ultimately up to us.

Where

Be Ready to See Art

At first, it might seem odd to analyze the locations where we find art. In most cases, an object that is considered art in a museum would be considered art in a gallery, at home, in a social media post, or on the side of a building. But critical distinctions exist in terms of how physical (or digital) locations impact an object's categorization as art, and its status as more, or less, respected art. If for no other reason than differing materials, size constraints, and history, it's useful to think about "where" something is art and what it means for viewing that art in the places where you're likely to encounter it.

Culture and Context

The "whereness" of art depends on the display environment. More important, the unique history and expectations of certain venues increase the likelihood that you personally will see art of a certain type depending on the location—and that unique expectations are attached to that art based on the venue.

For example, art in your home most likely brings a certain personal attachment, perhaps from your travels, family memories and beliefs, or to fit your interior design. Artwork in public probably projects power—or rejects it. Art in a gallery is likely a supportive and speculative business endeavor by the gallery to promote a certain artist. When art reaches a museum, you expect that it was approved by the informed critics and represents something important historically or culturally. Digital art could showcase any of the other mediums or exist entirely in cyberspace.

None of these comments are universal, but context matters, increasingly so in today's world of installations, conceptual and performance art.

Masks, church altars, and ancient ruins, such as Stonehenge in England, represent locations associated with types of art. Shock

art, brought to prominence by a group called the Young British Artists, includes corpses, blood, and feces, and has been shown as art in galleries and museums, but imagine those objects at home or on the public street. They would feel radically displaced and unlike art—more like nuisance or a crime. The core mission of the objects would change.

More important than *if* an object is art based on the context is understanding the peculiar benefits of artworks in various locations, and the history and story behind viewing art in these spaces. The arc of collecting and displaying art is a long and old cultural story, with distinct styles arising to suit physical locations and their respective cultures. This evolution continues, as new venues arise for the creation and display of artworks, notably today in the online, mobile app, and virtual spaces, which function across the digital landscape.

The whereness of art is not a single story, but one of overlapping histories that started at a single genesis point—caves—and expanded with wealth distribution from royal houses to the middle class, the street, and online as art has continued to evolve and disperse across modern platforms. The flux is constant—art is in iterative dialogue with its surroundings, both being influenced by physical site constraints and building culture around them.

Public Art

Reaching back to the caves of Sulawesi and Chauvet, early Homo sapiens art was almost certainly for collective use, even if it was protected by shamans and located in the labyrinthine caverns. While early caves also functioned as homes or shelter, art within harnessed the power of myths and rituals to support group hunting, harvests, and ancestral connection. It was meant to benefit the group.

Public art tells a bold story, typically *for*—or *against*—power. Public art has long filled squares and religious locations as an early form of broadcast media, often celebrating victorious gods and rulers. Imposing public sculptures and buildings rarely

describe how life was actually lived during prior eras. Rather, public art shows how political and religious leaders *wanted* their subjects to see the world. Royalty—mostly kings, not queens, princes, or lesser lords—ordered artworks according to their commands.

Art was beautiful propaganda. And in many cases, public art *was* art. It wasn't common in homes, and no galleries or museums existed to compete for attention. Art at home might hold sentimental value today, but it had no hope of competing with the grandeur of public art in the past. Even today, the Egyptian pyramids and sphinxes dominate their surrounding landscapes and our imaginations, as do the Sistine Chapel and churches across Europe.

Public art is free and it's mostly shown outside. It's easy for people to access. Museum advocates might argue their art is public, but the enclosures and entry costs often eliminate museums from the spirit of truly public art. The beasts of commerce limit their best intentions. Public art should be located at the nexus of transport and community hubs. Even better, it should breathe fresh air outside in open view. That's why, until recently, only governments held sufficient power to display art publicly. They did so as early as Egyptian dynasties in 3150 BCE, Minoan Greece around 1700 BCE, and during the Mayan empire in 100 BCE.

Then suddenly, in the modern era, public art turned against its masters and began to speak for social causes, often against government power. In the 1930s, murals by Diego Rivera, artist of Mexican independence, began to capture public attention. Rivera's murals beautifully showcased the plight and dignity of common citizens and their strength in the face of government neglect during the great depression. Their message demanded a response. The murals are said to have influenced US President Franklin Roosevelt's New Deal social programs.

The Christian church has been on the front lines of public art since its inception, as a skeptic, detractor, and ultimately as the engine

behind artistic energy and patronage for hundreds of years. The word *iconoclastic* comes from the Christian movement to break images and remove them from places of worship. But the power of images to communicate with churchgoers—largely illiterate peasants—was too persuasive to ignore. By 787 CE, the church had fully embraced the importance of controlling its public message,

> *"The Second Council of Niacea officially ordained the following: 'The substance of religious scenes is not left to the initiative of artists; it derives from the principles laid down by the Catholic Church and religious tradition The art alone belongs to the painter; its organization and arrangement belongs to the clergy.'"*[1]

As the center of gravity for community activity, the church was a de facto home for public art. Following the tradition of rulers before them, their artwork promoted origin stories, morals, and projected godly power. Knowing your bible stories will transform a puzzling visit to many famous museum wings into a tour through the essential biblical canon.

Public art still magnifies the voices of power today, but narratives for and against power compete. Mural art and graffiti speak against power in back alleys and on colorful walls across urban centers globally. An early, and still existing example, is *The Great Wall of Los Angeles,* created between 1976 and 1983 by more than 400 community youth and artists. The mural-laden wall stretches over half a mile through Latino neighborhoods in LA, telling stories of their community experiences. This public art is a source of history, hope, and social coherence.

We mentioned Diego Rivera. The Mexican mural art movement of the 1920s and 1930s is most singularly responsible for the revival of public art in the modern era—and for the focus of that work speaking against, rather than for, power. Rivera was an avowed communist and atheist, and a proud advocate of worker's rights. He painted dramatic, Aztec-inspired scenes in Mexico, the Union of Soviet Socialist Republics (USSR), and the United

States, in cities such as Detroit, San Francisco, and New York. His approach was a radical departure from the prior focus of public art. It propelled a global movement of revolutionary, antiestablishment, community-oriented artwork that persists today.

Graffiti, even more so than mural art, was also born from rebellious cultures: skateboarding, punk rock, and war. Early tags were found around Allied sites in World Wars I and II, notably the sketch "Killroy Was Here," showing a bald man with a prominent nose pointing over a wall. Later, skateboarding began in the 1960s, through the transformation of the Southern California's urban landscape by off-season surfers. They needed a new place to ride. Punk originated independently, from the social angst and counterculture of anarchic British social groups. Although the three were not ideologically connected, they began as ways to express their alienation and dissatisfaction—skateboarding through sport, punk through music, and war, through its very nature.

Graffiti pulses with confrontational energy that is captivating and provocative. It evokes a lifestyle set to the soundtrack of angry beats, filled with bold, colorful posters; mixed media; anti-capitalism; and aggressive street life. In many ways, it's the antithesis of the traditional art world: silent, cerebral, private, and sedentary. Although graffiti artists began their craft in the 1960s, the art world remained entirely separate for decades. The graffiti artists' propensity to paint buildings, trains, and parking lots didn't win them champions in the traditional artistic community.

Between the 1960s and the 1990s, graffiti grew in prominence and popular culture but still didn't gain critical acceptance. Even in 2017, discussion threads continue on artist forums debating the merits of graffiti as "art." We can empathize with the uncertainty. After all, graffiti art *is* illegal and it often *does* vandalize property. But it's certainly art, as much *because* of that vandalism as despite it. The public act of defiance leaves traces of a discrete performance art. Visually shouting a social message, publicly, in

prohibited space, magnifies graffiti's impact. Yet to a segment of the elite, accepting graffiti as art is akin to tolerating vandalism. Even critics who might support vandalism to artistic ends cannot necessarily sanction it publicly.

For decades, it was graffiti artists against the world. In the book, *Beautiful Losers*, by Aaron Rose and Christian Strike, the first graffiti artist is described,

> *"In the beginning, there was the word: TAKI 183. A name, a number. And the start of something. Something that, despite the many obstacles and frustrations placed in front of it, has continued, even thrived, for over thirty years, into the new millennium. The genesis of the whole subculture, art form and industry, and for many, a way of life. A life spent scribbling in books, scrambling over walls and fences, and scrawling on any available surface."*[2]

Graffiti artists consider themselves "writers." Their art is often certified as authentic by their signature, or tag. The tag itself is often the entire artwork, a signature itself as a defiant act. Some of the first tags were by TAKI 183 in the early 1970s, a Greek delivery boy named Demetrius, who *"using a small marker pen, he began to write his tag wherever he went in the city."*[3] Although many kids wrote their names by their houses, none ventured so far afield as TAKI 183.

Imagine during trips around your city, suddenly, and for the first time, you begin to see a distinct signature repeated, emblazoned in forbidden but public locations. That phenomenon created sensational buzz for TAKI 183, who watched his fame grow with each signature. The other originator of tagging, Darryl McCray, known artistically as Cornbread, wrote his name along the school bus route in Philadelphia of a girl he fancied to gain her attention. Apparently, it worked.

Although public art was elevated to prominence by Mexican muralists and US graffiti artists, the original concept of public

graffiti is older. The first images were nothing more than handprints and scribbles, but public art captured sufficient attention to earn its own name. Again, we look to Latin for inspiration, *graffiare*, which meant "to scratch." It described early graffiti, which was etched into walls, trees, or *latrinalias*— latrines— where many a writer gained inspiration and enjoyed the privacy to write. European grave robbers also tagged their targets with graffiti after striking, although probably with haste.

The public sketch relieves at least two human desires: the needs to both express creativity and rebel. Few of us appreciate being given orders, even if we comply, and graffiti pulls at that subversive inclination. Power resistance and creative urges are a happy marriage for bold expression.

As technical innovations increased the effectiveness of aerosol paint, and graffiti was approved by a groundswell of urban support, tags covered trains, buses, walls, and houses. It was an urban pandemic, or a refreshing revelation, depending on your position in the graffiti debates. Supporters had seen their way of life, to "get up" with their graffiti, in any place possible, reach mainstream consciousness and change the concept of public art.

Public art evolved from caves to religious sites and town squares, finally to reach abandoned and prominent buildings on city streets. Public art speaks for and against power, enlivening but also polarizing the communities where it's on display. Today, rebellious graffiti sells at auction in the traditional art world for millions of dollars. Art that was once on a grocery store loading door or a train car might be ripped away and coveted for a home, gallery, or museum. Whether public art speaks for the government or dissidents, its visual prominence creates a unique context and conversation.

- What are common themes you see in public art?

- Do you think graffiti is vandalism? How would you draw the line?

Art at Home

An early word related to art at home was the Italian *gabinetto*, or cabinet. In German, it was a *wunderkammer*. These words described the private home collections of wealthy patrons who were able to amass broad holdings of art and curious objects. The word gabinetto wasn't used alone, but rather in conjunction with its contents, hence, the cabinet of curiosities, collections of objects in Renaissance Europe. From the Renaissance to the French Revolution, and even still today, collectors have sought unique objects, often categorizing them with encyclopedic zeal, for display en masse at home. Collectors had bold aspirations for their cabinets:

"Collections of centuries past were mirrors of the world, attempting to capture the knowledge of the era in a panoramic vision, but also mirrors of the subject they examined, both intimate and universal; the cabinet of curiosities lies somewhere between the infinitely small and the infinitely big."[1]

Cabinets were not simply decorative displays or the location for gawking at oddities. They were also a genuine learning space filled with family history and stories, and objects of religious, scientific, and naturopathic significance. Collections included coats of arms, ancestral paintings, collections of butterflies and skulls, and in at least one instance, a midget who was both tour guide and a cabinet specimen. Crocodiles were a prize in any cabinet; they were considered an element that existed between animal and mineral, but hung as art. Italian naturalist Ulisse Aldrovandi collected more than 18,000 objects throughout his life, wrote a history of animals, an encyclopedia, and left everything to the University of Bologna, thereby creating one of Europe's first natural history museums, in 1617. It was an early example of art starting at home, then transferring to a museum.

Cabinets thrived during the beginning and height of European

colonialism and were a source of pride from the spoils of conquest. Therefore, such collections had at least a hint of Eurocentricity and cultural dominance, and yet they also showed true appreciation for the recently explorable world. The cabinets were a source of pride—a physical location where royalty held private meetings and brokered favors. It's said that diplomats and acquaintances who were *not* given entrance to a host's cabinet were shown offense. The access, or lack thereof, conferred status and could be wielded as a source to humiliate or endear oneself to visitors. And so, the wealthy accelerated the pace of their collecting, one that seems not to have moderated today.

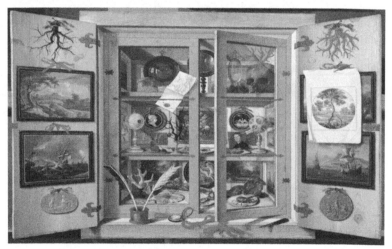

Cabinet of Curiosities, Andrea Domenico Remps, 1690s.
Museo dell-opificio delle Pietre Dure, Florence, Italy. Public domain.

Collectors and interior designers of the Renaissance separated the cabinet from the *galleria* and *studiolo*. Collecting and placement in Italy were precise: the studiolo contained small objects, carved walls, and gems, while the adjoining room, the cabinet, was reserved for classic treasures, and the gallery served as the grandest showroom for prominent objects. The word gallery started as *galleria*, from sixteenth-century Italian. It was "a *long, grand hall, lit from the side,* [and] *came to signify an exhibition area for pictures and sculpture.*"[2] Of course, the galleria initially

began in a personal home, a noble's home, well before the modern concept of an art gallery jettisoned from the home into commercial retail zones.

As collecting gained prestige, tastemakers weighed in on how to curate. Paintings were even made *of* famous cabinets and galleries themselves, which were then hung in galleries or cabinets—it's an early example of art going meta. In 1727, Frenchman Dezallier d'Argenville proposed a detailed method for cabinets. Specifically, d'Argenville recommended a mixture of Flemish and French art, with some Italian, and that people shouldn't be prejudiced against objects from their homeland in quest to display only the exotic. He advocated for ancient and small masters, described where to keep items in different portfolios, drawers, walls, and so on. He proposed an ornate system of classification and display, which included prints versus landscapes, sea shells, armor, clothing, coins, mummies, embryos, and instruments. Yet ultimately, despite the classification, collecting becomes a matter of style, *"While each man organizes his cabinet in his own way and claims it is the best, it is quite sure that it is good taste that must decide."*[3] In the end, the ever-elusive "good taste" was his guiding principle.

Predictably, collectors began to propose that collecting stood in equal artistic company with creating. The act of selecting, organizing, and displaying required such skill that the cabinet, as art, became greater than the sum of its contents. From this debate, we unveil . . . the modern *curator*. Tellingly, both *curator* and *curiosity* are based in the Latin word *cura*—to care.

Curators in museums and art institutions today wield immense power. They accelerate the careers of emerging stars and pluck young fine arts graduates out of academic obscurity. They decide *if* art objects are displayed at all. Curators must be knowledgeable guides to the art world, but their profession is cluttered with landmines of conflicting interests about which artworks to collect and display. The art world's expanding economic clout elevates the difficulty of their roles because limited floor and wall space is

brokered by the curator class.

While private home collections grew, democratic institutions and civic awareness also expanded. Awareness of private holdings became such that public outcry about art hoarding forced change. Aristocrats opened their galleries to a newly empowered public, and they began transferring objects from home gallerias and cabinets to another emerging location—the museum. More on that to come shortly.

Galleries Migrate from Home to Retail

Transitioning to a museum is one important path that art follows to exit the private home. Another path is through professional art dealers, often via their gallery network. While galleries began as a particular space at home, changing social dynamics and art awareness forced a different dispersion. As art's center of gravity moved from Italy to France and the United Kingdom in the mid-1800s, the gallery emerged as a different incarnation.

> *"In April 1854, art dealer Ernest Gambart held the first annual "French Exhibition" in his gallery space at 121 Pall Mall* [London]. *Gambart had begun his career as a print seller, and his early exhibitions in London followed the standard model of exhibiting a painting in order to publicize and sell reproductive engravings. At mid-century, however, he and other print sellers began to visibly separate the print business from the sale of paintings, hosting art exhibitions in dedicated spaces removed from the reproductive engravings that were still the major source of their profits."*[4]

Thus, the art gallery ecosystem was born. Almost 200 years later, in the world's largest art market, the United States, about 6,500 galleries exist. Far more art is sold in galleries than online, although growth trends point toward online transactions filling a larger part of the market in the future. Art galleries serve as the gateway from an artist's studio to your home. They certify and promote new art. Like curators in a museum, by virtue of simply

being in a prestigious gallery, artwork is covered with the halo of credibility. Trust is essential to commercial approval and has been critical for building support among collectors that artworks are authentic and valuable.

By the sixteenth century, artists had begun to organize fairs, the most famous of which was the Salon de Paris, but fairs still didn't lead to widespread or continually operating art galleries. Until the seventeenth century, the dealer was more of a courtier or agent rather than a physical shopkeeper. Finally, by the nineteenth century, when Gambart operated, the dealer began to look modern: identifying, authenticating, promoting, and selling art, and even advising and curating. As artists became independent from royal and religious commissions, art galleries arose as intermediaries to fulfill market demand.

It remains to be seen how galleries will adapt their physical presence to a digital world. The physical power of art in an approved gallery might begin to carry less weight as viewers and buyers become accustomed to viewing art first online and then at home.

A gallery can be quite welcoming. If you fit expected buyer demographics, the employees are warm and engaging, but if you look too eager, a salesperson will shadow your every move, or too immature, they'll ignore you. It is a business, after all.

> • What causes you to visit art galleries?
>
> • How much time did you spend there and what did you do?

While we are investigating the "where" of art, art dealers, rather than the physical location, are figures who have been in homes, public markets, galleries, and art fairs throughout history. They take a risk by bringing art from unproven studios to buyers. Through sales they establish a price and quality bar. Wherever art will exist in the future, a dealer will likely fulfill an intermediary role between artist and collector. We just don't know the format yet.

A noteworthy pioneer of art dealing was Frenchman Paul Durand-Ruel, who was a key patron for Monet and the Impressionists during their early years. Durand-Ruel staked his fortune and reputation on a belief in the Impressionist creative vision. Without his help, it's possible the Impressionists would have never arrived. That's why it's important we don't just look on art dealers with skepticism; they support and promote artists they believe in—often long before the public market agrees. The amount of risk borne by art dealers sits at the nexus of investing and retail: They provide promotional advice, financial capital, create distribution, and help build the brand. They take a big cut, but most artists are better at creating their product than running a business. It's a complicated partnership, but ultimately one that aligns incentives and capabilities.

The downside is that art dealers might foment rivalries among collectors, obscure historical sale prices, or set prices at arbitrarily high levels. That's why the art dealer's reputation and history are distinctly mixed. They contribute to the opaque art market that remains today. A lack of transparency is often the smoke that hints at hidden prices, fees, price collusion, and special offers to preferred buyers.

But art's opacity is partially natural, given the uniqueness of each product. If no two items or producers are alike, then the basis for comparison becomes an intricate formula where dealers know more than you do. They benefit from information asymmetry. And many dealers do their parts to maintain their competitive position. Nevertheless, the art gallery and the dealers offer a distinct physical location, and more important, a verified source, for transferring art from artists to your home, and without them, many of us wouldn't know where to start.

Viewing Art at Home Today

Today, art at home is within the reach of most middle-class families. The experience is unique from public art, and museum or gallery viewing. Most of us won't have a cabinet of curiosities to rival European dukes, but we will independently control our space.

It's worth appreciating the distinct emotional and intellectual phenomena that occur when you bring artwork home. We have provided hundreds of artworks to customers in their homes through our network, The Art Circuit. (Customers of The Art Circuit subscribe to the service and get a new artwork whenever they want it.) We've seen patterns emerge around how art is welcomed and appreciated, and how the elements of time, interior design, and community play roles, creating an experience that is richer than, or simply different from, the first impression of an artwork or an artwork seen in isolation.

Compared to museums, galleries, or public space, any artwork you display at home is available day and night, all year, to whomever you choose, without any defined starting or ending time. Your impressions will naturally change. Your interest will ebb and flow. At its most basic, given time, you can enjoy an artwork more, less, or the same as, when you first brought it home. It could seem obvious, but we first appreciated time-based changes as a common and expected phenomenon, in fact the dominant one, when customers began commenting, "I like this piece a lot more now than I did initially." Or conversely, and thankfully much less often, "I loved this piece initially but became tired of it after a while."

Liking a piece "more now than initially" is my favorite scenario. I enjoy it because it reminds me that we're not condemned to negative experiences, if our first glances leave us puzzled, and, more broadly, because "liking more than initially" means something inside us spontaneously changed, or that we consciously pushed and forced ourselves to investigate ways to change. We experiment with new written genres, with unfamiliar food or music, with visual artistic patterns we don't know or that cover subjects we don't usually discuss, because they help us grow. The blunt instrument of time helps us acclimate to bold color patterns or sharp, figurative lines, to political and social commentary, which pulls us into the artist's chosen cause.

Sometimes, luckily much less often, interest in an artwork fades.

It enters with a bang and leaves with a whimper. It settles and recedes into the background too quickly. Maybe it doesn't grab the space or become part of the room. Often this happens because the shapes, colors, and textures are too obvious, too safe, and match too closely the generic pattern of a room. Visual consumption becomes repetitive, like a song the radio repeats to death. This does happen, and from the data we've collected, a viewer likely won't know it beforehand via pictures or at first glance up close. You won't know it during a brief art gallery tour or viewing it online. It's a vicious kind of dullness—the surprise of melting into mediocrity. Be wary of familiar patterns.

When we began hanging art in stranger's homes, their zealous apologies were palpable. "We're sorry for the house," customers would say. Or "We know, it's so messy." Most of us at this moment could look around and quickly find fault with the shoes, socks, books, dishes, and mail—gosh, why do we still have piles of paper mail, strewn and randomly settled at awkward intervals? You couldn't host a dinner party in the next ten minutes. You'd need to clean first. We found that bringing artwork home injects a sense of freshness and self-awareness. It borders on pride. It encourages us to straighten or remove the random items and to provide a catalyst to treat your space with more conscious respect.

Through The Art Circuit, we ask customers to score attributes of artworks we bring to their home, from color and size to a defined list of styles. This isn't the place to examine those data, nor do we believe that an artwork is simply the sum of its constituent attributes (materials, height, width, medium, color scheme, etc.). Suffice it to say, viewers judge art at home *overwhelmingly* by how it matches their interior design. Homes have oddly patterned wallpaper, distant lighting, a disoriented range of non-white and colored walls, and trinket collections amassed throughout a lifetime. Art at home can't be sheltered from this organically grown and quirky compilation.

At first glance, people expect art to match these eclectic interior designs. Specifically, they want art to match the color scheme, not

an individual color, but an emotional and debatable composite of all the colors that collectively define the interior walls, furniture, and personal items. If an artwork doesn't match prominent color patterns, then most residents have immediate, interior design organ rejection—at first. However, the initial reaction rises with angst but fades quickly. Despite negative immediate reactions to artworks that conflict with established color patterns, we find that an artwork's content, style, and independent colors burst through after a couple of hours or several days. By viewing an artwork night and day, during wine or coffee-fueled discussions with spouses, friends, or roommates, settling in to stare at it while reading, you consider an artwork on its own merits. It transforms from mismatched oddity to a familiar friend.

My favorite way to reconsider an artwork is through natural, non-art conversation. By that I mean free discussion about your silly boss, your dog, a new outfit, or political chats, moments that occasionally turn to your artwork but that don't force you to opine on artistic meaning the way you'd be required to in a museum or at a gallery. The power of loose association brings an artwork, and, more important, your home, fresh energy. When the apartment dulls because of hurried and distracted days, visitors inject new attention. They appreciate the art that you've come to forget. This is so important, that when we ask customers how many days, weeks, or months they'd like to keep an artwork, they often don't pick a fixed duration. Unprompted, a critical mass elected "long enough to have a dinner party." Whether it's showing off or sharing, having and discussing beauty is fulfilling.

The freedom to change and curate your personal space is unique among the "wheres" of art. In most cases, we continue to enjoy art, or we like it more than we thought initially. This occurs within reason, of course, not with vapid artwork that leaves you gaping and hopeless, but it's incredibly common, and tells me that many, many more artworks are universally appealing than the art world would have you believe. Only at home, do we have the time and freedom to test this realization for ourselves.

Museums

Museums are the pinnacle of artistic approval. Artworks in courtyards, hallways, and on museum walls reside there because a critical series of influential rulers, thinkers, donors, and curators believed the artworks deserved a prominent cultural position. They collectively certified the artwork as worthy of our attention and praise. Other artworks by that artist, in a museum or not, are thereby also certified by association. This approval mechanism is wrought with elitism and luck. And yet, museums, more than any other cultural institution, preserve and showcase culture highlights.

According to the International Council of Museums,

> *"A museum is a non-profit, permanent institution in the service of society and its development, open to the public, which acquires, conserves, researches, communicates and exhibits the tangible and intangible heritage of humanity and its environment for the purposes of education, study and enjoyment."*[5]

But what should be acquired, conserved, researched, and communicated? The options are limitless, and indeed the world is overflowing with museums for barbed wire, parasites, toilets, intentionally bad art, and, yes, penises. It seems that humankind's drive to collect knows no bounds. But our focus is art. Duncan Cameron, past director of the Brooklyn Museum in New York City, proposed a theory that museums fall into two broad categories, either "temples" or "forums." The distinction is important because one is easier to morally support than the other is.

Temples, Cameron says, are locations for the spoils of victorious conquests, while forums are spaces for debate and ideas.[6] This designation would label temples as culturally regressive, or at least stagnant, because they've hoarded spoils of war, whereas forums are places to share ideas that support education and shared knowledge. Many Western art museums fall somewhere between.

Collections span artifacts forcibly taken through conquest and war and treasured historical objects donated from private collections or purchased by the museum directly. The points are to acknowledge the museum's complex history and to know that each artwork's journey, from artist, to museum display, is unique. The collection you see when visiting a museum is a mosaic of genius, luck, nepotism, elitism, inspiration, robbery, passionate debates, and piles of money.

We take the word museum from *mouseion* in Greek, or "house of the muses." The muses were nine nymphs born from the sexual relations between Zeus and Mnemosyne, the personification of memory. They slept together for nine consecutive nights, producing offspring that exemplify the best of artistic pursuits: epic poetry, music, love, hymns, history, tragedy, comedy, dance, and astronomy. A museum sets about to collect and preserve artifacts that represent the best of these categories, or that was the original intent of the word.

The first museum was founded in Alexandria about 300 BCE by Ptolemy I Soter.

> *"The Mouseion of Alexandria had some objects, including statues of thinkers, astronomical and surgical instruments, elephant trunks and animal hides, and a botanical and zoological park, but it was chiefly a university or philosophical academy—a kind of institute of advanced study with many prominent scholars in residence and supported by the state."*[7]

This is a far cry from what we'd consider a museum today. In classical times, art and precious objects, such as jewels, were more likely to be saved in a place of worship, such as a temple. In contrast, objects of learning were housed in museums, which sounds more like the predecessor to libraries. Important to remember, arts and sciences mixed inconsistently at museums for thousands of years, until modern systems began to classify and separate artifacts according to increasingly distinct

categories. A prominent example was the French decision to separate artistic and aesthetic objects at the Louvre from other French national and scientific artifacts. Museums evolved in the 1800s and continued expanding access to the public.

The lofty ambition, nonprofit status, and cultural power of museums, open them to substantial skepticism. It's easy to fall short of such high standards. Some critiques are especially biting:

> *"Museums place history, nature, and traditional societies under glass, in artificially constructed dioramas and tableaux, thus sanitizing, insulating, plasticizing, and preserving them as attractions and simple lesson aids; by virtue of their location, they are implicitly compared with and subordinated to contemporary established values and definitions of social reality. When we "museumify" other cultures and our own past, we exercise conceptional control over them."[8]*

On the other hand, where else should we turn, en masse, to view art, science, and natural history objects? Museums are a useful way to observe the past, to feel it just a little. They are places to spend your formative "looking time," building a visual vocabulary, and learning about artworks that broke with one tradition and launched another. This doesn't mean you must enjoy what's offered. As we've discussed, much of what's in a museum is sharply disconnected from our daily life, whether it's noble land, religious doctrine, or mid-century political satire. But the world's prominent museum collections create shrines to our shared memory. They document cultural and national triumphs, as was the case for nineteen-century American museums, African museums after World War II, and, more recently, in Eastern Europe as nations emerged from the Soviet Union. Museums collect because they believe parts of human civilization and national culture are worth saving.

Beyond government projects, museums are typically sustained by donations and bequests from wealthy individuals. Museums also buy select works from dealers or auction houses and borrow pieces for specifically curated shows. Ultimately, our museum experience is highly edited by wealthy collectors, dealers, galleries, and curators. That's why I can imagine an alternate history where alternate objects fill museum collections. Superstars, such as Picasso, probably burned too bright for obscurity, but many artworks displayed prominently in the world's top institutions benefit from strokes of fortune.

- Where are your favorite museums? What makes them your favorite?

- Which sections of museums do you like most and least?

- Which artworks do you remember best?

The Descriptive Challenge

After artworks are selected for a gallery wing or show, major decisions still remain. Outside of physical artwork placement, curators must decide how to transmit artistic meaning. Usually this is accomplished through the humble but powerful wall label.

It might surprise you to learn that artwork descriptions are hugely controversial. Each detail is a debate, from the label's location, to size, layout, font, and approach—technically descriptive or more interpretive. In the absence of artists speaking over your shoulder, or writing their own descriptions, museums employ curators to describe the artwork on offer. By describing a color as "bold" instead of "rich," curators open a raft of subtle complications. Bold is strong and potentially heroic, while rich implies financially successful but also maybe aristocratic. While only the curators might lose sleep over such details, they do influence our impressions.

Meaning is born from the interaction among viewer, artwork, context, and description, with the last attribute contributing more than you'd expect from a small, rectangular box at the artwork's

corner. During most museum visits, the average visitor is completely at the curator's mercy for providing useful and accessible descriptions. We don't know a single fact about most artworks we encounter in museums.

That's why it's considered daring when art exhibits forego labels entirely. Some do. Instead, they favor viewers independently engaging art objects. Curators might think that a viewer's struggle to search for meaning, or the lack of textual distractions, is more valuable than the crutch of written descriptions. But this approach is still unusual. Instead, museums increasingly rely on external support through an exhibition app, audio player, or pamphlet, which isn't in the artwork's visual field. Most still continue to also employ wall labels.

An exhibition I attended in 2015 adopted the opposite approach. Descriptions stretched more than a dozen lines in large font. Huge text boxes were directly in the visual field of most artworks. It was visually intrusive and distracting, but given my utter lack of history or context for most of the artworks, the labels were insightful, despite the distraction.

The point is that we shouldn't take wall labels for granted. Smart professionals who dedicate their work to guiding you through exhibitions probably underwent caffeine-fueled debates about each supporting word you read. Careers were accelerated and slowed based on the committee's interpretation of their descriptions. Our task is to balance reading the descriptions with enjoying the art on its own terms.

How do artwork labels affect your art experience? Have you thought about it before?

Museum Criticism

I have two criticisms of museums that I think should inform your time in them:

1. Hidden collections
2. Viewing support

Hidden Collections

Museums collect much more art than they display. Look at the percentage of art in museum storage:

> *"The numbers don't lie. At New York's Museum of Modern Art, 24 of 1,221 works by Pablo Picasso in the institution's permanent collection can currently be seen by visitors. Just one of California conceptual artist Ed Ruscha's 145 pieces is on view. Surrealist Joan Miró? Nine out of 156 works.*
>
> *The walls of the Tate, the Met, the Louvre or MoMA may look perfectly well-hung, but the vast majority of art belonging to the world's top art institutions (and in many countries, their taxpayers) is at any time hidden from public view in temperature-controlled, darkened, and meticulously organized storage facilities. Overall percentages paint an even more dramatic picture: the Tate shows about 20 percent of its permanent collection. The Louvre shows 8 percent, the Guggenheim a lowly 3 percent and the Berlinische Galerie—a Berlin museum whose mandate is to **show** [bold emphasis not in original quote], preserve and collect art made in the city—2 percent of its holdings. These include approximately 6,000 sculptures and paintings, 80,000 photographs, and 15,000 prints."*[9]

This doesn't make me feel good or proud of museums. Despite my love for museums, realistically they are hiding many of the world's most beautiful treasures! Museums are mandated to collect and preserve, but to use a cliché from one area in another, if a painting falls in a museum basement, but no one is around to see it, does it make a sound?

If Art Is in the Basement, But No One Sees It...

Viewing Support—Thirteen Seconds and the Art Experience

I decided to visit the de Young museum in San Francisco to see how much time people spend viewing famous artworks.

Through conversations and unscientifically experiencing the lack of welcoming seats in art museums, seats that make hard, plastic airport boarding gates seem plush, I had a sense that the time visitors spend with most artworks, even famous ones, was minimal. I could be wrong, and maybe it didn't matter. We do process images quickly, almost instantly. But processing isn't absorbing, so I had to take a look for myself at viewing time. Plus, museums surely know about our short attention spans and feeble concentration. Their curators and docents can't help but be terrified by our fumbling with text messages and group chats between selfies and social media posts. Being the experts and guides, museums should have a plan to counter our frailties, if they were as bad as I suspected.

The de Young was packed, perhaps due to a Keith Haring (American artist and social activist) exhibit in the basement. My plan was to view renowned pieces in the permanent collection first, and track how long the average visitor viewed those artworks. To the de Young's credit, the curators make it easy. They provide listings of important works for visitors who have only one to three hours. I knew exactly which artworks they considered "most important works" from a glance at the visitor's pamphlet.

The de Young is one of the most visited museums in the United States,[10] despite being physically smaller than what I've come to expect from museums in New York; Washington, DC; Chicago; or the national museums in Europe. It's beautifully set in San Francisco's Golden Gate Park, amidst trees, manicured bicycle paths, flower gardens, and a host of other attractions.

Two American paintings were listed as most important for the time-oppressed visitors with only one hour: *After the Hunt,* by William Hartnett from 1885, and *Rainy Season in the Tropics,* by Frederic Edwin Church from 1866. First, I sat with a double espresso in the cafeteria downstairs. Visitors clamored for kale salads and gluten-free treats, trendy health options that make the city proud.

Despite a bustling cafeteria, the second floor was calm. It was easy enough to find the two paintings. Upon seeing the map spread across my face, a few guards offered assistance. *Rainy Season* is in room 26, "Art in America until the 20th Century." The paintings hang with a masterpiece confidence in heavy frames, muted hues, and a preference toward landscapes that would please the landed nobility of post-Renaissance Europe. It's easy to spot *Rainy Season,* which is given a position of prominence, front and center, in the hall.

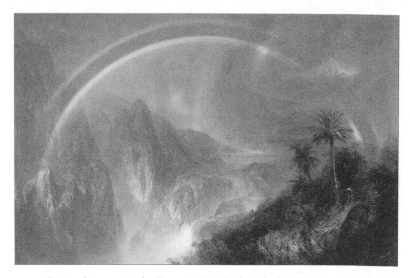

Rainy Season in the Tropics, Frederic Edwin Church, 1866.
Fine Arts Museums of San Francisco, California. Public domain.

I was eager to begin timing. I had been thinking about this exercise for weeks. Despite ample space, and being listed as one of two critical artworks in the entire museum, not a single bench exists in Room 26, or Room 25 for the matter, which contains *After the Hunt,* by Hartnett.

With journal, stopwatch, and pen in hand, I hit "start" when the first person walked up to *Rainy Season's* visual field and was clearly focused on that piece. My count of seconds was a best observable guess, but probably within the margin of error that political polls offer. The man walked up to the piece, raised, then lowered, his head slightly in acknowledgment of the artwork's verticality, and moved on. Three seconds. Surely, my first participant was an anomaly!

I had already written lines and columns in my notebook so I only needed to stand awkwardly without viewers noticing that they were also part of the show. If I had any drawing talent, I could have faked a practice sketching session, but instead I stood, walked, and faked interest in other artworks—especially the immediately neighboring paintings, excused myself to go into the

adjacent room, then returned. It was a long thirty minutes. I was on a head-nod-basis with the guards, not because they seemed suspicious, but because we shared a moment of empathy. We connected about how slowly time passes when you're viewing the viewers.

A few words about *Rainy Season*: I couldn't ignore a sense of hope, perhaps one that's clichéd now, but equally difficult to ignore or suppress. Dual rainbows drape over stiff peaks. The sun shines through passing clouds that merge with the waterfall spray. Two figures nestled in the foreground are eclipsed by their surroundings. These clouds aren't gathering, they're passing. The story goes that Church visited Jamaica in 1865 after two children unexpectedly passed away. *Rainy Season* was a cathartic return to positivity. An art history class could spend an afternoon dissecting and appreciating Church's painting.

As expected, visitors spent little time viewing the suggested artworks, at least this masterpiece, *Rainy Season in the Tropics*, on this day. The average viewing time was thirteen seconds. I'm not sure how much to lament thirteen seconds, given that we do process visuals quickly, and we have an uncanny ability to scroll through photo streams, but I do pity it. It seems we'd benefit from a pause and a question. Entire volumes have been written about how to view art, but if visitors haven't read those works before entering the museum, they won't have guidance. Masterpieces probably deserve more than thirteen seconds.

Something more troubling happened. While counting viewers, there was a pause, a yawning gap, without anyone viewing the artwork at all. And then it happened again, and again. During thirty minutes, there were eight entire minutes when I was the only person viewing *Rainy Season*. This was a Saturday. The de Young is a well-visited museum in the United States. Bodies were in the halls but not stopping here. It turns out that most museum visitors do *not* remember a single artwork mere moments after they exit the building. Visitors move quickly and skip famous artworks. We are more distracted than I thought. Where is the viewing support

from museums who allow this to occur? The museum listed only two artworks as critical for visitors with an hour in the museum, and yet clearly many visitors skipped these artworks entirely.

Downstairs, Keith Haring was a raucous celebration in comparison. When you think of an exhibit with buzz and star power, this was it. The show amassed more than 130 artworks across Haring's unrestrained experiments, on mediums such as tarps, canvas, and sculpture. Haring didn't live long (1958–1990), but his legacy includes an early embrace of street art, sociopolitical activism supporting monitories in the LGBT community, and a commitment to AIDS awareness later in life, after he was diagnosed with the disease. His classic motifs of dogs, penises, and stick figures are difficult to forget, especially pared with community-minded activism. The work still feels urgently contemporary.

Average viewing time in Keith Haring's grand hall was two minutes and eleven seconds. This is the time a visitor took to walk across the main 50-plus-foot panel until he turned to a separate wall. The wall in question was a visitor's first introduction to Haring's provocative and sexual style and contained more than twenty-five artworks, which dipped from floor to soaring ceiling (at least 30 feet high) and wall to wall. Visitors were chatting, smiling, giggling at penis drawings, dropping Andy Warhol references, and shyly allowing themselves to settle on the uncouth images. Although only a few seconds per piece on average, two minutes and eleven seconds seemed like a deeper experience.

The question becomes: Do you want to leave your apartment; drive through city traffic; find parking, which is usually expensive; pay for an entrance ticket, and navigate the crowds to spend two minutes and eleven seconds in the main hall of a major exhibit? Do museum curators want that? I don't know.

I leave you with a quote and thought about viewing time: One of my favorite artists, Julie Mehretu, spoke on Tate Artist Talks and described why she chose the style and scale of a recent exhibition:

"Because I was also frustrated with the desire of trying to decipher these paintings . . . it became such a hindrance to the ability to just be immersed in the painting and have a physical experience or a really time-based, slow experience. To think painting is very slow, it takes time, and we consume images so quickly, and our ability to really stay in front of a painting for 10 minutes is almost— you rarely see someone look at a painting that way, and paintings operate over such a long time, so a lot of what I was interested in in these paintings was the use and amount of information that goes into them to participate in this other kind of experience that could happen and I wanted to move away from the desire to try and read them or decipher them."[11]

Validating my bleak hypotheses reiterates the need for museums to provide better viewing support, in terms of descriptions, comfortable seating, and clear guidance to famous artworks. I can't say what's the definitive best amount of time to spend with famous works, but I know that we shouldn't skip them entirely or spend thirteen seconds with them, and that it should be easy and engaging. Now that you know a few of the shortcomings though, you can better prepare to avoid them and enjoy yourself!

- How much time is "enough" to experience artwork live in a museum?

- How would you encourage time, discussion, and engagement with live artworks in museums and public spaces?

Art Fairs

Art fairs have become a global focal point for the art world, as much a party as a viewing experience. They are the art world at full tilt, popping champagne and debating the zeitgeist. Since the late 1990s, the number of global art fairs has expanded exponentially. Only one art fair existed in London at that time, while now more than twenty occur

annually in England's capital. Around the globe's major art locations, hundreds of larger fairs and thousands of smaller ones occur each year.

We won't dive deeply into spatial or geographic constraints that art fairs place on the viewing experience. Viewing art at a fair is fast, furious, and infrequent. It's simple enough to say that objects presented at art fairs *are* art based on blessings from art world insiders, such as dealers and gallerists. Exhibitors are selected with care and scrutiny to fit the fair's brand image, and much of the artwork is presold or reserved for preferred collectors before the doors open. Fairs might include site-specific work or temporal performance components, but most of what you see would fit comfortably in a gallery, museum, or home.

Fairs create powerful gravitational pull toward famous sites, such as Basel, Switzerland; Venice, Italy; or Miami, Florida, in the United States—sites of three of the most famous global art fairs. They offer a compelling logistical alternative to gallery hopping, and a useful format for dealers and artists to present their work en masse. I enjoy the vibrant energy of a show, even if I can't buy the artwork on offer.

Digital Locations

The digital "where" of art gets an honorary mention in respect to future possibilities more than present realities. Most art shared digitally via apps or websites also exists physically. The digital channel *extends* a physical viewing experience but rarely is the primary medium itself. Outside of a few ecommerce websites and tests in virtual reality, digital is not *where* art resides but a window to a known location or a medium of production. Much can still be said about the physicality of art—the materials used and immediacy of having an artwork tangibly within your reach. That said, expectations about tangibility might change or evolve. Viewers might become accustomed to experiencing art digitally.

Given art's adaptability, we can't be sure how emerging artists will test the boundaries of new mediums and display methods. But

we can be sure that artists *will* test those boundaries. We can be sure that digital platforms *will* grow. Tests in virtual reality show promise for navigating museums and viewing artwork up close, all without the crowds. We live during a transitional moment for art viewership. *Where* we experience art will likely blend digital, physical, and augmented methods. One day, more art might exist digitally than physically. Until then, digital art is more of a reductive distribution channel than an independent medium. Colors and images don't pop with the vibrancy of live artwork. Texture is flat. Digital art doesn't fill your space at home.

Original artworks viewed digitally still feel derivative in their lessening of the original artistic intention. For now, digital is a thumbnail and a commercial avenue. I'm optimistic though, that eventually, art and technology will find a way to complement and enhance each other, and that it will probably allow us to view masterpieces up close at home. Where we view art today might be at the edge of the largest transition since art migrated from a handful of religious venues to the public market and common home.

Conclusion

Where art exists matters. Location validates importance in the art world. Location also foreshadows your likely experience. Each location is steeped in a unique history of collection and display, and those location types—a home, gallery, art fair, museum, or the side of a building—indicate unique themes. Art at home allows a depth of time, while in a museum, it projects institutional and historical power and builds shared culture. Public art supports or criticizes society, and gallery art fills a corner of the commercial art market. Digital art extends them all, while it also begins to test independent modes of value. It's useful to ask yourself why an artwork is displayed in a given location, if the artist intended for it to be shown precisely there, who selected it, and how they chose to describe it.

Part III: Rapid History When/Who

Art History: Fast Forward

In this section, our goal is to build on the foundations of why art matters: What it is; how we view it, and where we encounter it, to fill in the cement structure of a foundation with the grout of specific facts, dates, artists, and movement names. It's not a foolish delusion to expect real results from a few pages of art history. Art historians often lament the hyper-competitiveness of their field and blame the *scant amount of art history* to go around. Art scholars hustle to propose increasingly esoteric theories and fill a niche. But we don't need to concern ourselves with that. We don't need to break new ground. We will rapidly run across well-tread paths.

Western art history consists of a few significant milestones: classical Egypt; early and Hellenistic Greece; Rome; the Middle Ages, which includes Gothic and Baroque periods; the Renaissance; the Reformation; an explosion into modernist movements; and the fragmentation of contemporary art. You've heard all the terms, even if you didn't study them in high school or college.

My goal is to jostle your memory and spotlight salient movements and artists. This means we'll necessarily skim and take a traditional perspective. We don't have time for edge cases or caveats, but you should continue to explore movements and artists that catch your interest. In addition, it's useful to note that art historians and critics are beginning to reexamine and open the traditional art history canon to underrepresented racial minorities, women, and less-documented mediums that have been excluded by mainstream history books to date. In ten years, the art history classics presented here will remain high profile, but we'll have elevated lesser-known artworks to their proper place. That debate is only shaking out, so we'll cover salient themes in Western art history in a handful of pages.

Evolution of a Word

As mentioned at the outset, the word "art" isn't particularly useful anymore. You might have built your own definition in an earlier section, but here we're reviewing how the word, art, meandered into its ambiguous meaning, which exists somewhere between platitudes and a personalized, custom definition. That makes art both too big and too small. We found our way to this definitional paradox through generations of etymological change and a coinciding evolution in how art is positioned in society.

The earliest similar root for today's English word "art" derives first from Sanskrit, likely from *rtih*, which meant "manner" or "code." It's a way of doing something.

After rtih, in the language known as Proto-Indo-European, from the Eastern grasslands of Europe, the word was *artis*. Then we find related words appear in ancient Greece: *arti, artios, arête,* and *techne*. The first three words *sound* like rtih and arti, while the last word shares a productive meaning.[1]

Arti meant "just now" or "just" and artios meant "complete." Whether or not these words really laid the foundation for art as we know it, they do hint at a right action and output. They reflect ideal attributes more than physical production or the concept of fine arts that we have today.

Going further, arête was the ambition of Greek life. It was goodness, virtue, and the excellence that citizens strived to achieve—to be one's best self. It's hard to ignore common words like artis, artios, and arti, and the shared aspirations of being or showing goodness and virtue, whether through the action of winning an Olympic event or defeating a foe, in the flesh, or later, as a statue in stone. Arete also seems to align with the spirit of Sanskrit's rtih in terms of a manner or code for living, guidance for being or doing. Art of Greece, Rome, the Renaissance, and to an extent still today is measured by its successes displaying these positive attributes—tenacity and triumph, wisdom and power, humility and piety.

Techne, although it doesn't look similar, was a direct path from rtih and artis to art. It means "craft" or "skill." Techne was the skill applied to produce a proud urn or deliver insightful rhetoric. It was not the object itself but rather an ability to bring forth. Techne always applied to another, named end goal, like techne plus logia (study, lore), to mean technology -also, a skill of bringing forth or creating.

The eventual Latin form of art was *ars*. Ars is a noun, like techne, which means "craft" or "skill," and was also applied to specific ends, depending on its usage. The ars of X became a standard format, like the one we know today. While ars was an activity, *artem* was the related outcome.

Greek and Latin sources for art spawned a vocabulary of related words. Artificialis, for example, meant "of or belonging to art." It wasn't negative at first, just a humble, human-made product, rather than one sourced from nature. Aristocracy meant the rule by those who exemplified excellence or just action. Today most of us cringe to think that aristocrats were endowed with unique ruling power, especially the attribute of justice. Artiface, from the 1530s, acknowledged "workmanship, the making of anything by craft or skill." It also connoted a lesser attribute, "cunning." It came to represent the act of deception, the way of being artificial, which meant employing a "device or trick," or acting in an "artful" manner. From ars to artful, words related to art imply *both* skill *and* deceit.

More recently, art modernized in Middle English and French as related to the liberal arts-related skills in scholarship and learning. Beaux arts surfaced in France during the mid-eighteenth century (1753), associated with a specific architectural style of ornate columns, arches, domes, and the grandeur of classical antiquity. The French term expanded during the eighteenth century to encompass the fine arts, which were visual objects of beauty and meaning ranging across architecture, sculpture, painting, and more.

It wasn't until about 1880 that art broke free, when the English

language dropped beaux, fine, or associated prefixes, and adopted the individual term, art. Once art jettisoned associated words, such as beaux arts or ars technica, it was free to absorb whatever meaning that context or users deemed relevant. This is when the word and practice of modern art as we know it was born.

Any concept so tightly bound to both outcomes and techniques, skills and knowledge, was predetermined to suffer from a lack of specificity, a fate it tragically achieved. Art is physical, dirty, and tangible, and simultaneously it implies subject matter or process knowledge, and it connotes a mysterious sheen, the ability to create something that didn't originate from nature. The negative and skeptical connotations remain, although looking at common usage today, the balances are positive. Labeling an activity "an art" implies a lack of precision, yes, but also hints at the intuition and creativity, the deft skill and practiced technique, necessary to achieve one's ends.

Conveying Meaning—Aesthetic Philosophy

Aesthetics can be defined as follows:

1. The branch of philosophy dealing with such notions as the beautiful, the ugly, the sublime, the comic, etc., as applicable to the fine arts, with a view to establishing the meaning and validity of critical judgments concerning works of art, and the principles underlying or justifying such judgments.

2. The study of the mind and emotions in relation to the sense of beauty.[1]

Philosophy, more than art, is a topic where you expect one thing but get another. In art, we expect beauty but are often challenged with political, social, gender, identity, or commercial ideas. In philosophy, we expect wisdom and insights from sitting at the metaphorical feet of Plato and others, but we're treated to a slog through analytical definitions, intricate logical arguments, cultural battles steeped in time periods we can't translate, and, yes, a smattering of quotable insights.

The point is, you need to stick with me as we march through a list of ideas related to aesthetic meaning that many of history's bright minds didn't make easy to untangle. Knowing aesthetic themes will accelerate and deepen your art experiences in any setting. It will help you compare the artwork you see with prominent meanings that artists addressed or were aware of during related time periods.

Aesthetic philosophy, the philosophy of perception, taste, sensitivity, and the appreciation for beauty and physical experience, is where we turn to uncover how philosophers examined the meaning and value of art. While they *have* spilled ink on aesthetics, more so recently, it was rarely their primary focus—almost never. As I've mentioned before, until the eighteenth century, aesthetics was usually tucked quietly under the exploration of morals and ethics. To be good or true *was* to be

beautiful. Rarely did philosophers venture that aesthetics mattered independently from value judgments. Even Epicureanism, the school famously mislabeled as the hedonistic predecessor of frat parties, did emphasize how sensory experience ruled our lives, but it did so to address taste and judgment, not to encourage raucous behavior.

I think the challenge for philosophers lies in the nature of physical experiences. They are ambiguous, changeable, and personal, we could say selfish. We experience the world through our bodies and not on behalf of anything or anyone else, even if we contribute to another person's experiences, like bringing a bad mood from difficult clients home for dinner, or enjoying a movie more because everyone else is laughing at the jokes. Also, it's hard to find consistent words for our responses to literature, music, and art—or we default to platitudes, like good, or in language today, awesome and cool, but we feel something more complex. Philosophers need consistency in the argument to form their analyses, but we've spent almost 3,000 years debating the meanings of good, true, and beautiful.

In aesthetics, first and most important, we are *embodied* in the world. We are literally a body in the space and time of a physical world. For us to be a person and know who or what we are, we must exist in a world. Being embodied within a world causes our experiences, our encounters of *something* in our surroundings. We encounter it all *through* the body—it's the great limiter and broker of experience. Aesthetics must matter and be relevant, because it is the examination of our bodily and sensory exploration of the world.

As we are sensing through our body, we generate feelings and ideas. We are happy or sad; we remember early childhood love or rejection, a satisfying vacation, a terrible argument; and we feel them all in mind and body. Our body remembers the sensations from those experiences and creates new memories as circumstances unfold. As they do, we accumulate a reservoir of physical memory, not just emotional or intellectual memory. Our

body stores history and generates anticipations about the world around us. We can try to intellectualize life, we can preach on topics from war to peace, but we can't undo the reality that all experience is mediated through the senses. War is terrible and peace is comfortable, largely because of how they impact our senses.

Beyond the body, the way philosophers engage aesthetics is through art. Art isn't required for an aesthetic experience, but it's a common gateway. It easily enlivens our senses. It forces us to address physicality and observations. Art is composed of artist, art object, and art viewer(s). During an art experience, we consider our individual feelings, intentions of the artist, and the broader audience around us. We have individual and group experiences. The range and complexity of art experiences is why they're linked so tightly with aesthetics.

By the eighteenth century, suspicion and confusion about aesthetics was balanced or eclipsed by an admission of value. Maybe philosophers ran out of runway on traditional topics, such as ethics or metaphysics. You can only examine morals, being, and suffering for so long. The arts enable us to investigate the world through objects that redefine space (sculpture, painting, etc.) or feelings that redefine time and emotion (music, literature). When I view a Murakami sculpture or an Ai Weiwei installation, I'm forced to think about how the world works and how I'd like it to be.

Eras of Aesthetic Philosophy

Era 1 35,000 BCE–500 BCE

- Mystery
- Harmony

Era 2 500 BCE–200 BCE

- Harmony
- Derivative
- Inconsistent
- Hypocritical

Era 3 200 BCE–200 CE

- Harmony
- Therapy
- Diagnosis

Era 4 200 CE–1400 CE

- Morals
- Truth
- Godliness
- Goodness

Era 5 1400 CE–1600 CE

- Harmony
- Proportion

Era 6 1600 CE–1750 CE

- Uncertainty
- Emergence

Era 7 1750 CE–1850 CE

- Subjective
- Feedback
- Relationships
- Sublime
- Genius
- Attachment
- Judgment
- Dispassion
- Perfection
- Subjective universality

Era 8 1850 CE–1950 CE

- Community
- Social expression
- Equality
- Consolation

Era 9 1950 CE—Present

- Experience
- Connection
- Interaction
- Redefinition

Here I've identified nine eras of aesthetic philosophy, each with its own themes and attributes. There's nothing scientific about the eras. Certainly, academics could debate the pivotal moments and exact lengths, but emphasis is unique between eras. I think it will be helpful to consider aesthetic philosophy as a progression across time and iterative exploration of recurring themes.

Era 1

Art probably started with mystery.

The images on caves supported rituals that invoked the spirits stored within them. Art brought the force of its images to reality. We can't name the philosophers—the shamans or chiefs—who worshipped artistic images this way, but we have enough evidence from limestone drawings and figurines to infer their beliefs and intentions: art began as the representation of mysterious or superstitious ideas.

Era 2

Art is harmonious but doubted and questioned.

Plato probably sensed art's genesis in mystery and he didn't like it. He (about 400 BCE) was notoriously skeptical of art, saying that visual art was, at best, a harmonious distraction, and at worst, a dangerous imitation of an idea, a derivative of it. If art is to attract attention and convey meaning, nothing more, then Plato would have preferred we attract attention through our speech or writing, and convey the meaning of our ideas directly. Rather than sculpt a muscular statue raising a spear above a vanquished foe, or detailing the curvature of an urn with images worshipping the seasons, stand in the public market and ask your conversation partners to outline their beliefs about heroism or devotion.

Plato believed that truth should be known with certainty based on logic. The emotions we feel from an artwork are fleeting and changeable, but truth is consistent. To "know" something through your senses is to rely on a flawed mediator. To a wise septuagenarian, a Grecian urn is dim and hazy, while the sprightly

youth sees delicate leaves of gold. The senses degrade, so they cannot provide a consistent mediating faculty.

Art was inconsistent and derivative. But Plato went further, delegitimizing artists themselves: what did they know about holding a spear in battle or communing with the gods? They were hypocrites, presenting the illusion of knowledge through their objects. Artists knowing *how to make* a harmonious thing doesn't mean they *understand* its virtue. Their images portray glory, suffering, or lives well-lived, but they might not have personal capability to achieve those ends.

Era 3

Art helps us diagnose harmony and our ways of living.

After Plato, Hellenistic aesthetics more broadly wasn't as concerned about the attention that artists or art objects received. Their aesthetic project was understanding the attributes that created harmony between our minds and the world. Visual harmony was related—not quite an edge case, but not a significant thrust either. Aesthetics was an investigation of living harmoniously. Senses might degrade, and art objects be less divine than their source, but so long as they encouraged a harmonious life, the philosophical objectives were met.

Aristotle (about 300 BCE) agreed with his mentor Plato that art *is* imitation of more pure ideas but he still believed that art investigation could be valuable. He thought Plato's sour skepticism of aesthetics was misguided. To understand why, we need to think about aesthetics in the context of Aristotle's organizing framework, the four causes theory. His causes show the "how and why of a thing."

The material cause is the physical stuff, like paint. The formal cause is the shape, like the images on the canvas (not formal, like etiquette). The efficient cause is the force that made it—the artist. And the final cause is the purpose of the thing, what it does. Aristotle believed that art is useful, because it helps us understand our final cause as humans. That is, art allows us to know our

purpose. That final cause is our reason for living, and art, through images, objects, examples, and stories, and the empathy they engender, provide a tool for diagnosing our goals and finding our purposes. The fact that art objects were imitation didn't matter. What mattered was their function as diagnostic tools.

Era 4

Art is aligned with goodness, truth, and god.

As European thought became consumed by religion, it's understandable that the philosophy of aesthetics took a related tone. Neoplatonic aesthetics emerged centuries after Plato to claim his name, if not his entire mantle. Their core tenet was an idea called "the One," an intellectual competitor to monotheistic religion and a spiritual relative to Eastern doctrines of unity. If Plato's theory of ideas was meant to describe the source of physical objects, from where did these primordial ideas spring? What could be such a profound source that it held and generated ideas? The *One* was their answer.

Beauty was a physical extension of the One, and therefore a visible marker of truth. Neoplatonists would have agreed that physical sensations are fleeting, yes, but the One is not, and it underlies those sensations. Moreover, a philosopher might not be able to locate or identify beauty specifically on an urn or a statue, but that's because beauty pervades and transcends it. Truth is deeper, but we only see the statue. Accordingly, it's easy to understand how beauty is attached to morality. Judgments and opinions about beauty must be coherent with our beliefs in truth. If we think a person, tapestry, marbled column, or mountainside is pretty, we must believe and know they rely on a supportive *goodness,* which resides beneath the surface.

If true, consider the dangers inherent for the unattractive or disabled, for people and objects that were unappealing and imperfect! They must be hiding sickness, greed, treachery, or malice. If you were unappealing on the outside, you must be ashamed of your insides.

171

After the Neoplatonists, aesthetic philosophy fell into hibernation, lulled to sleep by a complete devotion to godliness, ethics, and religion. The current of morality persisted though, grasped by Thomas Aquinas (thirteenth century), a Christian philosopher. He viewed the world, and aesthetics with it, through an entirely Christian lens, and his philosophical project was to tie disparate subjects, like living, goodness, and devotion, back to the organizing principles of Christianity. Aquinas did comment directly on aesthetics as an independent topic, but mostly as a means to sense and reflect godliness and good moral character. He said, in much agreement with the Neoplatonist One, that beauty must emanate from an object through an indescribable effervescence—a quality deeper than the object itself, God.

Era 5

Art examines visual proportion and harmony.

The Renaissance, for all its creative achievements, wasn't a period of overt aesthetic philosophy. Aesthetics were shown more than told. That said, it's worth noting Leonardo da Vinci's *Vitruvian Man* as the exemplary idea of aesthetics during the Renaissance. The iconic picture relates the human body to mathematics, specifically architecture. Leonardo includes notes from the Roman architect Vitruvius around the drawing. It was a detailed list of male bodily ratios: *"a palm is four fingers, a foot is four palms, from above the chest to the hairline is one-seventh of the height of a man, the root of the penis is at half the height of a man."*[1]

Vitruvian Man didn't make explicit aesthetic arguments, but they are easily inferred. It reinforced the human connection to a naturally recurring order and emphasized harmonious proportion. If the Renaissance was a rebirth of learning, the emphasis on arts, math, music, and architecture relied on spotting patterns in natural numbers, those that supported new ways of holding structures and domes, despite great weight; of displaying images with foreground, background, and depth; and of decomposing the ratios behind an attractive human form. To live an aesthetically pleasing

life was again to find harmony. The emphasis on religion was unabated, but it was numerically informed.

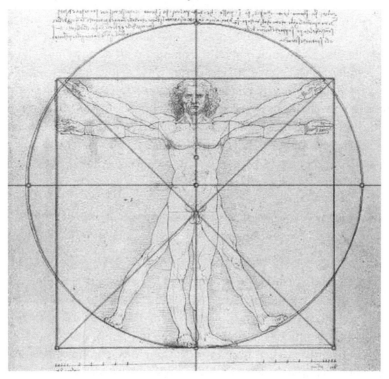

Vitruvian Man, Leonardo da Vinci, c. 1490.
Gallerie dell'Accademia, Venice, Italy. Public domain.

You are a harmonious composition of circles, squares, and triangles.

Era 6

Art is again questioned as unreliable or uncertain.

After the Renaissance, the age of Rationalism occurred. Aesthetically, we can't quite call it an era, so much as a transition. French philosopher Renée Descartes (1595–1650) cited "radical doubt" to claim that absolute certainty was an elusive concept. His sentiment informed and captured the spirit of a skeptical age. The senses were wrought with illusory perceptions, and therefore they were untrustworthy. Only reason could redeem uncertainty.

Descartes claimed he didn't know much, but famously leapt from the darkness with *"Cogito ergo sum,"* or *"I think, therefore I am."*

Descartes didn't comment frequently on aesthetics, which makes sense. In following logic similar to Plato's, how could he or anyone else know much about aesthetics with a reasonable level of certainty? And above all, Descartes was curious about *certainty* and innate qualities. If you can't trust your senses with certainty, then the observations of the senses were questionable. All of them. This included artistic observations, which were, at best, irrelevant to Descartes, and at worst, a misleading falsehood. Rationalism raised the burden of proof required to formalize aesthetic judgments.

Era 7

Art is exalted to new heights. Art theory is born as we know it today.

From the Hellenistic philosophers to Descartes, art was glorified and vilified. Opinions about art, beauty, and aesthetics were aligned with broader trends, which meant that when devotion and God were paramount in philosophy, the pursuit of aesthetics was related to virtue, when harmony or rationality captured the tone, aesthetics aspired to those ends or was condemned to fall short of them. The Age of Reason had birthed pragmatic and repeatable scientific exploration. With it, art was sidelined and viewed skeptically.

The Age of Reason preceded the Enlightenment, a movement that continued to champion rational thought, and introduced the first wedge between church and state, eased dogmas around social and religious tolerance, and systematized knowledge through landmark publications, like the first encyclopedia. Perhaps searching for meaning outside the church, perhaps as a natural expansion of detailed knowledge, the study of art and beauty changed in 1735, when German philosopher Alexander Baumgarten used the specific word, *aesthetics,* to capture an expanded but also more artistic connotation.

Aesthetics ceased to denote, simply, "to sense," following the Greek etymology, but instead it signified a standard of *taste or judgment*. Taste and judgment were the new muscles and habits that nobles and a rising middle class cultivated and prized during the Enlightenment. In the midst of social and scientific change, Baumgarten snuck aesthetics into the heart of perception. At first, the quality of beauty didn't change much. It still signified harmony and "unity in variety," inspired by Hellenistic and Renaissance ideals. But now the *experience of* beauty was as a unique phenomenon.

Scottish philosopher David Hume (1711–1776) said that people have a fluid, changeable understanding of their environment. We are constantly reconsidering our surroundings. Aesthetic experience is valuable to each person, because through it, we learn and reconsider what pleases us, so that we can then tend toward and emphasize those locations and situations. If we never visit crowded bars, vaulted theaters, or distant campsites, we won't know if those locations arouse our senses. If we don't attend art shows and concerts, or explore new literary or cinematic genres, we won't know which formats enrich us, and we'll miss opportunities to pursue rewarding impulses. But here's a trick that philosophers added: gatekeepers. Given the level of aesthetic subjectivity involved, society needs qualified, objective critics to arbitrate the standards of taste, to provide ratings and scores, and to deliver outright guidance so people avoid wasting their time exploring lackluster activities.

The calls for critics and experts make sense in context. During the rush of scientific discovery, a time when the encyclopedia was published and people were exploring new governments, it's understandable they'd designate experts to arbitrate newer discussions, like those around aesthetics.

German philosopher Gotthold Lessing (1729–1781) aligned with Hume's thinking. Art was useful, for artists and viewers, despite the lack of functional utility, for how art *reorganizes* our space and time. Reorganization *was* art's utility. Artists find ways to

recreate their environment: Poetry and literature order the inner self, while the plastic arts recreate physical, external space around us. Aesthetic experiences help us investigate the relationship between ourselves and the outside world, which again, in context, seems reasonable during times of unprecedented change.

During this time, Irish statesman Edmund Burke (1729–1797) changed the conversation by identifying a new concept, the sublime. The sublime was often physically beautiful, but it was more and distinct: it aroused awe, love beyond passion, and helplessness in the face of untold, natural power. It's the feeling of being overcome by a sight that you don't fully comprehend. The marriage of mystery and awe enliven a hint of fear. It's godlike but not necessarily religious. An endless sea of rough and frothy ocean waves, a violent clash of purple, charcoal and gray clouds spewing jagged lightning, or the dusty scattering of ordered stars on a black night, could all provoke appreciation and fear of the sublime.

Here we straddle across two broader intellectual movements, the Enlightenment and Romanticism. From a purely aesthetic standpoint though, appreciation of the arts continued to accelerate, natural beauty was exalted by the sublime, and philosophers began to identify the sources and causes for aesthetic phenomenon— genius and imagination.

German philosopher Immanuel Kant (1724–1804) was a giant in aesthetics due to his *Critique of Judgment* (1790). As a standalone work, it's not Kant's most famous, but in the field of aesthetics, it broke ground by identifying seemingly irreconcilable challenges, providing art-viewing recommendations, clarifying the need for professional critics, and defining genius. We introduced Kant in Part I, but his ideas are worth repeating.

Kant clarified the contradiction at the heart of the aesthetic debates, one that had troubled philosophers since Plato: we cannot seem to agree, despite logical argument or emotional pleas, yelling with conviction or pounding the table, on what's beautiful. In moments of aesthetic appreciation, we believe and *know* that our

peers should concur with our judgments. They'd be crazy not to agree with us! And yet, in many cases, they do not.

Kant named this issue subjective universality. When we bestow the label *beautiful* on an object, we do so with universal declaration. It's not beautiful on Monday and Wednesday, or beautiful when I feel well-rested or fed. It's beautiful now and always, and we expect agreement. But we are rarely able to convince others that a photograph or painting is beautiful, if they don't already and immediately agree with us. Time might soften their attitudes, but a momentary argument will not.

Kant advised that the best move to ensure consistent objectivity is to culture a high standard of taste and discerning judgment. A technique at our disposal is the dispassionate gaze. That is, being rational and impartial while viewing artwork. Dispassion allows the viewer to analyze art without emotion and to avoid the covetous feeling of possession. Look with the mind and tame our baser desires. Through a dispassionate gaze, we enable "free play" between our logical reason and imagination.

Artists cannot be dispassionate, though. Their work demands genius. Kant proposed what seems accepted today, that genius was the ability to express novel, fresh, and insightful ideas, to see and create what others were incapable of delivering. Kant's type of genius was creative, rather than academically gifted, inspired, not equipped for the rapid and precise ability to acquire information. Kant would not have been impressed by a perfect test score. Instead, he would praise genius for its unique, direct access to beauty, and more important, to the sublime. In a world where the sublime was our favored experience, genius was exalted, because it could reliably provide access through artwork.

Due to the complexity of the aesthetic terrain, Kant, like Hume, believed that common people were unable to consistently judge matters of taste. This again necessitated critics. Critics could circumvent or square the circle around subjective universality by applying good judgment to determine if genius was present in an artwork. If genius was lacking, a visual work was simply a craft.

During this period, we also meet German philosopher Arthur Schopenhauer (1788–1860), who placed aesthetics at the center of his philosophy, stating that people need to understand aesthetics in order to understand *anything*. The beauty, pleasure, and intuition that art fosters enable us to define the *truth* in life. Pause. With that assertion, Schopenhauer circles us back to times when truth, goodness, and beauty were equally balancing variables. But for Schopenhauer, we need the truth in art, because its perfection *eclipses* nature. He didn't believe any majestic cliffs or frothy waves were perfect or ideally formed. In pursuit of truth, art was *closer to* the Platonic idea than were images we naturally observe. In so stating, Schopenhauer takes an end run around Plato's critique of art: Platonic ideas *are* the essence of existence, but *only* artists can bring them to life. Therefore, art isn't dangerous, it's necessary. Life *should* imitate art.

It's heady stuff. Between the Enlightenment and Romanticism, we find European philosophers proclaiming genius as access to God, to the source of creation, the meaning of life, and that art is the only way we can comprehend, internalize, and appreciate our physical existence. Their works follow a clear, logical path, and we see how the ideas connect, but it's no wonder that critics might accuse these philosophers of navel gazing or overstepping practical realities. Nevertheless, they moved aesthetics from a mechanistic sense perception, to the standard of taste and physical judgment—the lens and measuring tool for physical interpretations.

Era 8

Art grows beyond genius expression to communal value.

Genius was an individual phenomenon, one of accessing a supernatural inspiration and expressing that for the world to behold. As grand an activity as that might seem, it was discretely limited. German philosopher Georg Hegel (1770–1831) said art was a social good. Being human requires the capacity to participate in society, history, and to examine our surroundings. Art was more than expression, feeling, or pleasure; it was a

conduit for social involvement. Art enabled social participation by *testing the capacity for free expression in society.* The actualization of free expression in a culture is beauty. As cultures change with time and place, so will beauty. Artists test current freedoms and propose imaginative futures, and, therefore, can unify the present and the future in society through art.

For all his nihilistic infamy, German philosopher Friedrich Nietzsche (1844–1900) placed aesthetics near the center of his philosophy. Yes, he believed the world was a spiteful concoction of pain and ill health, but art was a savior. Art supports the human need to mask our miserable existence. Art is the proper activity of humankind that reigns supreme over morality and can deliver redemption and consolation in a painful world. In this sense, art is therapy writ large for society. That's an optimistic designation coming from Nietzsche, a philosopher who's often considered history's greatest pessimist.

Beyond delivering at least two of literary history's most profound achievements, *War and Peace* and *Anna Karenina,* Russian writer Leo Tolstoy (1828–1910) was also an aesthetic philosopher. He penned a book in 1897 titled *What Is Art?* Given his revolutionary political leanings, it's unsurprising that Tolstoy didn't consider the purpose of art to express beauty. He proposed that art should *communicate.* It must spread good ideas, not bad ones, proletariat causes, not bourgeois, elite ones. Art is *not* craft or visual beauty, it is the expression and communication of ideas that enliven nobility in the common man. Art transfers wisdom and emotions from the artist to their audience.

English historian and philosopher R. G. Collingwood (1889–1943) also asserted that art should *not* champion beauty. It was better suited for communication, although not with the political bent that Tolstoy proposed. First, art was an emotional form of expression. Expressions were genius and artistic to the extent that they were novel or innovative, in contrast with craftsmen, who replicated or copied prior creations. Ideally, art expresses emotions that unify the artist and the audience. Art connects

subject and object, and genius is the only force that consistently bridges the gap between participants. Genius is the ultimate communicator.

Era 9

Art expands beyond communication; meaning fragments; art refines individual experience.

Here we are today, the twenty-first century. In this text, I have often employed the term "aesthetic experience," but earlier philosophers didn't frequently use the term. We use it today because John Dewey brought us *Art as Experience* in 1934, his foremost work on aesthetics. Dewey believed that we as participants *make* aesthetic experiences, we do not just *have* them. We are active in the creative process. Past descriptions of the art encounter categorized us as responding to external stimuli—reacting. Dewey said that a reactive understanding of aesthetics was wrong, that viewers were now responsible. This plants the seeds of Postmodernism and fragmentation.

There is a rawness and stoicism in Dewey's writings, almost a mechanic's gritty and practical sense of doing, not thinking. Art and aesthetics aren't classist or intellectual. Experience is the tangible matter of physically suffering through an activity. Experience is "the man in the arena" who lives passionately, to use a Teddy Roosevelt phrase from 1910 that Dewey surely knew. Dewey casts aside art, beauty, and genius for the mundane work of walking, talking, doing, and living. No artistic separation exists between viewer-subject and art-object. Aesthetic experience is the same energy as creative production. We are simply alive, not imitating anything, not requiring genius or dispassion to create, communicate, or understand. We are being.

Going further, in 1954 American English professor William Wimsatt and American philosopher of art Monroe Beardsley partnered on an essay titled, "The Intentional Fallacy." Heralding postmodern and contemporary philosophical movements, they said *"the design or intention of the author is neither available nor*

desirable as a standard for judging the success of a work of literary art."[2] We cast away glamorous notions of genius or imagination, and we confront a new intellectual movement, which questions the importance of artistic intentions. We cannot know an artist's intentions at a detailed level. Artists *themselves* might not be aware of the subtle and subconscious forces dictating their creative brushstrokes and stone moldings. We as viewers aren't simply participating in the cocreation of an art experience, our viewpoints and impressions are placed on equal footing with the artist's intentions.

Now we can *use* art for our own purposes. We aren't reliant on artists to help us communicate or unveil the sublime. Maybe Aristotle got it right, like he did so many things, back about 300 BCE, when he said art was a diagnostic tool, a thesis that has regained popularity. Contemporary philosophers have grabbed Aristotle's proposition, but unified it with Dewey's experience and viewer participation. Today, British writer and philosopher Alain de Botton (born 1969) provides a similar thesis in *Art as Therapy*, proposing that artworks are guides and sounding boards that console us through hardship and educate us with ideals worth emulating. Similarly, professor of philosophy Alva Noë (born 1964) says that art *is* philosophical inquiry. It sounds self-serving coming from a philosopher, equating his work with art, but Noë practically classifies art as tool, a *strange tool*, that helps us to create the experiences of our lives.

I find the "tool thesis" congruent with an era that believes technology has few limits, where scientific progress is inevitable. We've always used tools, like striking stones to generate sparks or carving wheels from wood, but today, the buttons have become larger, easier to push. We expect to find a tool for each job, and we control the tools. Our dominion over the environment is absolute, excepting the occasional tsunami or earthquake.

Art is no different. We employ art like a technology, for selfish ends or benevolent ends, but ends that are our own—artist intentions be damned! There are "good" or "bad" buttons,

technologies, tools—artwork. To know an object, to have an experience, sense perception, exert a standard of taste, or create an aesthetic experience, is to make a judgment about the quality of that thing, a marble column with floral etchings or a spray-painted brick building.

Today, whether we react to artwork or cocreate it, the beautiful, good, and true still remain the cornerstone trinity of aesthetic philosophy.

We still embed moral dimensions into aesthetic experience, but there is no accepted arrow of causality flowing from art object to viewer. It's an iterative circle.

Attracting Attention: Beauty and Shock

An investigation of beauty is wrought with landmines. Chronological reviews of beauty's timeline in society belie underlying, contentious themes, which have become more urgent in a contemporary society. But the controversial topics, like is beauty a worthy goal, or is beauty oppressive, have only risen to the foreground in the past two centuries. Dictating a study of beauty around them now, exaggerates their position in art history.

The pursuit of beauty was rarely questioned as an end, in and of itself. Art that is shocking or grotesque, conceptual or identity-based, is not where this story began. Most of art history followed the obvious pursuit of "beauty," a topic that hardly requires an explanation—a visual, physical object that effortlessly pleases the senses, that is easy on the eyes.

- **Ideal:** Is the depiction of beauty a worthy or necessary pursuit?

- **Goodness:** Is beauty indicative of goodness or truth?

- **Universality:** Is beauty universal or individual, consistent or varied?

- **Mathematical:** Do you agree that we define numerical patterns which foretell beauty?

- **Oppression:** Is the depiction of beauty inherently oppressive?

Beauty didn't have a hidden agenda or apply sleight of hand: it was used, for better and worse, to perpetuate religious myths, celebrate nobility and known power structures, whether those followed supportive or oppressive class or gender constructs. If historical works hinted at human suffering, it was usually wrapped in an attractive package. Look at Christ's muscular

body and peaceful eyes amidst the punishment. Images of Christ in pain almost universally glorify his physique or demeanor.

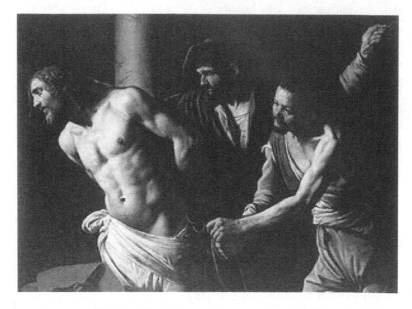

Christ at the Column, Caravaggio, c. 1607.
Musée des Beaux Arts, Rouen, France. Public domain.

Tolerating and idealizing blatant discomfort or shock, or embracing a fragmented, individualized standard of beauty, are recent phenomenon from the past 150 years. Art history books, usually contemporary ones, perform a service by rewriting history to be more inclusive, but they also try to sell us on the idea that perceptions of beauty are infinitely varied, that a gullible populace might accept any standards of beauty that elites or the vagaries of time push on them, and that we cannot spot patterns.

Although we introduced emerging scientific patterns, obviously opinions about beauty *have* varied along the axes of time and place. We've exalted prominent piercings on enlarged lips and ears; appreciated staid, muted robes; and romanticized vacant,

silent hilltops and the clanging of bustling cafés.

Humankind's success in finding beauty in diverse and mundane corners might be our distinct coping mechanism in a cruel world. But focusing on the edges causes us to overlook the patterns.

By stating that beauty is infinitely varied, or fragments in the eyes of each beholder, is to ignore that from ancient Egypt to contemporary New York, we can follow a coherent trail, and that the field of neuroaesthetics continues to uncover new patterns.

We don't need to approve of how mainstream artists have always presented us beauty, sidelining minorities or objectifying women, especially in the modern era, more than men, but visual beauty has been accepted as a worthy goal, one that helps us explore social-moral goodness.

Universality and goodness were visibly shown through attributes of color and light—vague principles about "rich" or "full" colors that framed or emphasized relevant sections of an artwork, and balance and proportion, which provided more mathematical direction, and were first explored most thoroughly though the human body, before moving to investigations of spatial balance in more abstract artworks. As their materials evolved, their mastery of balance matured.

Much of art history has been the investigation and celebration of naked bodies. Egyptian statues influenced Greek kouros figures, a nude pattern from the sixth century BCE, meaning "youth, boy, especially of noble rank."[1]

The Egyptians stand ramrod straight, while the Greek kouros eventually achieved slight flexion in the hips, knees, and body. Both were precursors to Michelangelo's *David*, a figure taut and ready to confront Goliath—a man whose stable torso balances his angular legs.

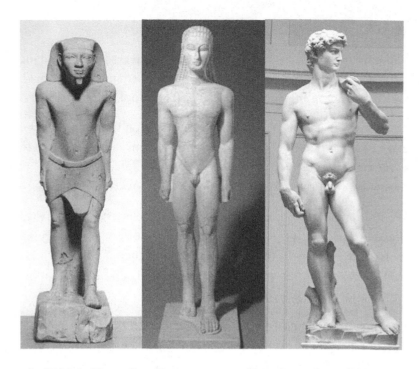

Left: *Male Figure Standing*, anonymous Egyptian artist, c. 746–335
BCE. Walters Art Museum, Baltimore, Maryland. Public domain.

Center: *Metropolitan Kouros*, anonymous artist, c. 590–580 BCE.
Metropolitan Museum of Art, New York, New York. Public domain.

Right: *David*, Michelangelo, 1501–1504.
Galleria dell'Accademia, Florence, Italy. Public domain.

Artists pushed the limits of social acceptability, painting and
sculpting under the guise of art, but still often raising charges of
controversy or lewdness. The male body has retained a similar
shape in artwork throughout eras, a lean strength with low body
fat. It's a look that would turn heads on a vacation beach today, as
easily as it enchanted the Renaissance public. The goal of male
clothing and adornments also changed little—projecting power
linked male beauty with instruments of war, functions of state,
exploration, and economic trade. Objects of power can beautify
even the least kouros or David-like figure, the plump, pasty,

angry, and unfit, to become attractive, or at least command respect.

Throughout the years, the female body, in diverse forms, has been the object of male fantasy, with the balance of preference indicating attraction to a robust, thicker beauty. As we determined in the "Investigate How We Perceive Art" section, attractive female body ratios have tended toward the 0.7 waist-to-hip ratio. Contrary to our perceptions on female exploitation today, females appeared as nude art objects with similar frequency and emphasis as male forms in Egypt, Greece, Rome, and during the Middle Ages and the early Renaissance. In the mid-1480s, Italian painter Sandro Botticelli painted *The Birth of Venus.* She was demur, covering her breasts and groin. A few years later, about 1510, Italian artist Giorgione painted *Sleeping Venus*, a reclining, voluptuous, and inviting nude, who lacked fear or shyness. The erotic female nude was born.

Through the early twentieth century, the female nude transformed into its own art genre, reaching a peak in nineteenth-century bohemian Paris, a moment where artists were socially unencumbered by chaste norms, and before social mores pushed back on sexualization of female bodies. It seems that every Frenchman in nineteenth-century Paris had at least one female muse or an artistic time period spent investigating the female form.

Ideal female beauty, seen through the eyes of male artists, has been shown as submissive and available, open for the male gaze to linger and contemplate pleasure. Early images of female power are also sexualized. See the famous *Liberty Leading the People,* by French artist Eugène Delacroix. See page 233. With her breasts exposed, leading a charging, revolutionary crowd, Liberty is a heroine who is confident enough *not to* adjust her clothing when running to battle. The wardrobe malfunction is conspicuously sexual.

We've repeated the waist-to-hips ratio. How else did artists identify proportion in bodies, and in compositions more

generally? They often followed nature. The Fibonacci sequence of numbers (0, 1, 1, 2, 3, 5, 13, 21, etc.), along with the golden mean (1.61803) has been a guiding principle for proportions observed in shells, flowers, and human features. We seem to have an innate trust and attraction to visuals composed around the golden mean, and artists took notice. *The Last Supper*, *Mona Lisa*'s face, Japanese wave paintings, the Acropolis, and more, overtly or subtly follow the golden mean.

Balance and proportion were supposed to form "unity in variety," the sensation that layout of a composition—sculpture, painting, installation—created equivalence among the visual weight of sections in the artwork. Objects should include a range of color hues and patterns across the color wheel. A coherent visual must arise from the blending of colors, sections, and opposing concepts that interact harmoniously, producing a beauty that is greater than the sum of its parts. Take the example of a biblical triptych with distinct stories across the panels—the birth of Jesus, his miracles, his crucifixion with angels and disciples. The artwork offsets tragedy with inspiration. An abstract example would be De Stijl movement artwork from Dutch artist Piet Mondrian, balancing vacant space with blocks of colors separated by black lines.

Western and Southern Africa

Beauty in early (BCE) western and southern Africa is difficult to generalize: the region is vast and timelines expansive. That said, two related themes are prominent: the equivalence between first, beauty and exaggeration, and second, beauty and ornamentation. Bodies, tapestries, masks, sculptures, and other art objects were exaggerated, elongated, or widened through bold usage of asymmetrical flair and oversized features that made objects pop against an otherwise natural landscape. Beauty wasn't meant to be realistic. It wasn't subtle or timid, and corresponding features, much as they have faded or dulled with time, weren't muted by faithful representation of visual reality.

Second, and related, we see artworks more heavily ornamented in West Africa than other regions, especially early Greek Europe.

Beads around the neck, arms, wrists, and waist; tubed lip and ear piercings; and sculptures that are enhanced to access the spirit world, augmented with *"oil, fabric, beads, amulets, or insert*[ed] *blades into an object to empower it or to communicate with the spiritual forces housed within."*[2]

While early African art animated and augmented realistic objects, the topics that beauty addressed differed little from later Egyptian and Greek ideals: power, myth, hunting, war and ceremony were recurring themes that beauty glorified. Later, after the arrival of European colonialists, African art would begin to incorporate realism, but exaggeration and ornamentation—elongated torsos or oversized headdresses, remained key elements of beauty, features that would play a role revitalizing European art in the modern era.

Egypt

Do you ever wonder why ancient Egyptian figures look so similar? Your assumption of consistency is correct, and it's more than just the proliferation of tourist-friendly scrolls that visitors dutifully carry home from holiday or vacation. Thousands of artworks appear similar and march to a coherent beat, whether they are stone or metal sculptures, or written papyrus. In contrast to the vitality and spontaneity seen in western Africa, ancient Egyptians prescribed *exact* ratios for artistic beauty in sculpture and hieroglyphics. Beautiful bodies were prescribed by a known configuration.

Considering the geography, it's understandable. After a millennium of surviving in the scorching desert, Egyptian civilization imposed order on the Nile river to control its environment and ensure order amidst the extremes of surging floods and parched agricultural fields. Art was an extension of society's thirst for order and prolonged success into the afterlife.

Throughout Egyptian images, we see an almost militant precision about what beauty was and how it should be depicted. If a human figure measured eighteen units tall, its foot must be three units long. To our eyes, this might seem odd, but we can appreciate the

order. Other ratios and rules for layouts also existed, about visual sizes for related images and relative positioning within horizontal and vertical alignments, like important or royal images being placed larger and atop, mundane items.

While proportion and order were paramount, exaggeration and ornamentation still played a role. See the limestone face of Nefertiti from 1345 BCE with an elevated crown and emphatic eyes. Pharaoh's tombs were the model of excess, hoarding beauty in this life for a trip to the next.

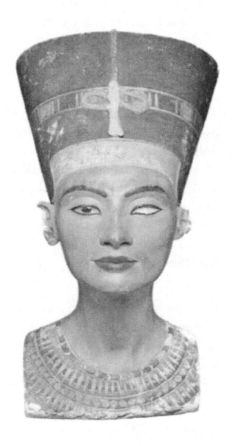

Nefertiti, Thutmose, 1345 BCE.
Neues Museum, Berlin, Germany. Public domain.

Greece

Building on Egyptian standards, Greeks defined their own ratios for physical beauty: the face should be one-tenth the length of the body, and the torso one-fourth of the body length. Champions arose within Greek society who would strengthen the connection between formal beauty and mathematical ratios. Pythagoras was one such man. A zealot for math and philosophy, Pythagoras forcefully advocated for evaluating and presenting beauty through numbers and ratios. Everything, from celestial to physical bodies, trees to triangles, at its most beautiful, should conform to understood equations. His zeal and logic were such that a cult of numeracy grew around him. The pentagram was his school symbol, one ruled by the organizing principle of the golden mean. His movement expanded to influence local politics and seep into Greek society, structured around a framework that ideal ratios should guide people's lives.

Pythagoras' famous theorem for triangles is but one enduring example of his devotion to mathematical equations. His appreciation and appetite for harmony were larger than geometry: *"Virtue is harmony, likewise health, all good things, and divinity. Consequently all things are formed in accordance with harmony."*[3]

That's right, all good things are forged by harmony. We've heard that story before. And if a thing—sculpture, song, book, tree, home, or person—conformed to an unknown, unsolvable pattern, then it was quite the opposite of beautiful—it was subversive, ugly, or sinister. Irrational numbers, zero, and the infinite, had no place in the rational, Pythagorean world. These numbers created undefined errors and irresolvable challenges in mathematics. A member of Pythagoras' cult, Hippasus of Metapontum, repeatedly drew attention to these troubling numbers, and his lack of self-control led to his demise. The records are unclear, but in retribution for sustaining unwanted visibility for irrational numbers, Pythagoras either put Hippasus to death, or banished him from the cult.

Despite emphasizing numerical patterns, Pythagoras, and the classical Greek world, defined beauty on a host of indefensible criteria, such as the idea that odd numbers, straight lines, and squares were beautiful, while even numbers and curved lines were ugly and evil. Unsurprisingly, Greek artists took liberties outside these contradictory criteria. Instead of using ratios, I mentioned before that painters and sculptors often copied the "best" or "most beautiful" version of a particular body part they observed in the market or arena. Artists combined ideal features—hair, noses, chins, feet, and torsos—into enticing bodily mosaics.

Beauty was also equated with *utility*, initially proposed by Socrates. A horse is beautiful if it effectively carries goods and passengers to their destinations. A basket carrying rubbish could be beautiful if it was ideally suited to the task of carrying. A philosopher was beautiful if he or she effectively probed questions of wisdom. Today we might know it as "form follows function," coined by American architect Louis Sullivan.

A building's purpose is to provide function for its inhabitants first, and then look a certain way, beautiful, next. Accordingly, a building should be considered pleasing if it provides the appropriate light, shade, space, and utility for the desired activity. The controversy here has arisen more recently, in that less visually pleasing styles have become accepted so long as they deliver a functional outcome.

Beyond numbers and utility, Plato's ladder of love introduced a hierarchy for beauty, one that would eclipse physical and visible objects:

> *"Starting from individual beauties, the quest for the universal beauty must find him ever mounting the heavenly ladder, stepping from rung to rung—that is, from one to two, and from two to every lovely body, from bodily beauty to the beauty of institutions, from institutions to learning, and from learning in general to the special lore that pertains to nothing but the beautiful itself—until at last he comes to know what beauty is."*[4]

Bodily beauty was the most mundane form. More profound were human souls, institutions, philosophical learning, and the transcendent beauty of eternal oneness. To locate pure beauty was to obviate the need for physical pleasures. Throughout history, we've had a sense that an essence of beauty lurks beneath the surface, whether Plato's pure beauty, a hidden ratio guiding our observations, or the French je ne sais quoi.

Middle Ages and Beauty

While controversially named for a chaotic era between glorious bookends, the period between ancient Rome and the Italian Renaissance was indeed a less *beautiful* period in art history than its neighbors. As physical appearances go, the name is justifiable. During this era, the artistic emphasis on mathematical principles diminished and innovation slowed. Artistic patronage outside the church was minimal, bringing beauty solidly within the church's gravitational control.

The Christian influence on standards of beauty was such that for more than 1,000 years, the essence of beauty was associated with godliness, devotion, piety, and sacrifice—all admirable qualities, simply a limited palate for a long expanse of time. Artistic beauty was architecture for churches, deeply etched reliefs, and realistic statues inside church corridors and filling their gardens, stained glass or windows for churches, and other adornments covering church walls and common spaces. Besides churches, knights of valor were also common motifs of beauty, their deeds directed to godly ends, to sustaining and expanding territories, or to conquests of love.

I already mentioned Italian Thomas Aquinas, a Dominican friar and Catholic priest. He was a, if not *the*, preeminent thinker in the European Middle Ages, so his perspective bears repeating. He believed that the most beautiful artworks were those devoted to glorifying God. Like the utilitarian Greek and Roman philosophers before him, beauty should be fit for a purpose, and the highest purpose was devotion of God, through penance and prayer. Physically, Aquinas supported the idea of proportion in

beauty, although without specifics of what proportion meant. Combining purpose with proportion, godliness was associated with attractiveness: Fit bodies displayed good character, while deformed bodies were ethically unclean.

As we mentioned before, the tight junctions among beauty, truth, and goodness were strongest and least questioned during the Middle Ages. Although we know that gorgeous men and women are equally likely to harbor negative emotions as are their more pedestrian-looking counterparts, this prejudice would not have been questioned. We can't seem to shake the inclination of trusting beautiful people more than unattractive ones. Socrates was disdained, in part, for his unconventional, scruffy, and off-putting physical appearance, in addition to the relentless intellectual barbs he slung. They were made all the more caustic springing from the mouth of a vagabond.

It's not to mock or belittle the standards of beauty during this time that I keep the references brief to godliness and devotional utility. It's in the spirit of simplicity, to understand and fully embrace the energizing agent of the time. We need look no further than the ornate churches, which were being built across the European countryside, or the warring lords who defended them.

Renaissance

The Renaissance resurrected mathematical standards of beauty—balance and proportion, which were first codified in Greece. The era introduced sharp, fresh colors from new geographic sources and improved classical artistic techniques, like foreshortening and three-dimensional depth, rendering vibrant canvases and works in stone previously unseen.

Upon viewing Michelangelo's *David* or Leonardo's *The Last Supper*, influential artists and philosophers of the day were awestruck. Surely the representation of beauty had been perfected! It was the end of art. Since beauty in architecture, sculpture, reliefs, mosaics, and painting had been perfected, an idea arose that art objects needed to capture an essence beyond

balance or proportion, a value that transcended visual classification. Their aspiration was akin to displaying Plato's transcendent beauty.

The urgency for new direction was compounded by exposure to scientific developments, which challenged contemporary understanding. Humankind's place in a previously balanced world was suddenly asymmetrical: people lived in a heliocentric, not geocentric, solar system; Earth's orbit was oval-shaped rather than a perfect circle; and Earth was offset asymmetrically against the sun. Further, we were probably embedded in an unknown galaxy with untold suns and planets.

In mere decades, humans lost their central position in the physical world. It's no surprise that late Renaissance artists began to visualize our collective emotions and question traditional balance, proportion, and symmetry. Art of the early- and late-Renaissance broadly differs in its reverence for symmetry. Look at *The Last Supper* by Leonardo da Vinci (below) and compare it to the *Last Supper* by Jacopo Tintoretto (see page 196), about 100 years later.

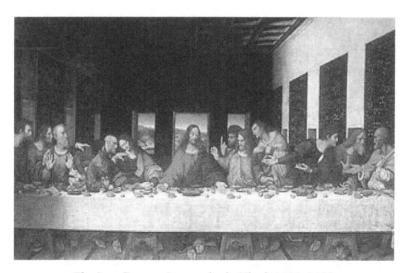

The Last Supper, Leonardo da Vinci, 1495–1498.
Santa Maria delle Grazie, Milan, Italy. Public domain.

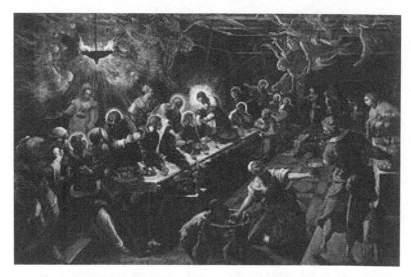

Last Supper, Jacopo Tintoretto, 1592–1594.
Church of San Giorgio Maggiore, Italy. Public domain.

Reformation and Counter-Reformation

After the Renaissance, definitions of beauty expanded. We see the first indications that beauty will become fragmented and individualized. As artistic production moved outside the church, especially in northern Europe, the most important change was recognizing beauty in the mundane, simple life. Dutch artists, such as Rembrandt van Rijn and Johannes Vermeer, spent lifetimes dedicated to the light and shade that fill a common home, or the shadows that linger on a facial profile. It was during this time that the still life was born—a genre entirely to itself, capturing moral tips to appreciate life's brevity or avoid gluttony. Independent of message, beauty was simple.

Simultaneously, artists such as Flemish Peter Paul Rubens and Italian Annibale Carracci were showing beauty as vigorous movement. Artistic subjects, again usually Christian, not slices of simple life, were falling, angular, fighting, eating—active. Canvasses were packed with thick, mostly nude bodies that provide instructional stories and showcase their subjects at moments of revelation.

Subjective Beauty and the Sublime

By the 1700s, no standard of beauty was sacred. Genre paintings specialized is still life images, ports and docks, sailboats, sunsets, Christian morals, high-society parties, portraits, or pastoral landscapes, to pick a few. Influential thinkers, such as Edmund Burke, called into question all the bodily proportions that people had come to accept. No longer could artists use a mathematical or ideal head, neck, torso, hand, or leg to present accepted beauty. Burke claimed that effective artists could do the exact opposite: Use ideal proportions to create an ugly body, or not use mathematical proportions at all and still compose a beautiful body or scene.

David Hume proposed that beauty was both the *"imitation of nature in accordance with scientifically established rules and as the contemplation of a supernatural degree of perfection that could not be perceived by the eye because it was not fully realized in the sublunary world."*[5] True beauty was two distinct polarities: imitation of nature or transcendent of nature.

Hume went further, hailing the postmodern spirit centuries before its time: *"Beauty is no quality in things themselves: It exists merely in the mind which contemplates them; and each mind perceives a different beauty."*[6] By the nineteenth century, balance, proportion, and tone would be relegated to modest tools of the artist's craft. Prevailing sentiment would fully embrace beauty being in the eye of the beholder. Implications would follow for aesthetics, judgment, and reality itself. The idea that reality, or more precisely, each individual reality, was uniquely determined, would provide the foundation for postmodernism: infinite truths exist in a world of complete fragmentation.

It would require more than another century for that idea to take hold, but while it did, artists were increasingly painting female nudes with more graphic detail and in a range of settings. Beauty was fragmenting, but consensus emerged that it took a female form. This era, more than ancient Greece, Renaissance Italy, or the Reformation, disproportionately portrayed female sexual

imagery. Everyone, meaning mostly male artists, it seemed, could agree, that despite other subjective criteria for beauty, female nudes were objectively acceptable. Incidentally, to this day portraits of women still sell for more than portraits of men.[7]

Conversely, we did learn that during the eighteenth century, a universal aesthetic idea materialized: *the sublime,* previously discussed at length in the "Relevance" section. It was the last gasp at universality, although distinct from beauty as narrowly defined. While *standard beauty* was in the eye of the beholder—the sublime was supposedly universal, and therefore, many artists and philosophers claimed that beauty was no longer a worthy goal. Perceptions of beauty continued moving in two directions, not the opposing views of simplicity versus dynamic movement, or common life versus Christianity, as seen during the Reformation and Counter-Reformation. It was the transcendent sublime in nature versus the infinite options for everything else.

Beauty in Ugliness

While the sublime was chipping away at beauty's prominence by calling it quaint, another factor was at play. Beauty pushed beyond appealing images, beyond nudes, harmony, proportion, and balance. The full weight of the Western Industrial Revolution collided with flourishing and unrestrained artistic movements, many of which only lasted a few years or decades and were idea-centric. Within this milieu of creative forces were factories, soot, accelerated urbanization, crowding of cities, tales of repression and poverty, mechanical accidents, and death. Romantic and sublime beauty clashed with industrialization and social transition. By the late 1800s, there was a growing acceptance that beauty might not be found in the classic shapes and styles of prior centuries and access to the sublime was diminished due to walled-off properties. Beauty might need to reflect the spirit of its day. It might shock or provoke discomfort. It could be odd, disturbing—real.

Contemporary art was launched during a time of colliding contrasts—sublime natural beauty generated by genius and

postmodern fragmentation powered by mechanistic, industrial production. Amidst conflict, we see a transition from naturalist landscapes and voluptuous bodies to the birth of Impressionism, Abstract and Modern art, and ultimately the complete rejection of visual objects through conceptual art that consciously avoids retinal pleasure. This frantic transformation occurred during just 150 manic years. Contrast that with the Sulawesi caves, which sustained consistent painting of pig hooves for more than 30,000 years.

Beauty takes infinite forms today: It pleases and arouses us, while it also doubts, reframes, creates discourse, and provokes us. Beauty questions established ideas of sexuality, religion, government, ownership, and accepted values. It criticizes war and military confrontation, rather than glorifying heroic acts on the battlefield. In the art world, this drive to shock and surprise is often considered more beautiful than classic forms, and yet, outside the art world, on social and traditional media, audiences follow a new cult of beauty and celebrity. Reality stars attract larger audiences than any artwork ever has, mostly because they are biologically beautiful, although they do also employ shock and surprise strategically.

Journalist and author Sohrab Aharmi laments beauty's demise in his book, *The New Philistines* :

> *"In today's art scene, the word "beauty" isn't even part of the lexicon. Sincerity, formal rigor and cohesion, the quest for truth, the sacred and the transcendent—all of these ideals, once thought timeless, have been thrust aside to make room for the art world's one totem, its alpha and omega: identity politics."*[8]

Paradoxically, attractive images are everywhere, but we do not agree on, or necessarily aspire to, beauty anymore. Confusing art isn't a mistake, it has a particular goal.

Today, a casual artistic reference to beauty might be applied for an object's witty and unconventional appeal as much as for

summoning the golden mean, balance, or proportion. I doubt that the sidelining of beauty will last. Human biology is still more instinctively drawn toward physically pleasing, proportioned bodies and landscapes than drab ones; to contrasting hues and shades rather than monochromatic objects; to sexually suggestive or emotionally inspirational topics rather than critical or depressing ones.

Subjectivity and shock might have reached their apex and run their course as de facto creative tools. We've seen that neuroaesthetics is leveraging new brainwave monitoring and neuroscience techniques to identify how humans perceive and judge beauty. Patterns and pathways are emerging. Skeptics abound, but I suspect that science will bring previously unknown structure to the mystery of beauty. Unless or until it does, the deceptively simple word, "beauty," like art, will be one we employ in such diverse circumstances and so loosely that it ceases to secure common ground.

Know Key Milestones in Art History

Throughout most of art history, artists aspired to create increasingly "realistic" depictions of their subject matter. Precise brushes and rare minerals ground into paint aided their pursuit of continual refinement. Whether physical objects or expressive human emotions, the goal was true, literal presentation. Recurring points of emphasis included facial expressions, hands, light and shadow, and folds of clothing. Artists sought to create more and better perspective: *more* depth of visual field, light and shadow, *better* folds on gowns or distinctions between skin wrinkles at age thirty-five and fifty. Art was a march toward descriptive presentation that portrayed surroundings beautifully. Art was the idyllic representation of plausible, recognizable forms.

This many-thousand-year arc of realism veered wildly off course with the invention of photography in 1832. Although we can't definitively control for photography as *the* singular cause, it sits at the center of a storm that blew away from realism and instantly eclipsed art's traditional stronghold on representation. Modern art as an approach was inspired by this disruptive technology and an attempt to avoid it. The pivot could hardly have been clearer.

Until the 1830s, with few exceptions, art and beauty followed understood, intertwining, visual motifs: the grandeur of royalty and gods, faith and devotion, victory and myth, and masculine and feminine bodily forms. Consistent patterns repeated through related incarnations between Egyptian times through the late Renaissance until the early-nineteenth century—almost 5,000 years, not to mention realistic depictions in early Homo sapiens caves. Genres emerged along the way but they were tributaries off the trend toward visual beauty and accuracy.

In beauty and realism, historical art was more purposeful and controlled than art today. It was directed. Beauty did not contradict function; it was a vessel. Communicating God's grandeur, or wrath, was a tool of the state. Archangel Michael is

trampling Satan in the 1636 painting *St. Michael Archangel* by Italian painter Guido Reni, because Reni was paid by the church to depict the scene.

Art didn't obey the whims of disgruntled or impassioned artists. It wasn't the object of collector affection or social protest. It was a conscious choice by the buyers of an art product. In contrast, no financial puppetmaster commanded Jeff Koons to sculpt mirror-polished stainless steel with transparent color coating into *Balloon Dog (Yellow)*. Presumably the fairies of imagination compelled him in that direction.

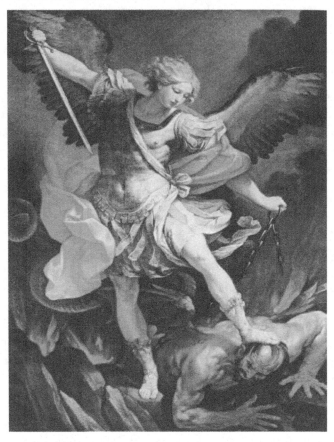

St. Michael Archangel, Guido Reni, 1636. Santa Maria della Concezione dei Cappuccini, Rome, Italy. Public domain.

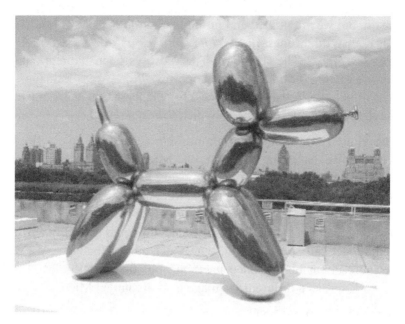

Balloon Dog (Yellow), Jeff Koons, 1994–2000.
Metropolitan Museum of Art, New York, New York.

Art is today, broader, and less anchored to beauty or function, than when buyers dictated subjects. It could be beautiful or not, but is unlikely commissioned by anyone, even a head of state. Art historian Ernst Gombrich elaborates:

"If we take art to mean such activities as building temples and houses, making pictures and sculptures, or weaving patterns, there are no people in the world without art. If on the other hand, we mean by art some kind of beautiful luxury, something to enjoy in museums and exhibitions or something special to use as a precious decoration in the best parlour, we must realize that this use of the word is a very recent development and that many of the greatest builders, painters and sculptors of the past never dreamed of it."[1]

Today we easily concur with Irish novelist Oscar Wilde's claim that life imitates art. Art is not commissioned to look like the

world, but we are guided and prompted by the objects we see. To this end, Wilde went further, *"Life imitates Art far more than Art imitates Life."*[2] The relationship has always been bidirectional, but we often overlook the likelihood that life—we as humans—will imitate the artistic influences, the visual art, theater, music, maybe video games, or TV, to which we're exposed.

The church knew this and commissioned artwork so its flock would raise hands in devotion. St. Michael looks like a real person. Remove the armor and cape and he might walk past you on the street. The contrasts between Reni and Koons are narrative and stylistic. Koons' work prompts childish smiles and shines molten yellow at us with unencumbered vitality. It's unapologetically perky, because he chose it to be that way. We're not sure about his intended meaning, but that's the point. The artwork speaks a different language than archangel Michael.

It's not just that one artwork is more literal (*St. Michael Archangel*) than the other (*Balloon Dog*), but that Michael is one of a million like it, mission-based from a source of power, the church, and realistic, while *Balloon Dog* is the opposite. And there are another million-odd contemporary artworks, just as random, that celebrate art for art's sake. We could also use Jackson Pollock's 1947 *Full Fathom Five* as an example, which has inspired song lyrics, movie dialogue, and comfort with unbridled expression, or Russian painter Wassily Kandinsky's abstract works, which idealize music and color. The point is that these artworks not only ignore prior conventions but directly disobey them.

Art has become a lens—a mentor set in motion by artists—to see and empathize with mental, emotional, physical, and social topics. It guides us in ways to love, relax, think, or even die—through attention, provocation, and still, maybe, visual beauty, such as Koons. What was once a defined craft now envelops creative life. Any artist today producing biblical scenes of St. Michael would surely need a major narrative plot twist to garner any attention, like making Michael a minority or a female. Probably they'd be

thrown out of the art world by their ear if they painted in a medieval style. That style of artwork had its time and place. We look at it fondly but with a contemporary skepticism. It's too pretty and too real, too much an errand boy for people who tell us how to think. We are more accepting of today's artists, people who seem similar to us, like renegades.

In the continued spirit of investigating how we got here, and what we like and dislike about "here," we should review key milestones of art history. We've already seen the lenses of attracting attention—beauty or shock, and the history of aesthetic philosophy, the theories of meaning that philosophers opined and debated. Those reviews frame the more mundane, but practical agenda that follows here, actual art movements and artists who produced pivotal works at important historical junctures. You'll surely see artworks like these at the world's prominent institutions, and by knowing the general narrative arc, and prominent movements and artworks, you'll more quickly understand how each museum room, theme, and object, fit into the whole.

The Caves

Genesis stories are usually opaque and mysterious. They begin beyond the edge of trustworthy records or verifiable clues. They might be scientifically dubious at first or were viewed skeptically by the establishment. According to this definition, the caves are the archetypal genesis story. Art began before a time we can fathom. We can't image the posture our ancestors held while eating nor can we hear the throaty sounds of language they yelled through the echoing cave hallways. The actual concepts they meant to visualize as art on those limestone walls, if we could ever verify them directly, might feel familiar and enduring to us or the subjects might cause us to chuckle. We can't be certain, and that's the point. We can imagine that some kind of spirit worship must have been underway—to the seasons, stars, ancestors, or nature, but mystery endures.

A story of art's genesis must nod to "the caves," this collection of

205

European and southeast Asian underworlds that persisted for millennia. Our ancestors were painting caves with charcoal and ochre long before coalescing into organized societies or writing. The idea that we lived in, painted in, and observed visual art in caves is core to our human story of defeating the beasts of prehistory and forging recognizable civilization.

Most caves are in southwestern Europe—France and Spain, a region where our ancestors could take shelter during the last ice age, but that's not the full story—one of the big four caves is in Sulawesi, Indonesia—nor has the origin story finished. As research progresses, we are merely one well-decorated cave away, say in South America or Africa, from a new theory of where human art originated. Color doesn't age well in the exposed, humid climates of the world's equatorial regions but it *is* possible that cave art sprung forth in undiscovered areas before the places that we know today.

The location of Altimira, Spain, was the first discovery among the major caves. It's where the modern fuss began, in 1868, when Spaniard Marcelino Sanz de Sautuola, and his daughter, Maria, ventured into the mountainous entrance for a look around. It was the eight-year-old child, Maria, who first observed artwork, exquisite bison paintings on the cave's ceiling, while her father was crouched, busily examining bone fragments in the wrong direction—the dirt floor.[3] Its age is between 18,500 and 14,000 years old.

Altamira's discovery unleashed decades of controversy. Critics simply refused to accept that our ancient predecessors, "primitives," could create elegant and delicate images. The narrative of hulking oafs mumbling with clubs was thrown into a lurch. These images required planning and craft. The sheer effort to collect ochre and grind colors was impressive, but their application into lively images of energetic bison herds astounded critics.

Then other caves would be discovered, older ones, notably at Chauvet and Lascaux, northeast of Altimira, in France. Chauvet

houses the oldest figurative painting in Europe, from about 35,000 years ago,[4] while Lascaux is noteworthy for the most complex images. Subject matter ranged from predatory animals, such as lions, bears, and hyenas, to horses, stags, bison, and birds, and also included environmental symbols, like stars, and the classic female image—the "Venus figure," which we saw in the "Relevance" section.[5]

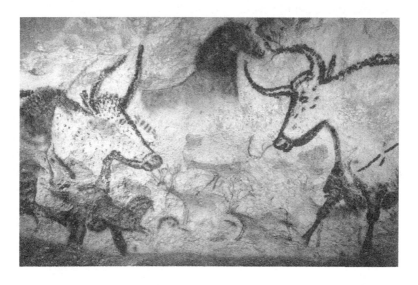

Depiction of aurochs (black bulls), horses, and deer, c. 17,300 years ago, Lascaux cave, France. Public domain.
This cave art was so good, that it raised doubts about its authenticity.

The most recent entry among the annals of significant, prehistoric cave art, is in Sulawesi, Indonesia. The cave includes images of decorative handprints and hoofed, pig-like creatures. In 2014, researchers dated a Sulawesi handprint at about 39,900 years old, an age that immediately eclipsed the Eurocentric origin of ancient art. Homo sapiens decorated these Indonesian caves for more than 10,000 years.[6] Given my sense of a brief human lifetime, and the relatively recent rise of modern civilization, 10,000 years of regular artistic production is incomprehensible, lost to the immensity of centuries.

Collectively these caves stand at the precipice of humankind's cognitive and artistic revolutions, mysteriously proclaiming that before we could write or command sophisticated grammar, we could draw the world around us—how it was and how we hoped it might be. The caves supported shamanism, hunting guidance, seasonal ceremonies, storytelling, and myth, in addition to mundane representation of worldly surroundings. The caves show humankind's primal need, and ability, to document images artistically, to share information and stories, and more important, to satisfy our urge to create.

West Africa

Early European caves are highly documented and publicized. They host complex, well-preserved images. But traces of our artistic origins are scattered across Africa from even earlier. At present, the oldest artistic *site* in Africa is Blombos Cave, a repository of ochre-mixing tools, engraved ochre, and bone, likely dating to more than 100,000 years ago.[7] It's not art, but the inputs for something similar. Again, new findings might be around the next corner. Until then, Blombos isn't elevated to the visual sophistication of the Indonesian or European caves. The earliest visual African art is Namibian rock paintings, from 25,000 BCE.

Time hasn't been kind to the materials of early African art, the wood, cloth, and bone that couldn't withstand humidity or erosion. The "what" of early African art has mostly vanished. Most of the West African art available today is from West Africa in a more recent era, the fifth to tenth centuries. Materials had progressed from earthenware, wood, and textiles to include ivory and bronze, but artistic forays began with less-durable materials.

The "where" of early African art is also unique. Masks, plaques, and figures that called the spirit world were usually handheld and portable. They were ready to be hauled into battle or carried to a ritual. Smaller items might have been rubbed to access the spirit world, as Egyptian art would later. Art was also prominently placed on the body, not just the expected types, like jewelry, which we haven't categorized as art throughout this book, but

notably as headdresses and headrests. Chiefs and warriors donned headdress to invoke spirit forces while everyday people, mostly women, used headrests to carry goods, or closer to the story of art, for funeral rites or religious processions. Art, like life, was more mobile and fleeting than in later eras.

Thinking of attention, the boundaries that would later arise around Christian devotion didn't exist. One gets the sense that early African artists wouldn't let realism obstruct their stories. The spirit of their art objects could be channeled with freedom, and spirits were surely more flamboyant and exaggerated than the mundane physical world. A survey of African masks and statues reveal motifs around elongated faces and full headdresses, robust females, the diverse emotions of consolation and anger. The last phrase around emotion deserves emphasis, because later Egyptian and Greek-world art—statues, frescos, and reliefs—were notably passive compared to their African predecessors. Early African art attracted attention in the same way it proposed beauty, through ornamentation and exaggeration, emotion and expressiveness. This came in flavors of beauty and shock, perhaps frightful faces or monsters.

Outside of wood-based art, the historic kingdoms of West Africa boasted rich artistic heritages—notably the Nok and Igbo cultures of West Africa. The Nok terracotta sculptures of present-day Nigeria exhibit a distinctly African perspective: one that is expressive, abstract, and boasts fantastically shaped human bodies, heads, faces, hands, and other features, but realism in size and shape becomes more frequent. The terracotta and bronze artwork verges on the accepted conventions of European beauty but remains unique. African artists consistently applied these techniques from at least 500 BCE through the fifteenth century, when colonial influence increased.

African art was little known in Europe until explorers and colonialists began carrying it home from their outposts, mostly in the Niger Delta. By this time, we're in the fourteenth century. Picasso and Matisse would later co-opt African art for inspiration

during the modern art revolution of the nineteenth century.

Otherwise, and until that point, African abstraction was viewed by Europeans with uncertainty or outright contempt. They didn't know what to do with it, so would prefer to cast it aside. Philosopher David Hume, who otherwise contributed useful philosophical insights, which I have quoted at length, provides a Eurocentric statement that reminds us of prevailing colonial views at the time: *"That one can survey the length and breadth of sub-Saharan Africa and find not even one work of visual or written art worthy of the name."*[8]

His remarks hint of ignorance, deep-seated racism, and lack of exposure, and he was shockingly wrong. He did not understand how the African artists were attracting attention through exaggeration, nor did he care to explore the ideas of the spirit-world, ceremony, war, or devotional life they depicted. If he did, he would have surely found stories similar to the ones he held dear.

Africa will become pivotal to art globally when the combination of African expression and European realism collide in the early-twentieth century. Until then, African art celebrated abstract human features, largely portrayed as sculpture or masks, dating from ancient times until today, and a beauty of unconstrained exaggeration and ornamentation, which stands in stark relief to the restrained images of Egypt, Greece, and Christian Europe.

North Africa—Egypt

Egyptian art is itself a field ranging throughout thousands of years, from 3000 BCE until the early Common Era. And yet, outside the occasional misfit pharaoh who changed directions, despite the length of Egyptian art history, the look appears suspended in time. Analogies about mummies and stone are therefore appropriate here, but will go unexplored. To us, knowing intricacies between the Old and New Kingdoms would include more information than we need. Wouldn't we begin to spot nuances if we learned more? Well, yes, but Egyptian art follows strict standards, consistently

applied, across the ruling dynasties. It follows their society. The fertile Nile river banks were an early triumph of human engineering controlling the environment and ensuring sustained comfort amidst floods and the encroaching, parched deserts. Egyptian society of 2000 BCE imposed heightened discipline and control on that geography and climate.

Two words stand out when I think about Egyptian art in terms of meaning: *administration* and *ritual*. The words are often connected, artistically. Through the lens of empathy, we consider that strict administrative control would be necessary to thrive in a harsh climate like ancient Egypt. A dose of help from the gods would also be useful. Art imitated these ruling methods: Templated images and standard visual techniques ensured that Egyptian artistic practice was stable and replicable. Wall reliefs, sculptures, and tombs were accentuated through sheer size and materials, like bronze and the gold we've come to remember about King Tut's sparkling face, staring at us youthfully.

Artists were hamstrung in implementation, clearly not following a creative adventure of inspiration. We've covered the idea of bodily ratios, but the rules went further. For example, human faces and legs were to be depicted from the side, while eyes and torsos were drawn and painted to face directly forward. That's why many ancient Egyptian wall figures appear to be walking sideways while still facing the viewer. The contortionist feat has inspired many a meme and cartoon, but we can respect it for the discipline it ensured throughout the centuries.

Furthermore, art was composed in "registers," parallel lines that separate scenes vertically. Items placed higher on a register are more important than lower ones, as were larger items superior to smaller ones, meaning kings and gods command more visual real estate than common citizens and were placed above. If or when artists intentionally broke this layout,[9] it typically meant they were describing chaos, perhaps a flood, famine, or war. To ensure meaning was accurately transmitted, wall text—hieroglyphics— accompanied many images.

Art propagated this ruling order after death, which leads us to ritual. It was believed that the body must be preserved for the soul to persevere during the afterlife. Back again to mummies and tombs, which are the heights of Egyptian artistic and engineering success. To stand at the base of Egypt's Great Pyramid of Giza is to marvel at human ingenuity. Pharaohs moved entire societies, their legions of slaves and laborers, to not only erect pyramids in the arid climate, but create a rich portfolio of ceremonial artwork. The tombs, images, reliefs, and statues were brought to life through ritual. Therefore, they needed to be fully formed and complete. A word for *sculptor* in ancient Egyptian culture meant *"he-who-keeps-alive."*

Scribes documented royal life diligently as a bridge to the afterlife. The written, painted, and sculptural record composed a canon of work, which would propel and sustain rulers. Given the spiritual nourishment that art supplied, it's no surprise that artistic endeavors would be overseen by rulers, not leaving their afterlives to chance. Artists were craftsmen using hands and manual effort. That is not to say their work was unappreciated: King Aha of the first dynasty of Egypt had at least three artisans killed as *retainer sacrifices* to join him in the afterlife, and presumably continue their artistic ways.[10]

Location is easy to understand in the context of administration and ritual. Art was split between the prominent, public works of pyramids and temples, and the secretive world of devotion housed within their chambers. We should also mention individual statues, some handheld, like in earlier West Africa, which were worshipped on the go or at home. These personal or family statues often showed the owner's name and titles, were home for the soul (ka), and recipient of devotional offerings.

Ancient Egypt was part of the early Mediterranean world and directly connected to Greece, Rome, and later, colonial France and Great Britain. It sits within the European artistic tradition and lineage. Today, we see Egyptian art in more places than we think we should, often raided or acquired before national interests could

prevent such transfers. You'll see artwork, such as described previously, in France, England, the United States, and more.

Ancient Greece

Greek art was a public affair. Art showcased a competitive culture that celebrated victory among harsh conditions on an increasingly crowded, Adriatic peninsula. The statues showed citizens and gods who were better than you, but provided a focal point for personal ambition. The temples were more confident and grander than you, but opened a channel to the gods. Superlatives, like beauty, harmony, and triumph, are completely appropriate.

They were the image that artists sought, and their realization was often achieved. In a way, the goodness and beauty portrayed in ancient Greece provoked a backlash, as much as Christian medieval artworks later (think *St. Michael Archangel*), that modern and contemporary artists still aspire to critique today, but that we as everyday museum goers can readily appreciate for being easy on the eyes.

The earliest art from present-day Greece, such as work uncovered on the island of Crete, was mostly destroyed by these competitive, "new" tribes, who entered the Mediterranean peninsula from the north, constituting what we know today at ancient Greece.

Existing evidence, while scarce, indicated that Cretan artwork included freer movement and standards of color application than those applied in ancient Egypt. But the "new" Greek society, the one we associate with classical and Hellenic Greece, began its artistic birth from the palette of Egyptian ideas, rules, and standards. Figures followed prescribed ratios and visual perspectives. Artistic license was constrained. Statues of kouros on page 186 show the starting line.

About the sixth century BCE we begin to see hints of flair emerge through subtle visual changes. Outlines of kneecaps became pronounced and biceps thickened.[11] Figures broke from strict profile or frontal viewpoints and began to display angularity.

Most of the mediums that could be covered with artwork received such treatment: flooring, including carpets and weaved rugs, marble, granite, and wood, ornamental architecture of stadiums and theaters, statues, and pottery. Overall, attraction was achieved through idealized features, which were meant to enhance *realistic* depictions of artistic subjects.

Potted urns are essential to our understanding of ancient Greek art. You will assuredly see them in any substantial survey of Greek art at a renowned institution. They were incredibly common artistic mediums that played a broad and varied role in Greek society. Their physical endurance and descriptive power have provided us a window into Greek life and early artistic innovations, such as the progression from strict standards to freer representation.

Wealthier citizens often owned metal vases and urns, while common homes were filled with urns made from clay. Uses ranged from tasks like liquid storage to temple offerings. Urns were fired and applied with colors, such as black, white, red, and yellowish gold, offering stories that portrayed meaning across the spectrum of Greek life, with an emphasis on prevalent myths.

One of posterity's most famous poems was inspired by the concept of a Greek urn. It expresses a sentiment that rang true in ancient Greece and then much later, in the Romantic era, when English poet John Keats wrote *Ode on a Grecian Urn:*[12]

> *Who are these coming to the sacrifice?*
> *To what green altar, O mysterious priest,*
> *Lead'st thou that heifer lowing at the skies,*
> *And all her silken flanks with garlands drest?*
> *What little town by river or sea shore,*
> *Or mountain-built with peaceful citadel,*
> *Is emptied of this folk, this pious morn?*
> *And, little town, thy streets for evermore*
> *Will silent be; and not a soul to tell*
> *Why thou art desolate, can e'er return.*
> *O Attic shape! Fair attitude! with brede*

Of marble men and maidens overwrought,
With forest branches and the trodden weed;
Thou, silent form, dost tease us out of thought
As doth eternity: Cold Pastoral!
When old age shall this generation waste,
Thou shalt remain, in midst of other woe
Than ours, a friend to man, to whom thou say'st,
"Beauty is truth, truth beauty,—that is all
Ye know on earth, and all ye need to know."

Hellenistic Greece, from roughly the fourth century BCE to the Common Era, was when Greek innovation and artistic spirit accelerated. The activities that we all know about happened then: investigation of the natural sciences and philosophy took hold, music and theater excelled, an inquisitive nature was prized, and visual perspective and movement were freed.

Artists continued to depict culturally important subjects, such as religious myths, military and political victories, and cultural stories. Female and male bodies grew robust and were sculpted into idealized statues, like the *Venus de Milo* statue created by Alexandros of Antioch (c. 130–100 BCE) and *Apollo Belvedere*, by Leochares (c. 120–140 BCE).

Two techniques stand out. The first is foreshortening:

"The visual effect or optical illusion that causes an object or distance to appear shorter than it actually is because it is angled toward the viewer. Additionally, an object is often not scaled evenly: a circle often appears as an ellipse and a square can appear as a trapezoid."[13]

Foreshortening creates the illusion of a third dimension on a two-dimensional surface. Foreshortening didn't exist in ancient Egypt or early Greece but would mark a transition that infused art with a new quality of realism and movement.

In addition, we see contrapposto, named later by artists of the Italian Renaissance, to show a standing human figure resting their

weight on one leg with the other knee bent. The shift in weight loosened statues and set a freer foundation for what would come, notably Michelangelo's *David*, as seen on page 186.

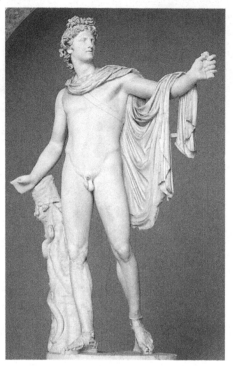

Apollo Belvedere, possibly Leochares, c. 130–140 CE.
Vatican Museums, Vatican City, Italy. Public domain.
Male beauty to match the gods.

By the late Hellenistic period, just before the Common Era, we see the transformation of artworks into thoroughly modern creations, a style that will be lost until the Renaissance, when artists again aspired to idealized realism. The *Laocoön and Sons*, which we will explore in the Anonymous Artists section, was discovered in 1506 in Italy but dates to about 100 BCE. It tells a story from Virgil's epic poem *Aeneid* about a Trojan priest, Laocoön, who warns Trojan citizens against accepting the infamous, wooden, Greek horse. Laocoön sensed the gift might be a trick and voiced opposition. The gods who supported the Greek

invasion of Troy were angered by Laocoön's insolent attempt to undermine their invasion. In retribution for uncovering their plot, the gods sent giant sea snakes to kill Laocoön and his sons (see page 264).

The resulting statue depicts Laocoön's family in agony. We see the anguish in his face. The active pain is ripely captured in full, etched muscles, diagonal visual fields, movement, expression, and the mixture of suffering with a handsome physical body. Laocoön is a phase shift away from *Apollo Belvedere* and *Venus de Milo*. Such was the leap of artistic style, as with natural science and philosophy, between early Greece and the Common Era, pushing toward modernity.

Rome

Rome was a philhellene world—one that loved all things Greek. It applied increased financial resources and expanded the empire toward further depiction of idealized, realistic forms. Roman poet Horace said that *"Greece, the captive, took her savage victor captive."*[14] While Greek art was prized, Roman artists also proudly adopted works and styles from satellite states across the empire. Copies and adaptations were appreciated, not scored, but were usually executed with subtle changes.

Throughout the Roman empire, art was treasured and available. Topics of meaning and techniques for attention remained mostly consistent during the next 500 years, from the Common Era forward. Notable exceptions included technical methods of showing depth of field, the invention of statuesque busts, equivalent to portraits in stone, and images that depicted common life.

The increased usage of wall reliefs instead of statues contributed to artistic needs for depth of field. Reliefs were etched with deep cuts into stone that caused the appearance of a near-statue emerging from the wall, depicting story lines that often followed true, historical events, such as battles. An uninformed viewer today could stand in front of a Roman wall relief or column and

follow the unfolding of real events, although somewhat aggrandized.

In this way, Roman art harkened back to a more Egyptian, narrative style, through the documentation of history that treated larger or higher objects as more important. Critical parts of the narrative were emphasized, carved, and refined into visual prominence. This was especially true of wrinkled and chiseled, facial busts. Reduced were the clean and idealized figures of young, Grecian athletes, like *Apollo Belvedere,* and increased were the wizened, stern rulers, who protected Roman civilization. Fearing rulers did not only necessitate fearing their physical forces, but the intellect and the will they commanded.

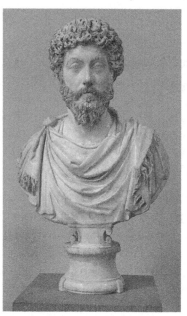

Bust of Marcus Aurelius, anonymous, 161–169 CE.
Musée du Louvre, Paris, France. Public domain.
Beauty now has a wise man's beard.

Art was prized in Roman homes, especially the aristocratic ones, for whom it projected sophistication and power, not unlike today. The sheer dispersion of art objects moved art from the mostly

public, wealthy sphere, like in Greece, to a widely held phenomenon. Artworks, executed in materials from marble to silver and bronze, continued to emphasize prominent topics, similar to Greece or even Egypt: state actions, grand rulers, military conquest, and godly myths, although scenes of common life appeared too, which represented a radical departure from earlier artworks.

We are lucky to have examples. Preserved in the ashes of Mount Vesuvius, which erupted in 79 CE, art in Pompeii, Italy, is the largest treasure trove of historic art in the world, containing a range and quality of art objects we won't see again for more than 1,000 years.[15] Art was widely collected, copied, bought, sold, written about, and even viewed as a tourist activity. Painters composed strikingly contemporary themes, including barber shops or scenes from the theatre. Scenes of everyday life were considered uniquely relevant and refreshing compared to the well-known stories of ancient myths.

The delicate brushstrokes would be familiar today—as would the landscapes and still life images. Although landscapes were noted during the early Greek and pre-Greek Minoan eras, they became far more common in Rome. Given the ready availability of contemporary themes in Pompeii, it's surprising we have found few other archeological examples of these styles across modern Italy. The dearth of similar artwork outside Pompeii makes it look like an outlier.

Roman Art becomes Christian—and the Middle Ages

While Greek-inspired artistic styles and topics flourished in Rome from 100–500 CE, with the adaptations and extensions described previously, Christian themes became increasingly common, at first barely noticeable amidst the thriving visual culture, but eventually, eclipsing traditional subjects and style.

Early Christian artwork emphasized the communication of faith and mercy, and the majesty of God. Slowly, narrative elements from the life of Jesus began to arise—his struggle, suffering, and

wisdom. For many centuries, Roman art simultaneously portrayed classic Greco-Roman deities, while Christian stories arose side by side, until eventually, Emperor Constantine coronated the Christian church as the power of Roman state in 311 CE.

Suddenly temples had to be reconfigured to reflect Christian themes and churches had to be erected rapidly across the feudal European patchwork. Pedestrian churches would not suffice. This was Rome, after all, a state that recognized no limits to its reach and claimed divine provenance as its source. Once Christianity infiltrated the hearts of Roman leaders, its triumph relative to other artistic constructs was assured. From Constantine, at first, to Charlemagne, long after Rome's fall, noble treasuries across the continent were dedicated to celebrating the greatest seat of power, not the one on earth, but in Jesus' heaven.

And yet, an internal tension lay at the core of early Christian art: Many priests and scholars stated flatly and emphatically that God should not be displayed in visual form. We've heard about the dangers of praying to false idols. Romans were no strangers to public art that projected power, and yet, intellectual leaders were torn about art's role in early Roman Christianity. The Eastern Church in Constantinople towed an even more aggressive line than the Pope in Rome. Their exacting guidelines imposed near-Egyptian order on artistic images, meant to ensure that God was visually imagined according to holy specifications rather than artistic whims.

Instead, artists worked at the behest of church elders from a biblical palate. Statues didn't fare so well under a visual regime directed to avoid the likeness of gods. Understandably so, statues were too immediate and potentially attractive. They projected coherent form and impeded on three-dimensional space, like real people might. In contrast, their more austere, flattened kin— frescoes, tapestries, and paintings—were less contentious, and therefore, more common.

This tension wasn't solved after Rome. *"This question of the proper purpose of art in churches proved of immense importance*

for the whole history of Europe."[16] It was a central tension, one which caused remote Christian regions to refuse dictates from the Roman pope. Art's role in religion would remain contentious for almost 1,500 years. Eventually, religious overreach, in part caused by taxes for devotional architecture, would contribute to the Christian Reformation and emergence of modern and contemporary art. These objects would be free from visual rules, especially religious ones.

By 500 CE, we're in the Middle Ages (until about 1300 CE), a time that banked relatively few artistic innovations, due to constraints placed by the church, and wars, famines, and struggles that have caused history to occasionally and infamously label this era the Dark Ages. The lack of visual art breakthroughs is particularly true when we remove utilitarian architecture and emphasize art objects, such as sculptures, murals, and paintings.

Images flattened. Bodies elongated and morphed from physically attractive beauty into an austere, devotional beauty. A period arose that we now title Romanesque, which emphasized painting without depth, where court scribes decorated manuscripts and drew stories, rather than continuing Greek and Roman traditions. That said, skepticism about statues was reduced. Textured Romanesque reliefs were layered and packed densely on walls, accompanied by well-outlined crowns, swords, shields, and cloth that hung realistically around lifelike faces and flowing hair.

The next 400 years were a triumph of churches. Visual representations were especially critical for enhancing communication with early congregations, crowds packed with worshippers who couldn't read. Artwork became the de facto method for transmitting lessons and stories. Although art must have persisted in various types of homes, away from monastic gardens and the golden, ivory shrines of church halls, little evidence remains relative to the vast holdings from churches. To the casual observer, art objects from this period are a procession

of biblical stories, saints writing those same religious stories under the watchful eyes of angels, and scattered courtly journeys or conquests.

The Pareto principle tells us that the majority of artistic innovation during this time occurred in—and on—the church. Grand cathedrals were produced from sophisticated plans, following advanced geometrics with ornate naves and barrel vaults and extended towers, and became a more regular sight, lording over humble towns. During this era, we see the building of Notre-Dame de Paris and similar accomplishments in the architectural glorification of Christian ideals.

A larger structure, the Notre-Dame de Reims, just outside of Paris, is tightly packed with 2,500 sculptures, an extreme example of the crowded style that we now call Gothic. Reims was executed with such precision and scale, between 1211 and 1275, that it would become the location where French kings were crowned. The name Gothic was applied retroactively and pessimistically to evoke a fear of raiding vandals and barbarians. We now recognize it as the apex of medieval architectural invention, if not advancements in tapestry or painting.

Simultaneously, and more subtly, a larger break did occur, one that was the most transformative for visual arts in the Middle Ages. Religious artists refined their presentation of inner feelings and emotions. We saw anguish and terror in *Laocoön and His Sons*. We felt the ruling dominance of Roman emperors. Rarely before were we invited into the minds and hearts of the protagonists within the artistic story. But during this time, a whole new repertoire was added—feelings of patience, penance, longing, humility, and devotion communicated the essence of Christian worship.

During this period, emotions entered the visual and artistic vernacular. The devoted were shown how to feel, and they were given support from Mary, Jesus, saints, and angels, who empathized with the common person's tenuous foothold in an often-bleak world. Jesus suffered the most profound offenses and

indignities, and in doing so, rural, common folk were comforted by images that promised redemption. Much of artistic advancement paused for a thousand years, but the diligent advances displaying humble worshipers were a high point during this troubled time.

Renaissance

Hardly a Western schoolchild emerges into the world today without being indoctrinated about the breathless triumphs of the Renaissance. That education is probably not wrong, but it's also not a path we must retrace here ad nauseam. We already *know* that greatness blossomed on the Italian peninsula during this time, and that it altered the seemingly endless and repetitive trajectory of cultural development. You might have visited Italy or seen Renaissance works in museums. There's no need to belabor and repeat what's now conventional wisdom, but simply to cover points for the continuity of our story.

During the fifteenth century, the early Renaissance in Florence was launched, in hindsight, not officially to courtly proclamation, by an architect, Filippo Brunelleschi. The dome of the Cathedral of Florence was completed in 1436, after architects originally finished the base but couldn't navigate the math needed to enclose the dome.[17] Brunelleschi designed a dome that would gracefully and safely enclose the ceiling of this massive tribute. In doing so, he combined mathematics and engineering into an artistic, religious structure, which required more sophisticated tools and financial backing than anything created before it during the Common Era in Europe.

A sense of temporal distance arose, a nostalgic respect for the accomplishments of Greece and Rome that were scattered throughout the peninsula. With that, engineers, philosophers, artists, and scientist were drawn by an increasingly conscious attempt to revive those achievements, combined with a self-confidence and knowledge they could eclipse the activities of their ancestors. In dreaming of breakthroughs, artists and scientists—creators of all types—looked outward at competitive city states—

Rome, Florence, Genoa, Venice, Naples, and Siena. The drive to outdo one another in creations more insightful or beautiful, to attract more attention for its own sake as sport, was a critical market force that made the Renaissance such a time of accelerated accomplishment.

Artworks produced across the Renaissance were almost impossible to conceive before the Cathedral of Florence was erected. From *David* to the *Mona Lisa*, numerous masterful adaptations of Jesus' last supper to the Sistine Chapel, Renaissance artwork echoes brightly in our contemporary thoughts. Artistic meaning of the period was still consumed by religious devotion, harnessing Christian goals of medieval Europe and fusing them with unparalleled aesthetic innovation, but nature and antiquity were two other prominent themes.

About 100 years after the Cathedral of Florence, the sixteenth century, is the time period we typically associate with the Renaissance. This was the age of Michelangelo, Leonardo, and Raphael. To the point about competition, it was often the time of Michelangelo *versus* Leonardo *versus* Raphael. Foremost artists of the Renaissance competed furiously for prestige and commissions.

Much of the Renaissance narrative is centered in Italy, but during the early Italian Renaissance, another revolution was occurring north, in the Netherlands. It was one that uncovered precise mastery of surfaces and light, exploring everyday interior scenes and non-religious subjects. As a matter of chronology, we should note that Netherlandish masters, such as Jan van Eyck, painted during the time of Brunelleschi's Cathedral of Florence. Vermeer, Rembrandt, and others would come later, but timelines between the traditionally categorized southern Renaissance, and bursts of northern creativity, overlapped somewhat. We often hear about the regions separately and therefore imagine the Renaissance as a singularly Italian achievement with aftershocks across the rest of Europe later. It was not that linear.

While Italian artists were combining the glories of Greece and

Rome with Christian stories, in the north, artists were evolving portraits, genre painting, landscapes and, yes, Christian altarpieces too. But the northern Europeans were already more biblically pessimistic, either emphasizing Christian themes less often, or through outright glorification of artists, notably Dutch Hieronymus Bosch, who painted bizarre insects and monsters in a style that predated Surrealism.

The north was also ripe with tapestries, which were more expensive and prestigious than painting at the time, and just as effective in portraying light and emotion. Materials included wool and silk, sometimes with gold or silver thread.

Back in Italy, achievements during the High Renaissance (about 1490–1527) were realized in perspective, anatomy, astronomy, mathematics, botany, and more, often owing to the cross-pollination of ideas and insights that manifested in densely populated areas and were supported by new means of public financing through trade. Leonardo da Vinci's drive to dissect cadavers and compose ideal replicas of the human form pushed the artistic medium forward through knowledge of anatomy that was transferred into artworks. The Renaissance confidently proposed that beauty was positive for its own sake, as a path to and from divine inspiration.

A rivalry of technique and prestige arose among not only artists, but cities and their signature artistic styles. The unique governments, industries, climates, and sources of pride drove the two main Italian schools to unique value systems. Florence was cerebral, while Venice was sensual. Florence was a city of learning and banking; Venice had the energy of a thriving port and more open borders. Draftsmanship was the approach in Florence. Artists conducted numerous iterations of pencil sketches before applying any dash of color. Venice, on the other hand, brought jovial images with translucent color and rich background details.

It's no doubt that time has elevated the artworks of Florence above those from Venice. The four Renaissance greats we easily recall are all from Florence: Leonardo, Michelangelo, Raphael, and

Donatello. The Florentine school delivered no less than *David*, *The Last Supper*, the ceiling of the Sistine Chapel, *The Birth of Venus*, and *The School of Athens*.

While their collective oeuvre is unrivaled, Venice did bring us Italian painters Titian, Giorgione, and Giovanni Bellini. They produced, for the first time, layered oil paintings, which would become the new standard, and the sexually suggestive nudes that launched a genre that continues today, *Sleeping Venus* (by Giorgione, 1510) and *Venus of Urbino* (by Titian, 1538).

Ignoring competition for a moment, it's important to appreciate the combined imprint these two city states left on the art world during the past 600 years. Florentine and Venetian artistic philosophical differences are apparent when viewing two versions of the *The Last Supper* on pages 195 and 196, but those, in combination with *The School of Athens* and *Venus of Urbino*, continue to highlight the contrast between approaches.

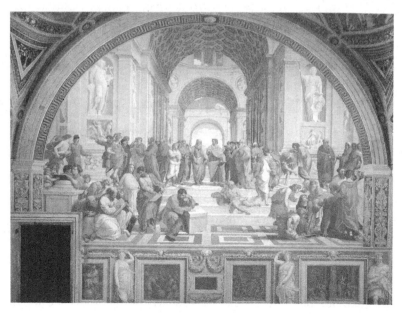

The School of Athens, Raphael, 1509–1511.
Apostolic Palace, Vatican City, Italy. Public domain. Florencian style.

226

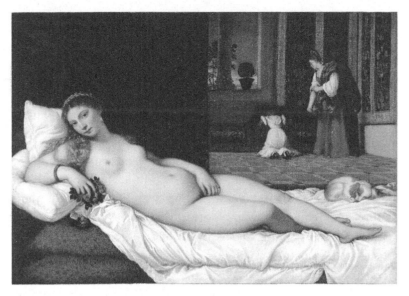

Venus of Urbino, Titian, 1538.
Uffizi Gallery, Florence, Italy. Public domain. Venetian style.

The Renaissance was a transition point between *artist as craftsman* and artist as an *independent, even elite, creative professional*. It wouldn't arrive yet, but was emerging. While guilds had existing for centuries, in Renaissance Italy and in the north, guilds gained notoriety for distinct styles and consolidated influence over production. They functioned as industrial scale workshops that produced thousands of paintings and managed supply chain operations with sophistication. Patrons competed for artistic services of not only the top few artists but also the best guilds.

The ability to produce unrivaled works of beauty increased demand for artistic services. As with ancient Rome, refined artwork commanded respect. It brought prestige and culture to its owners, in cabinets of curiosities and galleries across noble Europe. How could the *people* delivering honor to their patrons through artwork—the artists—*not* be honorable? As this question unraveled, artistic prestige elevated.

Toward the late-sixteenth century, chatter in artistic circles was that everything that could be created had been done. Topics and techniques had been exhausted. The essence of beauty had been molded in tangible form. We know this myopia is all too common throughout history, in art and across creative and scientific pursuits. During the Renaissance, artists were afflicted with a particularly acute case of finality.

Life regularly imitated art: Italian landscape paintings, popularized by Frenchman Claude Lorrain, had become so idealized that gardens across Europe were fashioned in their picturesque image. Viewers began to judge beauty, not just landscape beauty, as the idealistic world depicted by Renaissance artists, rather than as natural phenomena. Indeed, the word *picturesque* arose during this time, in Latin, as *pittoresco*—pictorial, the art-influenced look to which natural beauty now aspired.

As life was increasingly modeled after art, that pursuit hit the most practical place—the pocketbook. Christianity was the engine behind the Renaissance but also contributed to its decline. Pope Leo X (papacy 1513–1521) is alleged to have said, *"Since God has given us the papacy, let us enjoy it."*[18]

His appetite for the arts was driven by godly zeal and supported by the wealthiest institution on earth. However, he overreached. The oppressive taxes and indulgences that infamously fostered resentment of the Catholic church—those were substantially allocated to the arts. Pope Leo X's deepest yearning was to rebuild St. Peter's Basilica in Vatican City, burial site of Saint Peter, the first pope.

The rebuilding lasted more than eighty years and included Michelangelo's final act, completing the 448-foot ovoid dome, still the world's tallest.[19] St. Peter's Basilica stretched the financial capabilities of a European populace who would ultimately rebel in spiritual and economic opposition.

The Reformation and Democratization of Art

The Reformation was born. It began in 1517, as Pope Leo X and his archbishops were raising funds for artistic projects. Art's subject matter and commercial structure would rupture. As northern Europe split from southern Europe, religiously and socially, the church-as-patron, guild-as-provider relationship unraveled, with a few notable exceptions.

By the mid-seventeenth century, Dutch painters could no longer rely on commissions from the church. Their financial ability eroded, as did the artistic will of northerners to present a world that had become less relevant. Reformation art and architecture would diverge onto a more austere path, focusing religious effort on ideas rather than overwhelmingly grand statements of holiness.

The open but uncertain market arose, one where artists created first and found buyers next. Creativity was unencumbered to follow artistic passions and ambitions, but freedom came at a steep financial price. The artistic business model built to facilitate exchanges between guilds and patrons couldn't persevere. Large workshops required consistent commissions. They required that nobles, and to a greater degree the church, sustained their appetite for portraits and devotional, biblical scenes.

They could not. It wouldn't be long before "starving artists" appeared. So did specialization. Lacking financial assurances, artists began to concentrate on salable styles for their market niche. Specialists arose for ships, sunsets, landscapes, still-life paintings (like the vanitas, a symbolic work of art concerning death), and sub-genres of portraiture. And with them, art salesmen—dealers—became commercial agents for artists who preferred to focus on their creative process instead of selling. Perversely, without the hardship of reduced financial stability, artistic freedom would not have blossomed, but the monetary uncertainty drove increased risk and countless artistic failures.

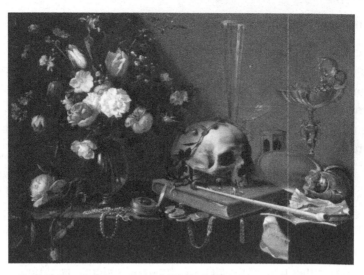

Still Life with Bouquet and Skull, Adriaen van Utrecht, 1642.
Private collection. Public domain.
A vanitas still life reminding us that beauty fades.

Rembrandt van Rijn was a Dutch, artistic pioneer in this era—he tamed light, shadow, and nuanced expression. He was also the tragic hero of art's shifting business model. Rembrandt died cold and broke, despite being considered one of art history's masters. Furthermore, unlike those who achieve posthumous fame in art or philosophy, Rembrandt *did* enjoy reputational success during his time, but commercial success didn't follow. Despite increased social prominence, artists could no longer ensure regular meals.

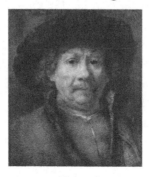

Self-Portrait, Rembrandt, 1655.
Kunsthistorisches Museum, Vienna, Austria. Public domain.

The Counter-Reformation punched back. The Council of Trent was not a singular event; it was a twenty-five-session cycle across almost twenty years, from 1545 to 1563. It refined and clarified doctrine in response to the Reformation. In the final session, art was recognized for its influence:

"And the bishops shall carefully teach this, that, by means of the histories of the mysteries of our Redemption, portrayed by paintings or other representations, the people [are] instructed, and confirmed in remembering, and continually revolving in mind the articles of faith; as also that great profit is derived from all sacred images, not only because the people are thereby admonished of the benefits and gifts bestowed upon them by Christ, but also because the miracles which God has performed by means of the saints, and their salutary examples, are set before the eyes of the faithful; that so they may give God thanks for those things; may order their own lives and manners in imitation of the saints; and may be excited to adore and love God, and to cultivate piety."[20]

The church emphasized art in the institutional toolkit and undertook an artistic offensive. It attempted to stimulate overwhelming experiences within church halls. The smallness that devotees felt would be heightened by the grandeur and consolation offered by God.

Even today, for the secular among us, a Catholic Church's largesse often commands hushed tones and respect. As the Catholic Church deployed grander cathedrals, murals, and statues, artists of the Reformation continued to paint every day common life, in all its beauty.

The art market struggled to clear inefficiencies, to find buyers for the newly spontaneous artworks. Buyers still sought the "old masters" and hadn't begun to fully appreciate contemporary styles. In response, groups in new locations arose, first Paris and then London, emerging artistic hubs that would overtake Italy and Holland, beginning to arrange large exhibitions to drive visibility

and sales. The events were called salons, and became high-profile, social soirees and public interactions. They were the precursor to contemporary art fairs.

The Paris Salon began in 1667. It hosted the largest annual and biannual art events in the world for more than 200 years. A cross section of society dressed in their social best, inciting enough revelry and intrigue to provide fodder for gossip publications. The Paris Salon was a democratizing artistic force that generated previously unknown publicity for established and emerging artists, who would first become members of the Paris Salon and then submit their artwork for a show.

Artists had reasonable freedom to select material that piqued their interest, at least theoretically. Even the curmudgeonly and conservative developed a taste for novelty, and artistic surprises become more common. That said, boundary-defying styles were occasionally rejected—an overly exposed breast (*Luncheon on the Grass*, Édouard Manet, 1862) or negative insinuations about the political elite, more so during later periods of social upheaval in the nineteenth century. Eventually Impressionism would be the death knell of the Paris Salon.

That's because one prominent but often unstated expectation remained. Despite the subject matter, an artwork itself was to be composed with a pleasing and *realistic* style. Artists could condemn the ugliness of politics or war, drop a female nude conspicuously front and center, but it must be wrapped in a veneer of true color notes and recognizable imagery. We had not yet reached the era where ugliness or shock was accepted artistic practice, or when abstraction was coveted.

As the Salon thrived in Paris, a new period arose. The Romantic era drove another mini revival of art historical styles from before the Renaissance. But rather than pining for Greek or Roman glory, Romantic affection was directed at the Middle Ages. Romanticism combined nostalgia for a simpler, natural past, with idealism about the political future. If the source of evil was overbearing tyrants, soot, and mechanized production lines, the

sublime was accessed through individual genius, freedom, and nature.

We've already introduced two iconic Romantic paintings, *Rainy Season in the Tropics* by Church on page 154 and *Liberty Leading the People* by Delacroix, below.

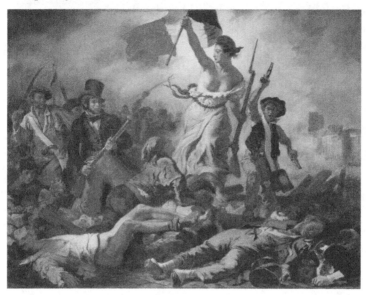

Liberty Leading the People, Eugène Delacroix, 1830.
Louvre, Paris, France. Public domain.

By the 1800s, artistic freedom had again eclipsed the evolutionary pace of public taste. At the macro level, buyers didn't want what artists were producing. Again, artists faced a crisis of choice about following their passion or producing for the market. The Industrial Revolution's rising middle class was not highly educated artistically. The people still had a fondness for Romantic, medieval, and Renaissance art, which filled their cities and reputable institutions. Art should look *like that*. But unfortunately, at the juncture when common citizens could create sufficient demand to support a market, artists and their visions began to diverge more wildly from mainstream society: *"Artists began to see themselves as a race apart, they grew long hair and beards, they dressed in velvet or corduroy, wore broad-brimmed hats and*

loose ties, and generally stressed their contempt for the conventions of the 'respectable.'"[21]

Societal upheaval was accelerating due to industrialization, urbanization, the loss of religious faith, and cultural globalism. A new artistic technology, photography, could capture a still life or a smile with precise accuracy. Amidst the chaos, artists sought originality for its own sake, through personal sartorial statements and the pursuit of novelty. This caldron would unleash a break with prior artistic conventions that overturned 2,000 years of realism. Artists and viewers would grapple with the accelerated present for the next 150 years.

Impressionists and the Birth of Modernism

The Impressionists were artistic revolutionaries. What today we consider a foundational artistic movement, even boring or trite, was so objectionable that its style was entirely rejected from the once democratic Salon de Paris. For that reason, it's worth revisiting Impressionism, even if it's one of the most widely known and understood artistic styles.

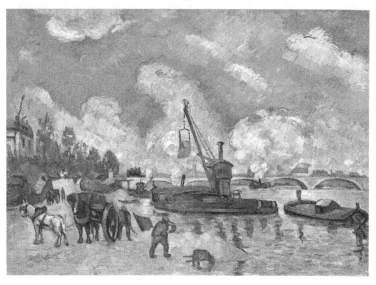

The Seine at Bercy, Paul Cézanne, 1878. Bridgeman Art Library, Kunsthalle Hamburg, Germany. Public domain.

It started with a simple observation.

"We humans, Cézanne reasoned, have binocular vision: we have two eyes. What's more, our left and right eyes do not record identical visual information (although our brain amalgamates the two into one image). Each eye sees things slightly differently. Added to which, we have an inclination to fidget. When we examine an object we move about: we crane our neck, lean to the side, bend forward, and raise ourselves up. And yet art was (and is) almost exclusively produced as if seen through a single, static lens. That, Cézanne deduced, was the problem with the art of his time and of the past: it failed to represent how we truly see, which is not from one perspective, but from at least two."[22]

Artists abandoned painting realistically, it seems, in part, because they thought the camera could take that job. In many cases, it did. The portrait never recovered. Cézanne, the father of Impressionism, wielded a compelling philosophical counterpoint. A camera was limited to a single frame. It couldn't capture the visual dance across a skyline that our fidgety eyes naturally undertook. Human vision is more than that—and less.

Using Impressionist techniques, changes in light and scenery would be wrapped in a single image that merges multiple patterns without lingering on anything precisely. It was an essence of a place across visual time. In contrast, later, we'll see Cubism, which captures a single moment from the perspective of multiple "places." Art was breaking from realistic shapes and experimenting with temporal changes.

Impressionists, such as Cézanne, Danish-French painter Camille Pissarro, Monet, and Manet, adopted color and movement as *the* subject matter of their artwork. Color and movement were on equal footing, in terms of both attention and meaning, with the ponds, mountains, sunshine, or people shown. The merging yellows themselves mattered equally with the setting sun.

They painted scenes of daily life *quickly*, outside, as the light and environment changed. It was called painting *en plein air*, and was more than a location out of doors. Painting en plein air was painting in a public location, yes, outside, but the location enabled an approach meant to harness a natural mood. It unleashed the loose creativity of a transitional social era.

Despite Impressionism's current fame, it was snidely derided by critics. Impression was meant to decry a lack of specificity, a lack of realism, which critics had come to expect from prominent artworks. Impressionist paintings were rejected en masse from the salons, which incited grief and anger toward the establishment. If their art was to be shown, it required nothing short of artistic revolution.

Impressionist painters defiantly birthed counter salons, first and most notorious being Salon des Refusés or "exhibition of rejects," which was formed in 1863. Pissarro, Renoir, Cézanne, Degas, and Monet were among the contributing artists. It was no meek-hearted feat to circumvent the traditional salon. It created career-defining reputational and financial risk. They were proud artists, and they had little to lose.

From a marketing perspective, Salon des Refusés was a winner. It drew sizable crowds, the balance of which turned up only to mock the artwork. Amidst the negativity, Impressionists were early beneficiaries of the adage that "All press is good press." In attempts to undermine the movement, critics had unwittingly named the most famous of artistic styles. In so boldly venturing outside the salon, and inviting open criticism, Impressionists contrasted themselves against the status quo, increased their public visibility, and gained a loyal following.

One loyalist was French essayist and art critic Charles Baudelaire. In 1863, he wrote an essay called "The Painter of Modern Life," which glorified the *flâneur,* the bohemian hero who was as comfortable in the city streets as among the trees or birds. He extolled the virtues of urban men who explored the zeitgeist on foot, strolling through the awakening streets of Paris. Baudelaire

was writing on behalf of dandies everywhere, but certainly for the Impressionists, who were increasingly spurned by establishment institutions.

He said, *"for the sketch of manners, the depiction of bourgeois life . . . there is a rapidity of movement which calls for an equal speed of execution from the artist."*[23] Baudelaire emphasized speed and pace. Modern Paris was in the throes of a beautiful upheaval from medieval city to the largest art and cultural center the world had ever known. Documenting and interpreting this transformation required artists to be outside, among the chaos. You couldn't document such a migration philosophically or walled in a studio.

Le Flâneur, Paul Gavarni, 1842. Public domain.

The Impressionists also found a powerful ally in French art collector and dealer Paul Durand-Ruel. He was so taken by Monet and Pissarro that he paid them a monthly wage and guaranteed their sales. It was a landmark in art dealership, and one we can now agree was a worthy gamble. Durand-Ruel believed the Impressionist ideas and mission were noble and that the world outside Europe was ready to embrace them. He would move their commercial focus to the United States.

Durand-Ruel was quick to claim that Impressionism's commercial success was due to an appreciative American public, rather than their European contemporaries. With that market discovery, he financed the Impressionist movement. Classical art knowledge, and therefore prejudices, didn't run so deep in the younger

American culture. It's the first time in our story, that we find the United States playing a major role in art history milestones.

Simultaneously, we encounter the first substantial non-European influence on Western art for almost 2,000 years—that of Japan. Japanese insight arrived unexpectedly, in paper stuffing stowed away for commercial packaging. Artists were surprised and intrigued when they saw decorative paper packaging from Japan. And then Japanese art was exhibited during festivals in Paris in 1867. It was a landmark. Monet attended and purchased more than a dozen prints from Japanese master Katsushika Hokusai (1760–1849).

The impact was immediate and dramatic. Among the many artistic inspirations provided to Impressionists, Japanese art liberated them from the demands of symmetricity, especially in landscapes. Japanese art removed the need for paintings to be centered. Instead, Hokusai and others emphasized asymmetry to redirect attention or embrace the viewer closer within a scene.

The subject matter was also novel. From kimonos to windswept, jagged trees, a surprising number of Degas and Monet subjects are *directly* copied from Japanese paintings. Monet didn't hide this fact. He installed a Japanese-style bridge at his home in Giverny and painted it tirelessly. He embraced Japanese artwork and superimposed it on Impressionism. Toward the end of his career, Monet responded to a question about how he wanted to be categorized and remembered: *"if anything,"* he said, *"compare me with the old Japanese masters."*[24] It's quite possible that Monet didn't consider himself Western at all, given his stylistic break with convention and his adoption of Japanese visual mechanisms.

If you look far enough, Japanese artwork is hiding around the corner of many Impressionist masterpieces. Impressionists actively studied and mimicked their Japanese counterparts in terms of subject matter, brush strokes, and perspective, while energizing artworks with their own distinct colors and rapid exploration. Perhaps the most striking alignment of all is the zen-

like core of Impressionist sensibilities. It goes beyond the canvas. Impressionists chased fleeting moments that would never again unfold in a given sequence. They documented impermanence with the same care as Buddhist monks who build sand mandalas, only to wipe them away after completion.

Explosion of Modern Artistic Movements

From here, artistic innovation accelerated, even hyper-accelerated, with the wheels coming off any traditionally established categorizations of art, or the artist in society. We've reached the era of *modern* art, not to be confused with *contemporary* art. Modernism is the period of micro art movements, relative to prior times in art history—decade or less investigations—bursts, into a certain theme or style. The overriding goal was to chase novelty, to tickle the intellect and senses with unseen artwork. Repetition was abhorred. The prize was a trifecta of visual technique, artistic medium, and social or political expression. Most movements also found that a written manifesto went a long way toward promoting their message.

Expressionism, Fauvism, Cubism, De Stijl, Constructivism, and Surrealism were all movements of note, relentlessly pushing, and critiquing one another or prior approaches. Modernism is a stark break with the past, an era that glorified art and artist alike—driving us toward undeniable celebrity for the creators of visual masterpieces. Between Impressionism in the 1870s through pop art in the 1970s was a golden age for artistic prominence. Art from this span is likely the reason you're holding a book like this today. The personalities and innovations caused a rupture, which ensured art would command broader social attention. Modern art still surrounds us and inspires the newest movements. It is still closely relevant to our daily life.

Expressionism

Artistic movements have a way of reacting to their predecessors, of being uniquely annoyed at or frustrated by their immediate role models. The Reformation was drab, a Counter-Reformation

Catholic artist would have said. Expressionism was partially a reaction to Impressionism's overly gentle interpretation of reality. Instead, Expressionism focused inward. It exposed a person's subjective emotions and unsettled interactions. Expressionist artists emphasized darker themes, such as isolation and confusion. A famous early inspiration for the movement was Norwegian artist Edvard Munch's *The Scream* (1893), the primal call of confusion and anguish that pierces our ears, as we try to imagine the horrible pitch emanating from the quiet canvas. It was an anxious time.

In 1896, artist Wassily Kandinsky saw a traveling exhibit of Impressionism in Moscow, Russia. He hadn't seen any artwork from outside Russia before. He was surprisingly sheltered from external artistic influences, given the innovations he would eventually achieve. As an artist of growing powers, the show deeply changed him at a pivotal moment. He was surprised and confused about how deeply Monet gripped him. Propelled by Monet's influence, Kandinsky would become an early figurehead in Expressionism, although he favored a distinctly more uplifting, positive, and abstract approach than those who followed. What they shared was a mission to shake loose and convey an inner emotional dimension.

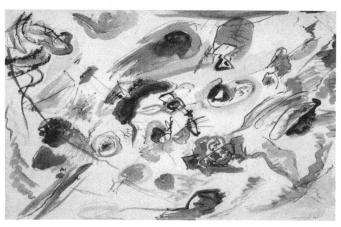

(Untitled) First Abstract Watercolor, Wassily Kandinsky, 1910. Musée National d'Art Moderne, Paris, France. Public domain.

By 1911, Kandinsky had entirely abandoned identifiable objects in his artwork. He favored pure emotional expression. While Kandinsky was expressive in meaning, certain art historians also label his style abstract art, since Kandinsky was the first to abolish recognizable images. His quest was to visually express musicality through art. Within days of a concert by Austrian composer Arnold Schoenberg in Munich, Kandinsky painted *Impression III (Concert)*. It showed bold strokes of yellow, blue, and orange with a large black nearly oval shape on the side. What in the world had overcome him? Suddenly, art channeled music and was inspired by the classical Germanic composers.

While Kandinsky and other Expressionists were largely based in Germany, an offshoot was centered in Vienna about 1900. They followed the decidedly darker tone. Gustav Klimt and Austrian artist Oskar Kokoschka loom largest among the group. They painted angst, subjectivity, and emotional depths, laced with academic insights from the emerging masters of psychology, Sigmund Freud and Carl Jung. Expressionists sought to uncover the subconscious and unsettled emotions that often irresistibly drive us.

Sigmund Freud was a contemporary of Klimt and Kokoschka. They interacted socially, and Freud exerted a powerful intellectual magnetism. Freud asserted that his insights about the subconscious were the third pillar of great revolutions in human thought, behind only Copernicus and Darwin. His confidence and force must have been difficult to ignore. Calling forth subconscious movement patterns, Expressionism takes a divergent approach to hands and faces, using the shapes and shading to invoke disturbed mental states, anguish, desire, rage, and complex, often painful emotions.

The Expressionists drew on similar inspiration as Freud, in wanting

> *"To create art whose external coherence is based not on the viewer's social equality with the people in the painting, but on the viewer's emotional (empathic) equality with them. Whereas Dutch painters invited the*

viewer into the physical space of the painting, Viennese invited the viewer into the emotional space of the painting."[25]

Fauvism

While Expressionism was peaking in Germany and Austria, another short but influential movement was also exploring human emotions. It was Fauvism (1904–1908), which embraced tribal art, African masks, totems, and "primitive man." Fauvism idealized "the noble savage." In a sense, it reeks of racism, imperialism, colonialism, and subjugation. Artists pulled native images from their context and used them to exoticize European art. That we cannot forget. And yet, it was a less direct and more subconscious usage of native cultures than outright mistreatment that went before.

Fauvists genuinely investigated and glorified a return to preindustrial society. Beyond patronizing native cultures, they longed for a simpler, more natural time. The injection of African symbols, images, and mystical primitivism into European tradition quite possibly was *the* pivotal genius that carried European art forward. Injecting abstract and bold African art into the caldron of European modernism showed that anything was possible. It was this combination that inspired the most famous artist of our era to practice the vocation, Pablo Picasso.

Inspired by African art, Pablo Picasso created *Les Demoiselles d'Avignon* (Young Ladies of Avignon, originally titled The Brothel of Avignon) in 1907 (although it wouldn't be publicly exhibited until 1916). The work would generate outrage and scandal once it was shown. Yes, we often talk about the disdain and outrage for new art, which brews in critical circles and the public, but this was a conflagration. Viewers were apoplectic.

Following Picasso's approach of inspiration from life experience, he painted *Les Demoiselles* in homage to close friends who died from sexually transmitted diseases contracted from prostitutes. The images were considered grotesque and aggressive, yet

sexually seductive and enticing. The artwork celebrates contradictions among beauty and disgust, mystery and fear. The provocation, vitality, and breakthrough technique provoked a visceral discomfort that viewers couldn't easily shake.

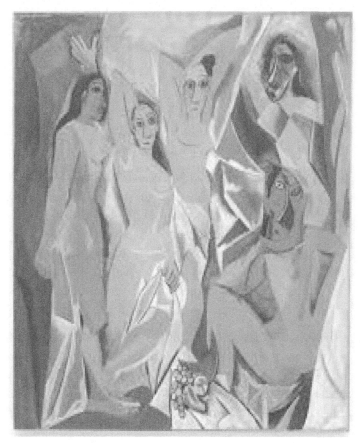

Les Demoiselles d'Avignon, Pablo Picasso, 1907.
Museum of Modern Art, New York, New York.

Cubism

Fauvism preceded Cubism, which was pioneered by French painter Georges Braque and, again, none other than Picasso. The purpose of Cubism was three-dimensionality: each frame of a Cubist painting depicted a different perspective on the subject

matter. The phenomenon of place was unfolded to create a layered visual texture.

Cubist artists focused on well-known images, like fruits, table settings, guitars, faces, and bodies, but instead of presenting flat images, they created overlapping visuals that collapsed the viewer's attention into merging and moving forms. It can be disorienting to unfold them.

De Stijl

From about 1915 to 1930, we see the success of another theoretically driven art movement. De Stijl meant "The Style," and its goal was to create an international movement around unity in life and culture. The cofounder was Dutch artist Piet Mondrian.

You've probably seen his imagines: vertical and horizontal black lines intersect, creating squares and rectangles of different sizes. The squares might be filled with red, black, yellow, or blue, but otherwise they remain white. You might have wondered what it was all about, or maybe you thought Mondrian was painting random, colored boxes, and that modern art critics glorify silly artworks. It was more intentional.

Mondrian's artwork was meant as a philosophical and political endeavor. He wanted to express *"what all things have in common instead of what sets them apart."*[26] Mondrian sought visual unity by balancing composite sections of squares and colors through spacing. Although Mondrian's paintings are not symmetrical in the mathematical sense, he proposed that each section of the canvas should bear *similar weight,* so as to reflect *equality among difference.*

That was also his social project with De Stijl: Encourage unity in life and culture *despite* the inevitable physical and historical differences that are apparent at the surface. Like other artists of the modern era, Mondrian had the capability to paint like a Greek or Roman master but instead chose to apply novel techniques that supported his mission.

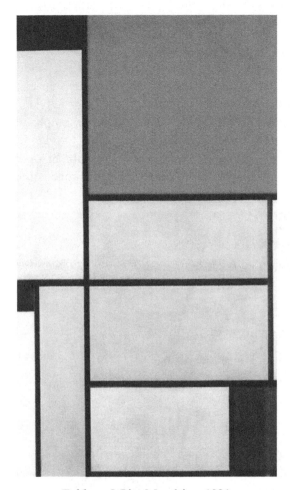

Tableau I, Piet Mondrian, 1921.
Museum Ludwig, Cologne, Germany. Public domain.

Constructivism

Another artistic movement advocating social equality was founded in Russia, called Constructivism. A key figure was Russian sculptor and photographer Alexander Rodchenko, who co-authored *Who We Are: Manifesto of the Constructivist Group* in 1922. He proudly proclaimed that art was dead. It was overly bourgeois and didn't reflect the circumstances or needs of common people. A similar critique might resonate today. Where

is the art that consoles our professional or relationship challenges?

It's noteworthy that Constructivism included more women than prior movements, with philosophical and artistic leadership from Russian artist Lyubov Popova, who was also an accomplished artist in other movements before. The Constructivists painted in mostly plain colors and generic shapes, for example, using red or black squares, offset at angles, and with overlapping, jagged compositions, seemingly influenced by Cubism or Kandinsky. The approach was simply meant to explore space or visual mass and their effects on human consciousness.

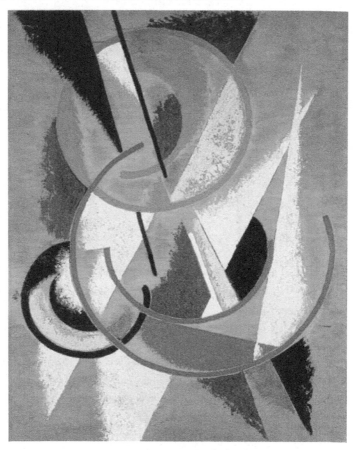

Space-Force Construction, Lyubov Popova, 1921.
State Tretiakov Gallery, Moscow, Russia. Public domain.

Eventually the Constructivists stopped making art entirely. They said it lacked utility. They became designers, which also might feel relevant in today's world of software design and usability. Their favorite patron was revolutionary politician Vladimir Lenin, as represented by his communist state. A preferred format was the revolutionary poster (Picasso would also later design for Communists). They designed furniture, buildings, clothing, and other utilitarian items. Despite the revolutionary attitude and genuine equality, once the Constructivists refocused their creative energies toward design, the female output became more cliché: Popova designed dresses.

Surrealism

André Breton wrote the *First Manifesto of Surrealism* (*Le Manifeste du Surréalisme*) in 1924, striving to *explore the subconscious in art.*

> *"Psychic automatism in its pure state, by which one proposes to express —verbally, by means of the written word, or in any other manner —the actual functioning of thought. Dictated by the thought, in the absence of any control exercised by reason, exempt from any aesthetic or moral concern."*[27]

With that, Surrealism was born. Breton was a writer, not an artist. He founded the movement and built critical mass by recruiting famous names to his cause, even if they didn't identify as a Surrealist. For example, Frida Kahlo of Mexico painted in a *seemingly* Surrealist style. Although she didn't claim affinity with the movement, affirming that her paintings were drawn from real experience, not the subconscious, Breton brought her into the cause. Picasso and Duchamp were recruited also but remained independent.

It was Spanish artist Salvador Dalí who would become the poster child for Surrealism. He was an excessive, imaginative, and magnetic character who used Surrealist art as a pure exploration of the subconscious mind. Dalí wanted *"to systematize confusion*

and thus to help to discredit completely the world of reality. "[28] Dalí is prized for a grand oeuvre of oil paintings that combined a slick, reflective beauty with grotesque, disorienting, and exotic figures.

Exploring a Dalí painting is an unwinnable exercise, if your goal is to accurately decode the layers of meaning through intellectual brute force. Viewers must submit to free association and exploration of contradictory and mysterious images and ideas. Come what will. *The Persistence of Memory* and *Swans Reflecting Elephants* are two masterpieces in which you can get lost.

As we established, the viewers' artistic interpretations *are* driven by their subconscious, like the Surrealists championed. Surrealism is powerful, and resonates with many of us, because it taps into accurate visual and emotional phenomena, much of which is supported by scientific research. Our art experience *is* often dictated by unknown and subconscious forces. Surrealism persists today more strongly than ideas from many other artistic movements of the modern period. It has become a known feeling. When we experience confusion or disorientation, we call it surreal.

Paintbrush Passes to the United States

Although the Impressionists had achieved commercial success in the United States by the early twentieth century, it wasn't until after World War II that the United States became the global center of artistic production. New York City was the focal point. A force who pointed the art world toward the United States was American Peggy Guggenheim, a wealthy socialite and art collector with the eye and ambition to find promising emerging artists. Although she lived much of her life in London and Venice, her connection to New York created artist-patron relationships with emerging superstars like Jackson Pollock. Guggenheim paid Pollock $150 a week, which provided him the support to explore his creativity.

Abstract Expressionism

With security ensured, Pollock pioneered Abstract Expressionism. Like other avant-garde artists before him, Pollock was classically trained and comfortable with traditional themes, like portraits and landscapes. But Pollock felt he had reached a plateau by painting traditionally. He decided to paint spontaneously and freely from his emotions by adopting an approach that didn't just *show* motion on the canvas, but that required him to *be in motion* while painting. Abstract Expressionism combined the emotional aspirations of European Expressionism with the Abstract Minimalism popularized by Kandinsky.

Pollock's first show in 1948 garnered mixed reviews. Audiences deemed his work overly simplistic, despite the variety of mediums employed. A primary artwork in the show was titled *Full Fathom Five*, and included *"Oil on canvas with nails, tacks, buttons, key, coins, cigarettes, matches, etc."*[29] It was a coherent mess of paint dripping in circular, curved, and random paths combined with a found assortment of materials a trash collector might find behind a New York City apartment.

Audiences and critics were confused by the perceived mess and Pollack's apparent lack of intention. The work wasn't a hit until another artist, photographer and filmmaker Hans Namuth, created a short film about Pollock's approach. In the film, audiences could see Pollock outdoors, smoking, melodically working above the canvas with a fresh and purposeful energy. And rather than belittling his artistic output, as they had before witnessing the action that was required, critics and audiences were absorbed in his thoughtful rhythm.

Namuth's camera work in the film, often shot from below or angularly, showing Pollock's lively maneuvers, is often considered a precursor to contemporary performance art. It was a prominent example of the *artistic process* as a complementary spectacle to the output.

Another famous Abstract Expressionist, one with an entirely different emphasis, was American Mark Rothko, who considered himself deeply religious and philosophical. He said that the sensations of color in his art were meant to radiate spiritual awe and encourage self-improvement. The first gallery dedicated solely to Rothko was set in the Phillips Gallery in Washington, DC.

Rothko mandated how the work should be hung, the height of viewing benches and the pitch of surrounding light. His work was simple, almost austere. It employed consistent usage of vertical canvases with two or three blocks of color. I'm sure you have seen it in museums or photos.

Many viewers have questioned why his work commands such attention, while stating that their fifth grader could compose similar material. That might be true, although they wouldn't know why it mattered. Stories abound of viewers being moved to tears in the presence of these mere blocks of color.

Pop Art

Pop Art in the United States was partially a criticism of Abstract Expressionism, which pop artists felt overreached by (falsely) claiming access to universal emotions. It was also a child of Dada movement sarcasm and social commentary on a new phenomenon—consumerism. Pop artists lived in a 1950s America that was ripe with a strong middle class consuming an unprecedented number of new products.

The Industrial Revolution's promise was finally being realized through seemingly infinite product choice. Consumers were awash in manipulative marketing for the first time. In prior artistic periods, it was only the church or state who wielded artistic powers for propaganda. Now it was companies and their brands.

Pop artists reacted by sarcastically appropriating images from marketing campaigns, company logos, celebrities, and consumer products and repositioning them as art.

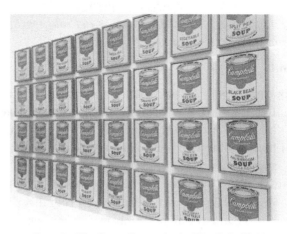

Campbell's Soup Cans, Andy Warhol, 1962.
Museum of Modern Art, New York, New York.

Andy Warhol was the undisputed alpha of pop artists, even penning his own book, *The Philosophy of Andy Warhol: From A to B and Back Again* (1975). It should come as no surprise that his first career was in advertising, where he honed his persuasive craft until turning his sights to art at age forty. Warhol combined marketing flair with pop culture insights to create images of consumer goods, like Coke and Campbell's soup cans. He then moved to images of celebrities like Marilyn Monroe. Warhol also reignited the artist's guild, which he called "The Factory." It became as notorious for raucous parties as artistic production. Unlike European workshops during the Renaissance, Warhol was able to mass produce at a level that moved artistic production into scalable commerce.

Warhol and pop art celebrated the marriage of art, commerce, and industrial production. Warhol's words sound surprisingly contemporary today: *"An artist is somebody who produces things that people don't need to have."*[30] The sarcasm and truth are wrapped into a paradox that we can't completely refute—we want art, beauty, and visual ideas in our lives, but we can't seriously elevate those desires to the level of "need," much like the consumer products we covet but can hardly claim as necessary. Warhol also said that *"Being good in business is the most*

fascinating kind of art. Making money is art and working is art and good business is the best art. "[31]

Minimalism

In what appears as yet another reaction to a prior movement, the next turn after Pop Art was Minimalism. Minimalist art might contain a single piece of yarn, a solitary color, or an unframed painting of boxes with plain lines. Minimalists backed away from the flashy aggression of pop art and the vibrancy of Abstract Expressionism. They wanted to do more with less—to emphasize prominent ideas and let the rest fall away. During this time in the 1970s, a conspicuously high number of artworks remained untitled. It fit the minimalist ethos. Why name an artwork if it stood independently? And why spend more time discussing a minimal movement?

And so, we reach the end. Not the end of art, but of the modern era. We transition into Postmodernism.

Postmodern Approaches to Art

The descendants of Modernism inserted "post" in front of an entire century. It's a skeptical worldview that presents *a meta critique of all prior genres*. It was a grand and final dismissal of art until that time. Modernism was over. Postmodern says that *knowledge is relative and no truth is absolute*. History was written by the winners; the media is also controlled by the winners—the economic elites with a vested interest in maintaining the status quo. We can't trust them. Furthermore, social norms are built by the confluence of time, place, culture, and the leaders who fostered them. Virtues in one society can't translate to another. As we've seen in prior sections about the history of attracting attention through either beauty or shock, and in the review of aesthetic philosophy and artistic meaning, Postmodernism announces the arrival of a post-fact, fragmented society.

Modern art movements from Impressionism onward often proposed ideas about personal emotions or social meaning, with an emphasis on originality and innovation. Art mines our

subconscious (Surrealism). Art represents pure emotion (Abstract). Art showcases and critiques consumerism (Pop Art). Art encourages social equality (De Stijl and Constructivism), and so on. Postmodern art would critique these ideas by changing the mediums and the messages.

If modern artists believed in Cubism to show an image—say a bed—from multiple viewpoints, then postmodern artists would create an entire installation of a bed strewn with clothing, food, and trash. In fact, they might not paint or sculpt it. British artist Tracey Emin would simply move the entire contents from her bedroom to a museum.

Installation art was a key force within Postmodernism. It did not just adopt readymade items, but pioneered complex, site-specific work that honed lights, videos, rocks, pulleys, huge metal sheets—anything—to fit the proclivities of a unique location or time.

Another force was **conceptual art.** If modern art believed in beauty and visual expression through images, then conceptual art would disagree, and say that we don't need images at all. Conceptual artists might place words on a canvas and write their ideas with clever language.

A third significant postmodern approach was **performance art.** It began long ago in Ancient Greece and resurged with the Constructivists and Dada in Europe. Performance art varies wildly but often incorporates poetry or spoken word with props. It's drama, but not necessarily meant to entertain by generating pleasure in the audience. If you are entertained, so be it, but the purpose of performance art is to express meaning, not generate laughter, to attract attention and convey ideas, and to provoke.

A contemporary example is the widely praised performance, *The Artist Is Present,* by Yugoslavia-born artist Marina Abramović in March 2010 at the New York MoMA. Abramović sat alone in the museum's atrium for 736 hours at a solitary table in complete silence. Without words or movement, she openly invited

spectators to sit across from her at the table. Spectators could sit as long as they liked, and they were welcome to stare into her quiet but steady gaze. Audience participants cried, laughed, and were puzzled, as Abramović invited them to stare into a stranger's eyes—her eyes, silently. It showed an intimate experience on public display.

Today we've reached a playful, commercial era of globalized artists who seem to encounter few limits in a digitally connected world. Artists have reached a height of wealth and celebrity, with top artists commanding net worth estimates in the tens and hundreds of millions. Even if you cannot visualize their art, you probably recognize the names of American artist Jeff Koons, English artist Damien Hirst, and Chinese artist Ai Weiwei.

Koons' work is sexual and enticing. Hirst trades in glittery, shocking, and thoughtful objects. Ai Weiwei is deeply political, prolific on social media, and specializes in site-specific installations. They are entirely unique artists experimenting across mediums and styles. They are not Impressionists. They aren't Dada or Pop Art.

Hirst placed a dead shark in a formaldehyde fish tank and called it the *The Physical Impossibility of Death in the Mind of Someone Living*. Can we really imagine dying? Ai Weiwei's show in the old prison on Alcatraz Island was called *@Large* (calling the digital-style Twitter handle with "@"), and commandeered cell blocks, a dining hall, and a hospital as sites for activist art about political prisoners. He planned and executed it while being forbidden from leaving his native China due to political reasons.

Art critics and historians have yet to name the contemporary period, although a few have begun to try. Until they do, it's all labeled **contemporary art.** In fact, everything since 1950 earns the contemporary moniker: Abstract Expressionism, Pop Art, Minimalism, and Postmodernism. But unlike art before the year 2000, our current era is one of *globalization* and *entrepreneurialism* in art. It includes a resurgence of mega studios with large numbers of staff, increased usage of new technology

and modern materials, and subject matter that neatly combines provocation with beauty.

Artists haven't developed an algorithm yet, but they know better which buttons to push. Artists can show their work in Miami, London, Geneva, and Los Angeles within a year. The same artists might feature in galleries, museums, biennials, fairs, online, and in mobile apps. Collectively, contemporary artists are pushing the art world forward but also smashing it together. They explore themes close to their own personal lives and political beliefs. Increasingly, these beliefs have relevance across a connected global media and population.

The Four Shifts

Much of Western art history followed a progression toward increasingly accurate visual representation of subject matter through murals, reliefs, sculptures, and painting. Artists sought to fuse the real world with ideal forms of beauty and grace. Dominant artistic subjects included royal prestige, military power, reproduction and death, and religious piety. Art presented stories largely by and for those who defined culture—those in power. Within that, for almost a thousand years, Christian art and architecture was the lone vestige of artistic innovation and expression in Europe.

While Christianity's monopoly on artistic production limited subject matter innovation, it did ensure consistent employment for a set of skilled craftsmen and the ability for them to test new pigments and artistic techniques. As religious power eroded, artists began to portray themes from everyday life for unknown patrons. In tandem, artists saw their economic security wane and revered legends, like Rembrandt, struggled in cold and hunger. Subject matter began to evolve from patron-directed topics, standards, and norms, and yet, the visual look of most artwork still aspired to realistic depictions of lifelike objects and images.

In the nineteenth century, everything changed. Amidst the unprecedented human turmoil of industrialization, militarization,

consumerism, and social upheaval, art tried to comprehend, critique, and propose meaning amidst uncertainty. The acceleration of artistic movements and adoption of mediums supported art's newfound quest to criticize and influence cultural direction. Until the modern era, few artists stood outside the shadow of a king or the kingdom of heaven, but now art was a global phenomenon where creators were more famous than their subjects. And it's all art, available anywhere. At a given exhibition during the Singapore monsoon or Chicago winter, any topic, object, or idea might be thrust at us as "art."

We're becoming ready for that. Art's unrestrained growth brings beauty and insight to unexpected locations, like subway train cars and abandoned warehouses. Art has emerged from church walls and galleries to cover our T-shirts and the canvas on our shoes. We're unquestionably subsumed in a world where art is around the next street corner or through the next click. The unlimited creative freedom might confuse general audiences, who remain more comfortable in a museum's Impressionist wing than looking at Tracey Emin's unmade bed or staring into a stranger's eyes. But by now we should be more confident, comfortable with both classic beauty and also the ideas and structures behind postmodern and contemporary art. We're becoming tolerant of discomfort and slightly willing to fight through the viewing process methodically, using stamina and knowledge to embrace art world novelty.

The Four Shifts

	Dominant in Past		Dominant in Present
Attention	Beauty	→	Shock / Concept
Meaning	Patron and Artist-Directed	→	Viewer and Artist Combination
Materials	Stone / Paint / Wood	→	Multimedia / Conceptual
Location	Royal / Religious / Fixed	→	Digital / Mobile

Artists Snapshot: Who

Art, being an ambiguous profession, offers us opaque and contradictory clues about its practitioners. We often conveniently ignore the question of who is an artist by saying they are anyone who produces art, or we fall into stereotypical tropes about famous artistic archetypes: eccentric artists, genius artists, starving artists—take your pick. We're awash in half-truths, confusion, and outright misunderstanding. We've read glamorized stories of the sensational and suicidal geniuses who willed art across new boundaries through inspiration and madness. Yet few of us consider the gritty realities of everyday artists and their working environments. How many times have you seen a studio or watched an artist work? Furthermore, throughout history, much of the art creation process was not conducted by "an artist" at all, but a group or guild operating together under the supervision of an artistic producer.

An "average" artist doesn't exist. Pick any occupation and we could make the same assertion—averages hide realities. But with artists, it's more pronounced. The winners really do take all, reputationally and financially. Visible museum space is shockingly finite; even historical greats wind up in storage space at the Louvre or the Met. Rather than averages, a few quick vignettes below will highlight several artists as emblematic of time-place-style intersections across art history. You probably already know their names and most have already been mentioned at some level in this book. Each was essential to a seminal moment, working in a critical location and genre that represented or has come to represent what it meant "to be an artist" at that moment.

Throughout history artists have been positioned uneasily between two poles: visual artist as *craftsmen* or artist as *cultural genius*. In Egypt, Greece, and Rome, artists generally created objects about known stories or that reflected common patterns. They worked foremost with their hands, and to a lesser extent their minds, to

produce known images, perhaps of Egyptian kings or gods, or of heroic myths, such as the Homeric Iliad. Artists produced visual flair, and their skills were respected, even admired, but they weren't cultural geniuses or keepers of the avant-garde. They were craftsmen. The thinking of their day was left to philosophers, while the storytelling was left to poets and bards.

Occasionally, artists broke through and created objects of such grandeur that their status was elevated. They nipped at the heels of genius. But the road was jagged, and the path to respect was long. Even in the Renaissance, artists were not the respected cultural geniuses of today. They didn't unearth the hopes and fears of society and show us our hidden beliefs. Artists didn't emerge to the cultural forefront until they mastered both *craft* and *idea,* regularly producing not just good, but great art. As artists eventually became the authors of their own stories, and the masters of their materials, they emerged from the dirty studio to become visual philosophers.

Today, we marvel at classic artistic creations as cultural genius, works that wrapped their momentary zeitgeist over a timeless human core. Genius comes from the Latin, and previously from the Greek verb for "to be born" or "to come into being." Genius brings objects and ideas from nothing. It grips, pulls, and forces beauty from the void of zero. Our admiration at the courage and insight to pull from the ledge of zero is the source of our modern admiration for artists. Indeed, the term applies to creative and intellectual leaders across disciplines, from math and science to technology and art. It applies to all the "creative cousins."

Geniuses are uniquely able to harness distinct human traits of mind, visual field, thumbs, and vocal chords to create objects that previously didn't exist. Our most revered artists are now considered geniuses who hold a mirror to society and challenge conventional thinking. It couldn't be more different from the slave-like craftsmen etching myths into Egyptian stone tombs for King Ramesses.

Here's a quote from art professor Mary Anne Staniszewski in her book. *Believing Is Seeing*:

"The most important artists of our time are visionary in that they continue to challenge us to see our world differently. They represent our culture in enlightened and, at times, beautiful ways. Artists prepare the mind and the spirit for new ideas—new ways of seeing."[1]

It's an ambitious quote, with words like enlightened and spirit as pillars of the argument. It certainly alludes to the idyllic, genius cliché. And that's fair enough, Staniszewski is calling forth artists at their best, those who know more about us than we do about ourselves.

Thomas Lawson is the dean of CalArts School of Art in Valencia, California, one of the most prestigious arts programs in the world. His definition was humbler, almost narrative, when he said,

"It's [being an artist] *not necessarily someone who sells a bunch of objects through a fancy gallery. An artist thinks about culture through visual means. Sometimes it's thinking about culture through any means possible, but it's rooted in the visual."[2]*

It's telling that Lawson started with what an artist is **not**—someone selling objects. An artist is a person disconnected from fancy galleries, or at least not encouraged to seek recognition through vehicles of commerce. We'll come back to this, because a lack of commercial success is truer than we think. For Lawson, an artist is a documentarian. Artists think about culture in any way they can—not necessarily through visuals.

Lawson's definition is likely rooted in the fact that CalArts famously helped pioneer the more conceptual approach to art, the idea mentioned in the What Is "Exceptional" Art section, worth repeating: wrist up versus wrist down. Previously we leaned heavily on the concept of wrist up versus wrist down—whether art attracts attention and conveys meaning through idea, craft, or both.

Relevant to the discussion is this distinction's ability to instruct us about who artists have been during different time periods. Some artists tend toward beautiful visual styles (wrist down) without as strong an emphasis on conceptual meaning. Other artists emphasize concepts (wrist up) without using technical beauty as the vehicle. The geniuses who strike our deep imagination often manage to hit both, but that was not always allowed or encouraged in previous eras.

The Christian Reformation is relevant here, as is photography. The acceleration of wrist up conceptual work, and the merging of artists producing both wrist up and wrist down material, occurred first after artists lost the church as their major patron during the Reformation, and next with the adoption of photography in the 1830s. When art was mostly craft, wealthy patrons either decided or heavily influenced artistic subject matter—the wrist up patron and the wrist down laborer.

Yes, artists always had various degrees of freedom, but if a church commissioned their work, it must be religious. If a noble commissioned their work, it might be a portrait, or subject matter relevant and flattering to the noble. In the nineteenth century, when artists approached the faceless town markets of northern Europe *hoping* that common citizens *might* buy their work, an artist could document everyday life, inspiring or challenging would-be buyers to a study of culture through visual means.

These definitions describe artists as people who document and foreshadow transitions in culture, and peer into our hearts for universal experiences. Even if artists sculpted and painted known images of gods and nobles, they still summoned universal traits of piety, strength, honor, and beauty. Artists were always people and teams who told universal stories for a living. But as the twentieth century dawned, and art turned modern, it grappled with a changing, mechanistic society. Artists, liberated of patrons, become people who questioned the common social order, and whether the previously accepted emotions of piety, strength, honor, and beauty meant the same things as they did before—

whether they held equivalent value.

Adopting this biting and more critical stance pushed artists further outside the mainstream of economic and political power. Suddenly, artists were outside the system that their predecessors had once glorified. They were people responsible for questioning as much as supporting the way of things. That is a divergent kind of person from a guild member who mastered sculpting techniques. A visual skeptic requires an educated balance between physical skills and mental aptitudes. It requires an attitude of irreverence for society but a respect for methods of attraction. With this context, it's easier to understand why an artist today might defy easy definition, and why their disposition seems incongruent with the history books.

"The artist is an enemy of . . . ah . . . general sensibilities."

—Ai Weiwei[3]

The artist described by Ai Weiwei is no less visionary than the artist described by Staniszewski, and no less able to think about culture visually than Lawson's archetype. Ai Weiwei's artists might create through wrist up or wrist down techniques. They must understand culture to critique it, but you get the distinct impression they'd prefer to mentally shock viewers (wrist up) than visually please them (wrist down). Ai Weiwei's artists are not simply "challenging" or "representing" culture in beautiful ways—they are the "enemy" of common understanding. We fight our enemies. We isolate them. Artists who subscribe to this definition are fighting common expectations of the average person. That average person is often you and me.

It's difficult to overstate the role transition that has occurred during the past 200 years, not to mention the past 2,000 years. It's not like water hardening to ice, it's completely different. Today, Picasso's signature alone is more recognizable than entire portfolios of art across hundreds of years. In museums across the world, under the same roof, we see classic, reverent art, and works that use art to fight general sensibilities. It's often disorienting,

until we understand who were artists during various time periods, and how their different roles would necessarily produce *The Last Supper* or giant prints of Coke cans.

Artists were anonymous. They were craftsmen. They were and are creators, but now many aspire to be visual culture pioneers. Yet they are also your neighbors and community members. They shop at the local stores and send their kids to your local public schools. Artists document everyday life and channel inspiration to fight general sensibilities. But it's still a job.

The practical reality is that most contemporary artists don't even make a full-time living from their art. That's the numerical reality of artistic life today. Even the craftsmen of ancient Rome were full-time. Today, most artists make less than $10,000 annually by selling their artwork. According to the US Census, there were only 12,480 people in 2012 who claimed art as their full-time jobs. Those artists made an average of $54,000 annually, about an average household wage.[4] But 12,480 is a micro-fraction of the US economy. More people work at Starbucks in California than are artists in the United States.

In the United Kingdom, the statistics are similar: almost a third of visual and applied artists earn less than £5,000 a year from their creative work, according to a survey conducted in 2015 by Artists' Interaction and Representation (AIR). Of the 1,457 respondents, 57 percent said that less than a quarter of their total income was generated by their art practices and only 16 percent of them paid into a private pension fund.[5] This raises questions about how professional artists will support themselves once they reach retirement age. Yes, even artistic geniuses must save for retirement.

This archetype is an everyday hero among us. It's not the story of artists emerging from dirty workshops to cultural fanfare. This is the middle class, part-time artist. But part-time artists can still push culture forward and challenge our assumptions. They can still harness wrist up or wrist down techniques to convey unique meanings. And a precious few, of course, do create art full-time to

fill cultural institutions and challenge our imaginations on a grand scale.

Being an artist today encompasses the spectrum of historical and modern incarnations: Full-time and part-time work, wealthy artists in high society, and mostly middle-class artists, sometimes with regular customers. But the path here was built by a collection of pioneers who forged our impression of an "artist."

Likely the first artist's signature in Western art history is by Sophilos, who scratched his name on a Greek pot about 580 BCE. He wrote "Sophilos drew me" (Sophilos me grafsen). Technically speaking, this isn't a signature so much as a statement. Perhaps it was meant as a competitive, chest-thumping statement among potters, as ancient Greece thrived on competition, or maybe it was a human urge to possess his creation, or to support commerce in his business. Either way, it was the exception, not the rule, for artists of the anonymous era, as we'll call it.

During the prehistoric, Egyptian, and Hellenistic periods, the *who* of art was largely anonymous. It's not that we can't point to this or that artist, like the sculptor Phidias, but rather the sheer number of unattributed works or art likely attributed to groups. While a portion of the blame lies with obscure records, it's more accurate to simply state that signing artwork was not the norm in the ancient world, which often makes attribution difficult to impossible, even before the need to excavate through layers of dirt on a mountainside. In fact, signatures weren't even common in the Renaissance, but it was an especially nonspecific practice in Greece, and more so in Egypt before.

Here's a telling quote from leading scholar of ancient Greek art Jeffrey Hurwit, in *Artists and Signatures in Ancient Greece*:

> *"To sign may be human, but it is still hard to divine . . . no Greek artist signs all of the time. . . and so were quite capable of resisting a supposedly universal and innate human impulse. (And ancient artists, incidentally, are not alone: no Byzantine painter ever signed an icon; Giotto*

signed only three times, and briefly; Raphael signed only 18 of the roughly one hundred paintings attributed to him; Leonardo signed nothing at all; and neither did Michelangelo, with the exception of the Pietà in St. Peter's—and that, if a dubious story told by Giorgio Vasari is to be believed, only under unusual circumstances)."[6]

With later Renaissance artists, other forms of attribution existed, such as royal or church documents. Artists were known and chronicled, even if they didn't sign their works. We are relatively certain of attribution for the majority of famous artworks from the Renaissance—the vast majority. By then, artists were highly visible, if not fully respected, compared to other professions.

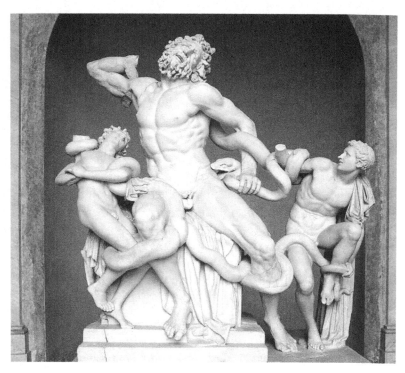

Laocoön and His Sons, c. 200 BCE.
Vatican Museums, Vatican City, Italy. Public domain.

During earlier periods, attribution is exceptionally unclear. That's why we named this the anonymous period. Let's take the era's most famous artwork as an example: *Laocoön and His Sons*, introduced previously, was discovered in 1506 Italy, and dates to Greece about 100 BCE.

Surely this artwork was famous and the creator had notoriety. The sheer size, detail, complex emotions, and classic mythology must have drawn wide praise and fame. But the reality is that we can't be sure of the artist or artists who created the marble sculpture.

It was unearthed in Italy during the Renaissance and restored in part by Michelangelo, sparking at least a few conspiracies that Michelangelo actually created the Laocoön anonymously, although that's doubtful. Otherwise, historian Pliny the Elder, copious documenter of ancient Greek life, praised the work and attributed it to three different artists. But Pliny's enormous effort of thirty-seven volumes and 20,000 facts, while heroic, was filled with errors. And still he cited three artists, and likely an entire workshop, for the supplies and labor required.

Pliny said:

> *"In the case of several works of very great excellence, the number of artists that have been engaged upon them has proved a considerable obstacle to the fame of each, no individual being able to engross the whole of the credit, and it being impossible to award it in due proportion to the names of the several artists combined. Such is the case with the Laocoön, for example, in the palace of the Emperor Titus, a work that may be looked upon as preferable to any other production of the art of painting or of [bronze] statuary. It is sculptured from a single block, both the main figure as well as the children, and the serpents with their marvellous folds. This group was made in concert by three most eminent artists, Agesander, Polydorus, and Athenodorus, natives of Rhodes."[7]*

We find ourselves in that world where artists rarely signed their artworks. They created art in groups. It's likely that powerful figures of their time, let alone everyday citizens, couldn't identify the original force behind the numerous statues, urns, frescos, and paintings of the era. This is *who* an artist was in ancient Egypt and classical Greece. They were mostly anonymous craftsmen, or at best, guilds, with moderately renowned leaders.

This is how artistic attribution continued for almost 1,000 years, spilling into the Renaissance. The Middle Ages are occasionally labeled the Dark Ages, partially because of notoriously spotty records, for births and deaths, political proclamations, property, and the origins of artwork. Artists designed religious sites and promoted a noble's sense of their own nobility, while artisans created jewelry, housewares, and crafts. Most products of quality wound their way up the protected road to castles and abbeys on the hill.

You could devote a lifetime to artistic study between the bookends of Rome's fall and the Renaissance. Your studious devotion would be rewarded with knowledge of inspirational, nuanced artwork from the period. But for our purposes, outlining the basic nature of who artists were in the Western world at various times, their position remained stagnant. Even for a dedicated art history student, anonymous guilds would be a recurring feature.

Being an artist didn't bring much notoriety, unless you achieved outsized, once-in-a-generation fame. Glory was in warfare, nobility, or the church. The title or designation of a *genius* wasn't yet conceived, and few would have considered themselves visual culture pioneers or enemies of general sensibilities. The humble ambition was to propagate noble and religious stories, and remain subservient to another person's narrative vision. For most of modern human history, at least 2,000 years, being an artist lacked any halo of glamour.

In the previous quote by Hurwit, he mentioned that an artist named Giotto (1266–1337), the accepted father of Renaissance style, only signed his artwork three times. This is telling, since we've now entered the early Renaissance, or the cusp of Renaissance. Almost Giotto's entire early body of work is questionable. Giotto was supposedly born in a farmhouse to a poor sheepherding family. The circumstances of his early training are entirely unclear, but luck brought him to the workshop of a famous Florentine painter, Cimabue. We don't know when his career began, and we can't be sure which early works he produced.

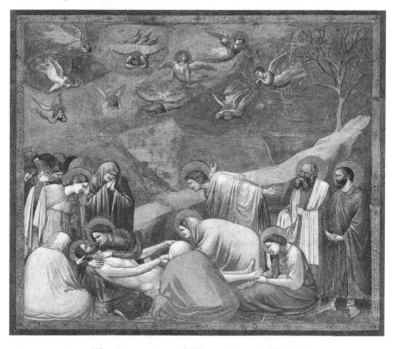

Lamentation (The Mourning of Christ), (probably) Giotto, c. 1305. Cappella degli Scrovegni, Padua, Italy. Public domain.

Imagine the challenge: Giotto is a young man working under an established artist. That artist sends Giotto from Florence to another city, perhaps Assisi. We're not sure exactly when Giotto left or arrived. The church provided Cimabue a commission. It

was for the Basilica of Saint Francis of Assisi. The Romanesque church is 260 feet by 160 feet, with a nave extending 59 feet skyward. Commissions were usually for one section of a church—an altar, wall fresco, or stained-glass installation. But maybe the commission was for the entire church. We can't be sure.

The church contains dozens of sections and hundreds of frescos across walls and ceilings in both upper and lower chambers. The most prominent section is a cycle of twenty-eight paintings, each describing a unique story in the legend of Saint Francis. Scholars know Giotto was *there*, but they believe all twenty-eight artworks in the cycle cannot be attributed to the same artist, let alone artwork across the labyrinthine site. So, which art did Giotto produce? We'll probably never know.

Later works are more certain. Giotto's fame was solidified by Dante, his prowess earning a fourteenth-century shout out from the legendary poet. Later frescoes in Padua, Italy, at the Scrovegni or Arena Chapel were enough to solidify his reputation for a rebirth of classical realism and rich, humanistic depictions of subject matter. Giotto's *The Last Judgment* (1306) stands as a fresco that propelled Renaissance artists to the success they would accomplish.

Giotto did achieve fame during his lifetime across Italy. The city of Florence designated him "Great Master" and appointed him as the manager of public works after his successes in Padua, Rome, Naples, and elsewhere. It's telling that gaps continue to haunt one of the most famous artists of a century at the precipice of the Renaissance. Where Giotto was, specifically when, is often uncertain, and once he entered churches, attributing each fresco remains a challenge, not least because the artwork has been damaged and repaired throughout the centuries.

Giotto was a pivotal artist, emerging from the anonymous era into the Italian Renaissance. Anonymity finally began to fade after one and a half millennia, at least for the most famous artists.

Patronage and commissions still continued as the primary drivers of artistic practice, but the storyline became more transparent as historians began citing named artists with increased frequency. As art began to bring prestige to its owners and locations, the Renaissance-era producers started to achieve consistent praise.

Even when artists did achieve fame and mingle with society's elite, like Leonardo da Vinci (1452–1519) and Michelangelo (1475–1564), in a world of strict hierarchy, the artisan class was fixed a rung below. Artists of the Italian Renaissance were almost exclusively tied to the church or feudal commission structure. They were told what to paint, if not how to exactly realize the vision. Michelangelo was no exception, essentially bonded to the Roman pope while he completed the Sistine Chapel and fighting artistic choices through the project. In Northern Europe, as we've said, the patronage association ruptured sooner, but was still a cornerstone of the art market for centuries.

Take Peter Paul Rubens (1577–1640) as an example, famous for works such as *Descent from the Cross* and *Massacre of the Innocents.* Born roughly a decade after Michelangelo's passing, Rubens is perfectly placed to exemplify a last gasp of religious painting that occurred during the Counter-Reformation, at the intersection of the northern and southern Renaissance.

Rubens' oeuvre was still firmly grounded in traditional male and female roles in society, biblical stories, nobles, and their property, but he also addressed a newer topic, not the glory of war, but its tragedy. Yes, his workshop produced hundreds of idealized portraits, landscapes, and scenes of physical perfection, but he also introduced voluptuous nudes—painting the naked body of his second, younger wife, up to a dozen times in a single artwork. His work, the *Massacre of the Innocents,* emphasized the scourge of war. It displayed full-figured, visible bodies in active motion. Some think *Massacre* looks like an orgy of sex and slaughter, shining through oil on wood.

269

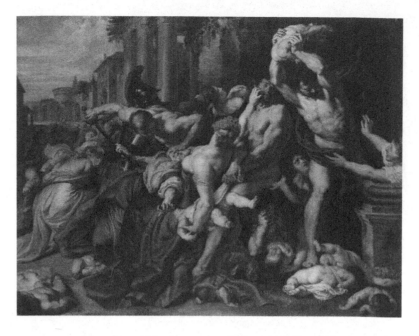

Massacre of the Innocents, Rubens, 1611–1612.
Art Gallery of Ontario, Toronto, Canada. Public domain.

Rubens and his team completed between 1,400 and 2,000 artworks in his efficient workshop, managing the large number of commissions by quickly painting test compositions in oil, which were used to gather client responses. Members of his workshop would complete the paintings based on client reactions. Contemporary software designers would be proud. It was an early use of iterative design and user feedback, which is so popular today for technology products. His style is representative of the European world at that moment—glorifying a religious past, while simultaneously addressing the carnage of war and rebelling against old social conventions. Old patterns were breaking.

With Oscar Claude Monet (1840–1926) we finally see the renegade artist, perhaps not yet an active *enemy* of general sensibilities, but certainly not a natural fit with the status quo.

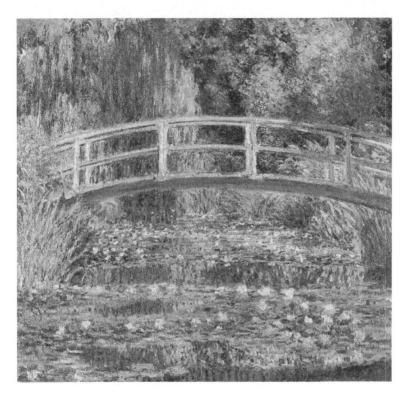

Water Lilies and Japanese Bridge, Monet, 1899.
Princeton University Art Museum, New Jersey.

Watching historic footage of the aging Monet strolling his gardens at Giverny fosters an appreciation for the wise, soulful, jovial, and carefree artist he became. Proudly wearing a rotund, wide-brimmed hat, with a bushy white beard that flowed seamlessly into an all-white suit, he smoked and painted, dabbing oil on canvas, glancing quickly at the scenery, then dabbing and smoking again.

Monet's life wasn't easy. It cleaved into two parts, prolonged poverty and sustained fame. He was a rebel at heart, relentlessly pursuing an artistic vision that conflicted with accepted norms. Along with years of critical rejection, his family was impoverished due to lack of sales. His Impressionist colleague

271

and friend, Pierre-Auguste Renoir (1841–1919), saved bread from home to share with Monet and his family. His submissions to the Paris Salon were derided and his group show with other Impressionists—the Salon des Refusés, was labeled a disaster.

Monet sat at the vanguard of artistic innovation. Before Monet, water, hills, skies, and landscapes were typically shown at a distance, and smoothed with glossy, fine details. Monet pushed the viewer directly into the frame. He brought it in closer and rushed to embrace his surroundings with greater urgency. He embraced Japanese artistic styles, storytelling ethos, and elegant minimalism. He carried paints and canvas onto boats to paint while bobbing on gentle waves, rather than remaining a distant observer from shore.

By 1876, he began making consistent sales, in the United States and to those who had tired of the traditional Paris Salon. That such a break was possible showed a sign of the times. The institutional grip on artistic approval was weakened.

By the age of forty-one, Monet was finally triumphant. He was the overnight success that incubated for decades. The Impressionist movement had caught fire. With the collective artistic output of Monet and his peers, and the shrewd patronage from Durand-Ruel, Monet's work would become highly desirable.

Remarried and with a collection of seven children, some from his own doing and some gained through marriage, Monet moved to the small village of Giverny. Without city or financial distractions, Monet's artistic output hit the accelerator. His creativity flourished, and it did so nearly uninterrupted for forty years! He'd become a prolific dynamo, painting up to fourteen canvases at once, like a chess master playing an army of hopeless opponents simultaneously. Monet painted without a workshop or army of support staff. During his life, he would complete almost 2,000 artworks. Today we might yawn at Impressionism as

boring due to overexposure. This only goes to emphasize Monet's stubborn determination and triumph.

Artists of Monet's time navigated the newly complex art market, changing societal norms, and pushed untested techniques to their contemporary audiences. The archetype, and reality, of the starving artist, was launched during this time, as was the profile of a famous, international genius. Monet was both.

If Monet was both, it was never a question for Pablo Picasso (1881–1973). The name Picasso is practically synonymous with artistic potency. His signature has been copied (Radisson hotels), his lifestyle emulated, his personality exalted, and his techniques replicated endlessly. Picasso's personal flamboyance enables the image of and stature of artists that we accept today. He worked shirtless and in shorts, often on the beach, surrounded by beautiful women, his lifestyle muses.

Picasso would rapidly rise to prominence. Unlike Monet, Picasso's legacy was almost assured from a young age. Many historical accounts say he could draw before speaking, that his first word was "pencil," and that he had completely perfected classical painting by age sixteen. Born as Pablo Ruiz, he independently adopted his mother's surname, *Picasso*, later speculating about the lackluster alternate life he would have lived under the dull surname, Ruiz. He gravitated to the name Picasso because of the association with picador—the bullfighter who lances the bull, a topic with which he had a youthful obsession, as he was already painting with vigor by age eight.

Picasso embraced novelty, tirelessly innovating and experimenting with new methods and mediums. He regularly employed the shock of grotesque and challenging images, usually building narratives around his personal experience, without a hint a religious or noble patronage. His work was a visual diary of painting, drawing, sculpture, design, ceramics, and more.

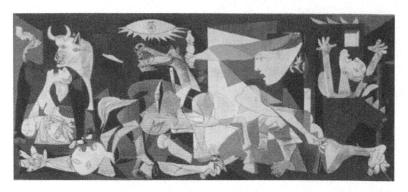

Guernica, Picasso, 1937.
Museo Reina Sofia, Madrid, Spain. Courtesy of
www.PabloPicasso.org.

Picasso believed that his era of rapid industrialization issued modern artists an urgent call. They needed to address social and technological challenges more aggressively than past artistic movements had responded to their own eras. A modern artist must adapt to stay relevant and push social conversation forward. Picasso took his own advice, continuing to investigate each vector, often combining and remixing ideas, such as merging European with African art, and abstracting the content, culminating in Cubism.

To be a European artist during the early and middle-twentieth century meant to live among war. Picasso's response was to rage against violence and crusade for peace. Rubens had also done so through his art, but the approach was subtler, sexual bodies notwithstanding. Now artists were unshackled. The civil war in Picasso's native Spain was notoriously brutal, often causing gruesome civilian casualties. One prominent example was carnage in the small village of Guernica, where an absurd 5,000 bombs were dropped, leading to 1,600 civilian deaths over six weeks. Picasso would paint an eponymous, mural-sized masterpiece, *Guernica*, in the village's honor. It was sent on a global tour to fifty locations in support of peace and against fascism.

Picasso's quest for peace would lead him to communism, which he saw as an antidote to the destructive fascism that gripped Spain. He embraced the movement and would participate in what we might today call branding, or logo design. Picasso designed the *Dove of Peace* (1949) for the communist-leaning First International Peace Conference in Paris.

In older age, Picasso was still virile and productive. He drank, partied, and created in the warmth of southern France, often still accompanied by attractive, young muses. Rubens and Monet were previously submitted as highly productive artists, but Picasso's output was staggering and almost comical. He completed *"50,000 works of art, including 1,885 paintings; 1,228 sculptures; 2,880 ceramics; 18,095 engravings; 6,112 lithographs; and approximately 12,000 drawings, as well as numerous linocuts, tapestries, and rugs, not to mention his letters, poetry and plays."*[8]

Today, we find Picasso's influence throughout the visual arts and in music, where contemporary stars stake claim to his legacy through albums titled *The Life of Pablo* (2016) by Kanye West, or in Jay-Z's song, "Picasso, Baby."

Marcel Duchamp signifies a new breed of artist. Picasso, for all his innovation and copious output, was easier to categorize as a classic artist, a person with the financial profession of making art objects. As we reach the contemporary age, the lines are less clear. Duchamp was among the first to emphasize intellectual, not retinal, art, and for much of his life, Duchamp was not an active artist at all. For decades, Duchamp's production was sporadic, instead preferring curating and chess, which he believed was more beautiful than art. Yet with a few brilliant moves, he deeply swayed a century of art and his influence continues today.

Duchamp was entirely detached from any particular medium or style, employing readymade sculpture, mixed media,

performance art, and painting. He ridiculed visual pleasure as "retinal art," that which primarily excites the visual senses. He asked, *"Why should we be only interested in the visual side of the painting. There may be something else."*[9]

Duchamp believed that art is a thing "to do," and that *doing* **anything** makes you an artist. He also proclaimed that *"art is dead,"* not because the act of sculpture or painting was irrelevant, but to *expand* the definition and encourage us that *everything* is art. If *doing* in all forms is art, then art is much larger than the confines of a single word or creative medium.

Duchamp's work, *The Large Glass,* would continue for eight years. He tinkered with it while teaching French, curating, and providing art advice. In 1923, he would designate *The Large Glass* as "formally unfinished." It was a risky but genius declaration—to abandon a work, but rather than admit failure, label the incompletion as a formal concept, and then question the worth of "completeness." The insightful defense of all things unfinished increased his fame. *The Large Glass* includes implanted features, gunshots, scratches, and various undefined shapes. It was obviously damaged during transport, which Duchamp embraced as part of the artwork's organic journey.

As described previously, Duchamp anonymously (signed by the fictitious "R. Mutt" instead) submitted *Fountain* to an art show in New York in 1917. Despite being a part of the show's organizing committee, Duchamp was unable to sway them in favor of accepting the readymade urinal into the collection. When they rejected *Fountain,* Duchamp resigned from the group in protest. The original *Fountain* was never seen again. Its legend was propagated through a single photo. A simple photo of a displaced urinal—not even the real urinal itself, changed the course of art history and is arguably the most influential artwork of the twentieth century. If for no other reason than his support for *Fountain,* and the ensuing dramatic legacy, it's critical to know Duchamp.

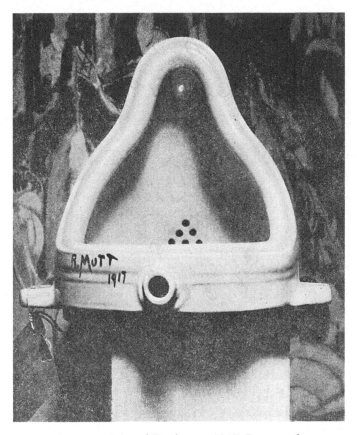

Fountain, Marcel Duchamp, 1917. Destroyed.

After his rebellious submission of *Fountain*, Duchamp continued to retreat from active artistic production. He would still produce an artwork periodically, as he did in 1919 with the notorious *L.H.O.O.Q.*, a cheap postcard reproduction of Leonardo's *Mona Lisa* that sported a moustache and beard. It was signed in French as "L.H.O.O.Q.," which is a phonetic game, translating from French "Elle a chaud au cul" to "She is hot in the arse."[10] Duchamp created a masculine Mona Lisa through the addition of a thick moustache, while simultaneously sexualizing her body through words. The juxtaposition shows his artwork as more than a lazy joke, but rather an attempt to confuse gender identity and question historic expectations. During the time he made

L.H.O.O.Q., Duchamp occasionally attended New York parties in drag to explore and provoke thoughts of identity.

For the next thirty years, Duchamp lived a modest life of art critic, competitive chess player, and socialite. It wasn't until the late 1950s, when New York modern artists rediscovered his perspective, that his influence across Dada, Cubism, and conceptual art inspired a generation. Duchamp was elevated to the position of public figure and aesthetic lecturer. We now accept Duchamp's perspective as the norm, that art can be anything, whether physically beautiful or not, and that through art we can challenge conventional wisdom or subvert social norms.

Where did that lead us? Today, if you open a major art publication, such as *Artforum,* on any given month you'll note a cadre of famous contemporary artists. They range from Jeff Koons to Damien Hirst, Ai Weiwei, Marina Abramović or Takashi Murakami. The early twenty-first century chapter of art is just beginning. We can't say any single artist represents the zeitgeist, but a few contemporary themes are clear.

Gender and racial inclusion: Finally, by the 2000s, women represented half of the working artistic population. That said, they still only fill 28 percent of solo shows in museums throughout the decade and earn about 22 percent less than men. Similarly, only about 25 percent of working artists are minorities. This is a huge disparity, but until the modern era, the written and documented story of art was almost entirely male and white.

Globalization of the art world: Collectors and artists have unprecedented access to art from global locations, and the artists themselves are rarely tethered to a single location for long.

Fragmentation of mediums: Artists still compose traditional sculptures and paintings, but immersive experiences; electronic, digital, and mixed media; site specific; and conceptual frameworks have risen in frequency and public exposure.

Accelerated merging of visual arts across creative fields: Public entertainment, music, fashion, and sociopolitical

commentary all call on the visual arts.

Given the artistic moment where we find ourselves, Takashi Murakami (1962–present) is as fitting a mascot as we can hope for. Yes, he's a man at a time when women are finally achieving their due visibility, but otherwise Murakami is from outside the United States and Europe, living, producing, and selling globally across boundaries, who fearlessly innovates across mediums, from sculptures to fashions and movies. The meaning of, and reception to, his work, are also distinctly contemporary.

Murakami was born in Japan in 1962. He grew up in the aftermath of World War II, with the Japanese defeat fresh in society's consciousness, and with the Vietnam War in the recent past. Murakami is inspired by Japanese history, tradition, influential, global pop culture, unrealistic teenage obsessions, and nuclear and environmental catastrophe, which are lingering, ever-present threats.

Murakami wears these phobias on his sleeve without shame. Consequently, his art has the potential to disturb viewers through the use of misshapen or foreboding figures. And yet, while his figures often display pain or anguish, Murakami is careful to emphasize bright colors with a glossy or shiny finish. He believes that the contrast between playful colors and challenging subject matter tempers the emotional burden of his artwork. In a single room, Murakami will showcase radiation-deformed monsters with cuddly cartoon creatures and maybe a fashion accessory. It's a dizzying and delightful confusion.

Murakami first found the spotlight for an idea called Superflat, coined to invoke the classical Japanese landscape style, which had limited depth of field and only minor lighting contrasts. Like classic Japanese scrolls, his work appeared visually flat, but it emphasized super slick, glossy composition. Philosophically, Superflat now means the combination of high-brow and low-brow Japanese culture—a flattening of culture through globalization, and the extension of visual icons across mediums, like cuddly creatures that appear in painting, sculpture, film, and fashion.

Murakami admits that viewers have projected more conceptual depth than he intended. In that sense, Superflat is hyper-contemporary: audiences have played a starring role shaping the meaning and narrative beyond what the artist intended.

Murakami runs an art factory called KaiKai Kiki, where he's known for harnessing global cultural trends, leveraging advanced technology, following exacting design standards, and producing voluminous, scalable output. He employs about seventy people at factories in Japan and the United States, with his own characters and storylines as reusable franchises. Murakami's works have included music videos with Kanye West and Pharrell Williams, fashion lines with Louis Vuitton, prints on Vans shoes, and feature-length children's movies emphasizing similarly bright colors and cuddly characters from his earlier artistic palette.

His artwork presents contradictions that span the world's tragic darkness and jovial happiness, styles that are ancient and modern, grotesque and beautiful, and, throughout, effectively visualize opposing elements—a similar thematic style that made Rubens (war and sexuality) so captivating. Murakami shows who an artist is today, or can be for the first time, in that the art world eclipses borders and extends genres. Geographic and formal restrictions are minimal. Murakami has enjoyed success through traditional methods—in galleries and museums, with painting and sculpture, but his work isn't easily confined to a location or genre. It might end up on your feet.

Are Curators Artists? Who Else Might Be?

Throughout history, artists have been collectors. Given their proximity, it only makes sense. Rubens was a prominent example, as was Duchamp later. Duchamp's assertion that art meant to "do," his use of readymade materials, and his devotion to collecting and curating formed an intellectual foundation for curating as art, proposed by an artist. Today there is an openness to the idea that curation itself **is** art, although not consistent acceptance. It is a distinct practice, with defined methods, rules and constraints, and theories that practitioners can consistently apply. Some are agreed to as better than others, which implies a sense of objectivity.

Taking the question seriously is a distinctly contemporary phenomenon. Historically, only the production of original artwork would designate someone an "artist." But the idea of production has changed. Postmodern theory, among others, is consistent with the belief that curation is art. Curators combine one or more original works into an entirely new composition, and potentially a new physical location, which creates distinct visual and intellectual meaning.

When a curator creates a thematic installation, it generates new meaning distinct from the initial works. Under this theory, original artworks are but inputs for the next layer of creation, a show on the photography of dissident figures from Latin American history, a retrospective for a contemporary painter, or a survey of Japanese influence on the Impressionists. To a curator, individual artworks are almost analogous to the paintbrushes, paint and canvas, and individual images—like a tree or a hill in an original work.

Who is a curator today? Okwui Enwezor is a famous practitioner. Born in Nigeria in 1963, a year after Murakami, he also lives in New York. He started as a poet but made his name bringing

contemporary African photography to the popular imagination. He did so by challenging our assumptions about how Africa was portrayed. Since then he's curated global shows in dozens of countries, often with an African theme, notably including the Venice Biennale in 2015, the most prestigious of global art shows. He's at the top of the curating profession. His curating requires an astute command of art history, expansive views of contemporary political issues, deep connections in the art world, and sharp opinions about artistic quality.

Curating unambiguously sounds like a discipline. Enwezor is an incredibly accomplished, global thinker. But curating and art seem like different disciplines, not simply two flavors of the same dish. That need not be derogatory to curators. Maybe it's a question of finding the smallest coherent unit? Yes, artists *could* splash a few specks of paint on canvas, but only a few would get away with it for long before audiences became bored. Not so with curation.

The curator already works with raw materials, art, which are formed enough that even a few selections would produce a workable show. They don't bring forth objects from the void of zero. Curators attract attention and convey meaning, but with almost finished inputs. Without a curator, each artwork still stands alone. Brushes and paint without an artist are reduced to bland commodities on store shelves. Curators "care" for the art and installation. They direct and orchestrate groups of artworks. They are able to build shows that frequently embrace a bolder scope than individual artworks could achieve.

Because of this, and as they select works for display, discussion grows about their role and power in art institutions. They are the art world gatekeepers, who define and select, display and safeguard the ideas of their institutions. It's a position of unique power, but I don't think it's the same art as starting with a blank slab of stone or a set of acrylic paints.

If curators are artists, maybe everyone really is an artist. Our art is the work we do. Maybe the definition I proposed in the "What" section is too narrow: *"An object whose sole purpose is to attract attention and convey meaning."* That was my definition for art *objects*. But what if all our actions are meant to attract attention and convey meaning? They do to some degree. If so, it's plausible that not only curation, but all our doing, as Duchamp said, is art. With that, our actions drift toward the contemporary vision of art, which proposes that art is the essential verb for *doing*.

> - What do you think, are curators artists?
>
> - How are they similar or different from a sculptor or painter?

That still seems like a semantic stretch. We're speaking in technicalities. Much of society's productive work, like growing or serving food, building telecommunications networks, transporting goods, and transferring money to a friend is just an activity—it's not art. Nor do we need to call it art to recognize its value. Meaning is not art's alone. All our actions do include doses of intuition and algorithm. That's where we get confused, like with the differences between art, design, and engineering.

Creative processes, such as serving food or building telecom networks, are not entirely repetitive. They ask us to use judgment and intuition, and that's important. But artists actively create objects and propose ideas that cause us to gasp at life's beauty and pain, and provide us tools to know ourselves and our society more deeply. It's a unique job.

Even if we aren't *practicing* artists, if we're curators or cooks, remember, most working artists today don't commit as a full-time job. Practically speaking, most artists are history teachers by day and artists at night. They work in hospitals and office parks, but sculpt outside. Duchamp was a chess player and a cultural critic.

Monet and Picasso were drinking socialites before they were economically independent artists. Artists step into and away from periods of artistic production, but it doesn't mean they cease to "be" artists when they aren't actively creating artwork. They do not become artists in the studio and lose the title outside it, like superheroes without their suits.

Logistically, most artists are part-time, and biologically, we all have a capacity to create, view, and understand, visual art. Together this indicates that anyone **could** be an artist, given enough time and focus. The barriers to entry are small and the rewards are deeply human in an increasingly mechanized world. Art is **in** us. We are artists waiting to be.

Conclusion

Despite the deluge of visual data in our daily lives, one type of image has persisted in giving us pause, in feeling less accessible than the rest: art. Art objects provide slightly mysterious, perhaps attractive, items in our visual field, objects with the sole purpose of "attracting our attention and conveying meaning." Now that we have defined art, we have more clarity about its purpose. Also, we are conscious about the unique interaction we have with art, the lack of guidance about where to start or stop, or how long to look. Independence has often been a recipe for boredom, or at least a gap between uncertainty and certainty.

I wanted to connect what art is—its definition—to *how* we view it, both how we do so naturally, biologically, without a conscious approach, and how we could view it more easily with a few pointers and guardrails. If we have a definition of art, understand basic materials, viewing locations and milestones in art history, then we can lock-in a framework and apply it consistently.

We should *have* definitions and approaches, rather than only reacting to impulses. Even if you think my definition is logically flawed, fatally so, you probably still agree that connecting your definition and viewing method will elevate joy beyond cursory glances and chance encounters. *Any* defensible definition can move you beyond fight or flight and biological impulses to a balanced confidence, to a gentle blending of biological reactions and inherent biases with learned reasoning and conscious evaluation. You might never naturally appreciate images of blood, feces or cruelty in art—I probably won't, but you can evaluate the artist's technique as relying on shock, and then decide if they are critiquing death or a political party. Guessing at the mystery or even solving it need not seem pretentious. You are a collaborator in the game.

Whether you think art is imitating life, or life, art, the distinction becomes moot. Aesthetic philosophy has moved from an art-

centered view of the world, projecting images of truth at subservient viewers, to one that recognizes dynamism between art object and a viewer's understanding. Beyond that, the artistic process and viewing process share creativity as the common denominator, as do art, design and engineering, the creative cousins. Art is a dialogue with creativity as the glue. Knowing we are in a dialogue releases us from a "correct" answer, although I believe we should give deference, if not preference, to the artists' intentions. But we don't receive a failing grade if we don't "get" their jokes or historical references.

Still, knowing art world stock topics gives us confidence. Artists remix known rhythms. If the storytelling world is limited to seven basic plot types, the art world is slightly larger than that, maybe a dozen. Topics *are* known, however: love of person or god; fear of death; glory of war; projection of identity—racial, gender, sexual; commentary on politics or social movements; or a simple exploration of color. Artistic movements, ideas, and artists themselves can be categorized. Artists are people taking a stand *for* or *against* these topics, just like we would in a café conversation or social media chat board.

This book is *not* meant to reduce or flatten the subtleties rich in artwork, but to provide a starting point from which to launch your investigation. If each of us is creative—to some level, if we are critics, curators, or artists waiting to be, so to speak, a framework is necessary for us to reevaluate how art fits into our lifestyles, conversations, and work.

Depending on your scenario for the artistic future, that becomes more or less important. But with how humans are wired to view, to tell stories, to appreciate color, texture, and pattern, I wouldn't bet against art remaining a foundational pillar of our civilization, even as technology expands into our houses and cars. Knowing about art establishes visual creativity in our basic vocabulary. I hope you are more confident using that vocabulary now, to talk about art, collect it, and make it.

Acknowledgments

First and foremost, participants in The Art Circuit, members and artists, contributed ideas, debate, and support to this book. Their curiosity was the catalyst for this exploration. Next, my wife, Chisaka, lent a guiding eye and ear to numerous revisions of the manuscript. Joni Wilson was my detailed editor, taking the project from rough form to finally readable. Stephen Reich provided the graphic design to bring my images into a clear form. Islam Farid used his magic on the cover design. My dad lent a positive and critical eye through detailed review, while my mom's adventures in publishing inspired me to take my own leap.

About the Author

Aron Kuehnemann runs The Art Circuit with his wife, Chisaka. They share art on a subscription basis with clients in the San Francisco Bay Area and increasingly, beyond.

Aron was born in Iowa and now lives in California. Being from a small town compelled him to venture out and keep moving. His goal is to consistently visit more countries than his age, which is becoming more difficult each year.

You can find him at www.theartcircuit.com.

Chapter References

Why Is Art Important?
[1] Chua-Eoan, Howard. (March 1, 2007). "Stealing the Mona Lisa, 1911." *TIME*.
[2] Peruggia Letter. (December 22, 1911). Archivio di Stato, Florence, Italy.
[3] Reymond, Rhonda, and Mann, Jon. (November 2016). "Art and Cultural Heritage Looting and Destruction." ArtHistoryTeachingResources.org.
[4] Reymond. "Art and Cultural Heritage."
[5] "True or False? Vision Rules the Brain." (November 20, 2012). ImageThink.com.
[6] Spence, Charles. (2015). "On the Psychological Impact of Food Colour." *Flavour*. DOI 10.1186/s13411-015-0031-3.

Relevance
[1] Tattersall, Ian. (2012). *Masters of the Planet: The Search for Our Human Origins*. St. Martin's Press.
[2] "Exhibitions. Mezzanine." (2016). Vienna Museum of Natural History.
[3] Tattersall. *Masters of the Planet*. p. 206.
[4] Harari, Yuval Noah. (2015). *Sapiens: A Brief History of Humankind*. Harper. p. 27.
[5] Fagan, Brian M., ed. (1996). *The Oxford Companion to Archaeology*. Oxford University Press. p. 762.
[6] Kandel, Eric R. (2012). *The Age of Insight: The Quest to Understand the Unconscious in Art, Mind, and Brain, from Vienna 1900 to the Present*. Random House. p. 404.
[7] Kenny, Anthony. (2010). *A New History of Western Philosophy*. Oxford University Press.
[8] Riding, Christine, and Llewellyn, Nigel. (2013). "British Art and the Sublime." In Nigel Llewellyn and Christine Riding (eds.). *The Art of the Sublime*. Tate Research Publication. https://www.tate.org.uk/art/research-publications/the-sublime/christine-riding-and-nigel-llewellyn-british-art-and-the-sublime-r1109418.

Building a Definition
[1] "art." Dictionary.com. See http://www.dictionary.com/browse/art.
[2] Staniszewski, Mary Anne. (1995). *Believing Is Seeing: Creating the Culture of Art*. Penguin. p. 43.
[3] Cattelan, Maurizio. (1999). *La Nona Ora*. See https://www.perrotin.com/artists/Maurizio_Cattelan/2/la-nona-ora/15420.

The Materials of Art
[1] Horejs, Jason. (2016). "Initial Results from Xanadu Gallery's 2016 State of the Art Survey." See http://reddotblog.com/initial-results-from-xanadu-gallerys-2016-state-of-the-art-survey/.
[2] Harris, Beth, and Zucker, Steven. *Tempera Paint*. Khan Academy. See https://www.khanacademy.org/humanities/art-history-basics/artists-materials-techniques/painting-materials-techniques/v/tempera-paint.
[3] "Fresco painting." See https://www.britannica.com/art/fresco-painting.

[4] Horejs. "Initial Results from Xanadu Gallery's 2016 State of the Art Survey."

[5] Harris, Beth, and Zucker, Steven. *Oil Paint in Venice.* Khan Academy. See https://www.khanacademy.org/humanities/art-history-basics/artists-materials-techniques/painting-materials-techniques/v/oil-paint-in-venice.

[6] Editors of Phaidon Press. (2001). *The 20th Century Art Book.* Phaidon Press.

[7] Blake, Diana. "Stretched Canvas: A Recent Innovation in Painting." See http://www.dianablake.net/ArtHistoryArticles/Canvas.htm

[8] "Understanding the Difference between Canvas and Linen." See http://www.winsornewton.com/na/discover/tips-and-techniques/other-tips-and-techniques/difference-between-canvas-and-linen.

[9] "Cindy Sherman, Imitation of Life." (2016). See http://www.thebroad.org/art/exhibitions/cindy-sherman-imitation-of-life.

[10] Lee, Pamela M. (2012). *Forgetting the Art World.* MIT Press. p. 70.

[11] Fontana, Lucio. (1947). *Primo Manifesto dello Spazialismo (White Manifesto).* Milan. p. 130.

[12] Shanken, Edward A. (2009). *Art and Electronic Media.* Phaidon Press. p. 24.

[13] Morton, J. L. (2017). "Color Matters." See http://www.colormatters.com/color-and-design/basic-color-theory.

[14] Jaffe, Eric. (2014). "The Fascinating Neuroscience of Color. See http://www.fastcodesign.com/3027740/evidence/the-fascinating-neuroscience-of-color.

What Is "Exceptional" Art?

[1] Thornton, Sarah. (2008). *Seven Days in the Art World.* W. W. Norton & Co. pp. 52–53.

[2] Dutton, Denis. (2008). *The Art Instinct: Beauty, Pleasure, and Human Evolution.* Bloomsbury Press. p. 193.

[3] Melamid, Aleksandr, and Komar, Vitaly. (1997). *Painting by Numbers: Komar and Melamid's Scientific Guide to Art.* Farrar Straus & Giroux. p. 13.

[4] Melamid. *Painting by Numbers.* p. 24.

[5] Melamid. *Painting by Numbers.* p. 25.

[6] Wolfe, Thomas. (1975). *The Painted Word.* Farrar, Straus, and Giroux. p. 79.

[7] "El Greco." See https://en.wikipedia.org/wiki/El_Greco.

[8] "Frida Kahlo." See https://en.wikipedia.org/wiki/Frida_Kahlo.

[9] Zug, James. (2011). "The Theft That Made the 'Mona Lisa' a Masterpiece." *All Things Considered.* See http://www.npr.org/2011/07/30/138800110/the-theft-that-made-the-mona-lisa-a-masterpiece

The Future?

[1] Watson, Leon. (2015). "Humans Have Shorter Attention Span than Goldfish, Thanks to Smartphones." *The Telegraph.* See *http://www.telegraph.co.uk/science/2016/03/12/humans-have-shorter-attention-span-than-goldfish-thanks-to-smart/.*

[2] "Museum Facts." American Alliance of Museums. See http://www.aam-us.org/docs/default-source/museums-advocacy-day/museum-facts-2017.pdf?sfvrsn=2

[3] "Museum Facts." See http://www.the-numbers.com/market/2016/summary

[4] Lockett, Hudson. (2017). "Global Art Market Sales Drop Estimated 11% in 2016." *Financial Times.* See https://www.ft.com/content/901c3d32-c81f-3f2c-bdc5-627ad05a39f5?mhq5j=e1

[5] Khomami, Nadia. (2014). "2029: The Year When Robots Will Have the Power to Outsmart Their Makers." *The Guardian*. See https://www.theguardian.com/technology/2014/feb/22/computers-cleverer-than-humans-15-years.

Getting Good at Viewing Art
[1] "Flow (Psychology)." See https://en.wikipedia.org/wiki/Flow_(psychology)#cite_note-PsychologyProfessor2001-3
[2] Kotler, Steven. (2014). "Create a Work Environment That Fosters Flow. *Harvard Business Review*. See https://hbr.org/2014/05/create-a-work-environment-that-fosters-flow.
[3] See http://www.flowgenomeproject.com/about/.
[4] Nakamura, J., and Csíkszentmihályi, M. (2001). "Flow Theory and Research." In C. R. Snyder, Erik Wright, and Shane J. Lopez. *Handbook of Positive Psychology*. Oxford University Press. pp. 195–206.
[5] Csíkszentmihályi, Mihaly. (1991). *The Art of Seeing: An Interpretation of the Aesthetic Encounter*. J. Paul Getty Museum. pp. 7–8.

Investigate How We Perceive Art
[1] Graham, Daniel J., and Redies, Christoph. (2010). "Statistical Regularities in Art: Relations with Visual Coding and Perception." *Vision Research 50*, no. 16. Doi.org/10.1016/j.visres.2010.05.002.
[2] Chatterjee, Anjan. (2014). *The Aesthetic Brain: How We Evolved to Desire Beauty and Enjoy Art*. Oxford University Press. p. 7.
[3] McVeigh, Karen. (2009). "Why Golden Ratio Pleases the Eye: US Academic Says He Knows Art Secret." *The Guardian*. See https://www.theguardian.com/artanddesign/2009/dec/28/golden-ratio-us-academic.
[4] Henss, Ronald. (1998). "Waist-to-Hip Ratio and Female Attractiveness." See http://www.femininebeauty.info/i/henss.pdf.
[5] Cooper, Belle Beth. (2015). "Why Getting New Things Makes Us Feel So Good: Novelty and the Brain." See https://blog.bufferapp.com/novelty-and-the-brain-how-to-learn-more-and-improve-your-memory.
[6] Kandel. *The Age of Insight*. p. 338.
[7] Kandel. *The Age of Insight*. p. 425.
[8] Honan, Daniel. "The Beholder's Response: How the Brain Responds to Ambiguity in Art." See http://bigthink.com/think-tank/the-beholders-response-how-the-brain-responds-to-ambiguity-in-art.
[9] Tracey, David, ed. (2012). *The Jung Reader*. Routledge, para. 161.
[10] Dewey, John. (2008). *The Later Works of John Dewey, Volume 10, 1925–1953: 1934, Art as Experience*. Southern Illinois University Press. p. 308.
[11] Noë, Alva. (2015). *Strange Tools: Art and Human Nature*. Hill and Wang. p. 97.

Seeing Art, Fast and Slow
[1] Kahneman, Daniel. (2011). *Thinking, Fast and Slow*. Farrar, Straus, and Giroux. pp. 20–21.
[2] Kahneman. *Thinking, Fast and Slow*. p. 24.

Where

[1] Dewey, John. (1989). *The Later Works, 1925–1953, Volume 10.* Southern Illinois University Press. p. 332.

[2] Rose, Aaron, and Strike, Christian. (2004). *Beautiful Losers.* D.A.P./Iconoclast. p. 193.

[3] Wheelock, Tristan. (2006). "The Writing on the Street." *The Oracle.* See http://www.usforacle.com/news/view.php/832029/The-writing-on-the-street.

Art at Home

[1] Davenne, Christine. (2012). *Cabinets of Wonder.* Harry N. Abrams. p. 9.

[2] Alexander, Edward P., Alexander, Mary, and Decker, Juilee. (2017). *Museums in Motion: An Introduction to the History and Functions of Museums.* Rowman & Littlefield. p. 4.

[3] Davenne. *Cabinets of Wonder.* p. 169.

[4] Fletcher, Pamela. "On the Rise of the Commercial Art Gallery in London." See http://www.branchcollective.org/?ps_articles=pamela-fletcher-on-the-rise-of-the-commercial-art-gallery-in-london.

[5] "Museum Definition." (2007). International Council of Museums. See http://icom.museum/the-vision/museum-definition/.

[6] Irvine, Lois. (2006). "In Memoriam: Duncan Ferguson Cameron, 1930–2006." See http://www.maltwood.uvic.ca/cam/archived_news/20060429_memoriam_cameron.html.

[7] Alexander. *Museums in Motion.* pp. 3–4.

[8] Alexander. *Museums in Motion.* p. 53.

[9] Bradley, Kimberly. (2015). "Why Museums Hide Masterpieces Away." See http://www.bbc.com/culture/story/20150123-7-masterpieces-you-cant-see.

[10] "List of Most Visited Art Museums." See https://en.wikipedia.org/wiki/List_of_most_visited_art_museums.

[11] Mehretu, Julie. (2014). American Artist Lecture Series. See http://www.tate.org.uk/context-comment/audio/american-artist-lecture-series-julie-mehretu.

Art History: Fast Forward

[1] "Online Etymology Dictionary." See http://www.etymonline.com/index.php?term=art. See also https://indo-european.info/dictionary-translator/translate/English/Indo-European/?q=Art.

Conveying Meaning—Aesthetic Philosophy

[1] "aesthetics." Dictionary.com. See http://www.dictionary.com/browse/aesthetics?s=t.

Eras of Aesthetic Philosophy

[1] Kosakowska, Gosia. (2015). "The Vitruvian Man." See https://prezi.com/uvskcyezsuta/the-vitruvian-man/.

[2] Wimsatt Jr., W. K., and Beardsley, Monroe C. (1954). "The Intentional Fallacy." *The Verbal Icon: Studies in the Meaning of Poetry.* University of Kentucky Press. p. 3.

Attracting Attention: Beauty and Shock

[1] "Kouros." See https://en.wikipedia.org/wiki/Kouros.

[2] Editors of Phaidon Press. (2011). *The Art Museum*, Phaidon Press. p. 314.

[3] Laertius, Diogenes. (5–4 BCE). *The Lives of the Philosophers.*

[4] Jantzen, Grace. (2004). *Foundations of Violence: Death and the Displacement of Beauty.* Routledge. p. 198.

[5] Eco, Umberto, ed. (2004). *History of Beauty.* Rizzoli.

[6] Hume, David. (2000). *Essays and Treatises on Several Subjects. Vol. 1.* Adamant Media Corporation, *p. 245.*

[7] Tarmy, James. (2016). "Why Modern Art Portraits of Men Sell Less than Those for Women." See https://www.bloomberg.com/news/articles/2016-11-01/why-modern-art-portraits-of-men-sell-for-less-than-those-of-women.

[8] Ahmari, Sohrab. (2016). "Remember When Art Was Supposed to Be Beautiful?" *The Wall Street Journal.* See https://www.wsj.com/articles/remember-when-art-was-supposed-to-be-beautiful-1477090696.

Know Key Milestones in Art History

[1] Webb, Dan. "The Everything Cup." See http://danwebb.squarespace.com/writing/2016/10/3/the-everything-cup.html.

[2] Wilde, Oscar. (1889). "The Decay of Lying." See https://en.wikipedia.org/wiki/Life_imitating_art.

[3] "Altamira Cave, Spain." *Encyclopedia Britannica.* See https://www.britannica.com/place/Altamira.

[4] Netburn, Deborah. (2016). "Chauvet Cave: The Most Accurate Timeline Yet of Who Used the Cave and When". *Los Angeles Times.*

[5] "The Salle du Fond Chamber—The Venus and the Sorcerer." See http://www.bradshawfoundation.com/chauvet/venus_sorcerer.php

[6] Sample, Ian. (2014). "35,000-Year-Old Indonesian Cave Paintings Suggest Art Came Out of Africa." https://www.theguardian.com/science/2014/oct/08/cave-art-indonesia-sulawesi.

[7] "Blombos Cave." See https://en.wikipedia.org/wiki/Blombos_Cave.

[8] "African Art—Works of Power and Beauty," See http://www.rebirth.co.za/african_art/introduction.htm.

[9] "Egyptian Art." See https://www.khanacademy.org/humanities/ancient-art-civilizations/egypt-art/beginners-guide-egypt/a/egyptian-art.

[10] "Ancient Egyptian Retainer Sacrifices." See https://en.wikipedia.org/wiki/Ancient_Egyptian_retainer_sacrifices#King_Aha .

[11] Brouwers, Josho. (2015). "How Were Ancient Greek Pots Made?" See https://www.karwansaraypublishers.com/ahblog/how-were-ancient-greek-pots-made/.

[12] Keats, John. (1819). "Ode on a Grecian Urn." See https://www.poetryfoundation.org/poems-and-poets/poems/detail/44477, lines 31–50.

[13] Schreuder, Duco A. (2014). *Vision and Visual Perception: The Conscious Base of Seeing.* Archway Publishing, p. 663.

[14] "Greece and Rome." See http://www.historymuseum.ca/cmc/exhibitions/civil/greece/gr3010e.shtml.

[15] Koekoe, Jade. (2015). "Art of Pompeii." See http://etc.ancient.eu/photos/art-of-pompeii/.

[16] Margaret, Rudd E. (2016). *Divided Image: A Study of William Blake and W. B. Yeats.* Routledge. p. 217.

[17] "Cathedral of Florence." See http://www.museuminflorence.com/musei/cathedral_of_florence.html.
[18] "Pope Leo X." See https://en.wikipedia.org/wiki/Pope_Leo_X.
[19] "St. Peter's Basilica." See https://en.wikipedia.org/wiki/St._Peter%27s_Basilica#Financing_with_indulgences.
[20] Beale, Stephen. (2013). "Lessons from the Council of Trent." See http://catholicexchange.com/lessons-trent.
[21] Gombrich, E. H. (2006). *The Story of Art*. p. 382.
[22] Gompertz, Will. (2013). *What Are You Looking At? The Surprising, Shocking, and Sometimes Strange Story of 150 Years of Modern Art*, p. 81.
[23] Gompertz. *What Are You Looking At?* p. 29.
[24] "Looking East." Asian Art Museum, San Francisco. Photo in possession of author.
[25] Kandel, Eric. (2012). *The Age of Insight: The Quest to Understand the Unconscious in Art, Mind, and Brain, from Vienna 1900 to the Present*. Random House. p. 107.
[26] Gompertz. *What Are You Looking At?* p. 189.
[27] "Paris: The Heart of Surrealism." See http://www.artic.edu/reynolds/essays/hofmann3.php.
[28] Caws, Mary Ann. (2002). *Surrealist Painters and Poets: An Anthology*. The MIT Press, p. 179.
[29] MoMA. See https://www.moma.org/collection/works/79070.
[30] Randolph, Eleanor. (2011). "The Andy." *The New York Times*. See http://www.nytimes.com/2011/05/14/opinion/14sat4.html.
[31] Howard, Billee. (2016). "Andy Warhol's Lessons for Success." See http://motto.time.com/4214244/business-success-andy-warhol/.

Artists Snapshots: Who
[1] Staniszewski. *Believing Is Seeing*. p. 289.
[2] Thornton, Sarah. (2008). *Seven Days in the Art World*. W. W. Norton & Company. p. 64
[3] Thornton, Sarah. (2014). *Thirty-Three Artists in Three Acts*. W.W. Norton & Company, p. 26.
[4] US Bureau of Labor Statistics. See https://www.bls.gov/ooh/arts-and-design/craft-and-fine-artists.htm.
[5] Day, Elizabeth. (2012). "Can You Make Any Kind of Living as an Artist? See https://www.theguardian.com/culture/2012/jul/29/artists-day-job-feature.
[6] Hurwit, Jeffrey M. (2015). *Artists and Signatures in Ancient Greece*. Cambridge University Press. p. 150.
[7] "*Laocoön and His Sons.*" See https://en.wikipedia.org/wiki/%C3%B6n_and_His_Sons#cite_note-21.
[8] Selfridge, John W. (1994). *Pablo Picasso*. p. 102.
[9] Duchamp, Marcel. (1968). "Transforming Freedom." See http://www.transformingfreedom.org/hyperaudio/be-artist-not-noticed-artist.
[10] "*L.H.O.O.Q.*" See https://en.wikipedia.org/wiki/L.H.O.O.Q.